CW01035444

Headwaters

Headwaters

And Other Short Fictions by
Lucy R. Lippard

New Documents
Los Angeles

Contents

Letter to a Fellow Writer
April 29, 1970

I've just had a tremendous craving to talk to somebody who's tried to write anything vaguely resembling a—you should excuse the expression—novel. I don't have any doubts about how I'm doing. I mean doing it is, and has been, exhilarating and appalling and all the betters and worses I'd expected. Not that I like the thing, but that's somewhere else. I just wonder what the hell it is I think I'm up to. Did or do you? I know what could be said about it and what I say about it.

After periods of wondering what gives me the guts to go through with it, I arrived all formalistically fortified to produce something properly classifiable and neat and clear and all hell broke loose and all the dirty laundry and even criticism got thrown into it too.

I work day after day in a daze and today I suddenly realized I probably wouldn't be doing this particular thing I seem to be doing if I were in NYC. I think I'd be sidetracked and sidewinded and forsworn, skinned alive, etc. By myself.

Fuck it.

I guess after all I know what I'm into but want it rubbed up against other aspirations or something. I love this place and haven't been more content in years. Spend all my time reading, writing, or walking and looking at bigger skies and light changes and color changes—the whole nature bit— and am really spilling into it and out of it. 3 months will probably be enough and I'll be ready to go back to the Prince's filthy lap but at the moment have no urge to budge ever. This doesn't make much sense and I'm not even high on anything except being here out from under responsibility.

Do write, though, and tell me something about what, if anything, happens when you find yourself drowning in a puddle of words. Picked on you tonight because for all your paranoia (somebody told me you didn't think I liked your books when I damn well did and I didn't see how you could be so dim as to think I didn't), they are still the best novels I've read since

9

then and I'm fond of you for some
reason aside from or because of
that.

P.S. I think what I started out to
say and didn't is that immersed
in the avant-god as we all are,
why would we let ourselves in for
sounding/looking/acting like such
fluorescents?

Lucy

Casa Clay, Carboneras
Almería, Spain

The fifty-year-old letter above refers to the process of writing
my only published "novel"—*I See / You Mean*—while living
for a few months with my five-year-old son in the little fishing
village of Carboneras, in a casita lent me off-season by a fellow
writer. (The book was translated into Spanish by Paloma
Checa-Gismero in 2016 and published by Consonni, in Bilbao,
then republished in English by New Documents in 2021.)

After some success at serious fiction in high school
and college, and some failed attempts to break into popular
magazines after arrival in New York City in the late 1950s,
I realized I wasn't very good at writing the kind of fiction
I liked to read—with developed characters and narratives.
Influenced by conceptual art and performance in the mid to
late 1960s, I began to write experimental vignettes.

The bulk of this book was written over five decades, during
a more substantial career of art writing and cultural criticism.
Reading it over so many years later, I'm often hard put to un-
derstand what I was after, though Joyce and Beckett were my

favorite writers early on. Mainly, I was enjoying the process, freed from the constraints of journalistic criticism, to free-play with words. Don't look for sense; it's all about words, almost on their own, hooking up with other words. Take it in small doses!

In the 1990s, after starting but never finishing another "novella" called *Islands* and half-heartedly beginning one called *Upriver* after a raft trip on the San Juan, I put a stop to these occasional attempts. Now and then, while I'm walking the dog, the first lines of new fictional ideas pop into my head. I let them blow away into the landscape.

I still read a lot of fiction, books that are "good reads," but my taste does not run to the experimental, though that's all I can write. A sucker for any kind of narrative, I only read novels late at night, for fear of getting nothing else done in the workdays. Writing is the only thing I can do, so even at age 86, retirement isn't imminent. Freelancers die with their boots on.

Lucy R. Lippard

Summer 2023
Galisteo, New Mexico

I.

Early Fictions
(1951–58)

The most interesting man I ever knew was Herman, one of the Bay Point Spinneys. Herm was a taciturn, shrewd, Maine lobsterman, but lobstering was not his only business, as you will see. When I was little, Mother used to buy lobsters from Herm and take me along. I liked him a lot, for he was a charming man and very fond of children. However, I am afraid Herm was not so popular among his fellow men.

His father had been a lighthouse keeper on Pond Island at the mouth of the Kennebec River, but his mother was of different stock, for she was the daughter of a Munsey, of the famous *Munsey Magazine*. Herm was reared on Pond Island with his eleven brothers and sisters. Whether the Spinneys had a normal childhood or not, I do not know, but Herm and four of his brothers certainly made a reputation for themselves, though not the kind one would expect of a Munsey mother.

When the children became of age they drifted off to different parts of Maine, and only Herm and four brothers stayed at the Kennebec, though moving their residence half a mile to the mainland to the fishing village called Bay Point. Here they set up their lobstering business and were apparently satisfied for a while. In the meantime Herm had married and seemed to be settling down. But then came prohibition. Now the Spinney brothers were not "drunks," but they were fond of their bottle and also of the sound of money jingling in their pockets, so when they found that it was profitable to be bootleggers and rumrunners, they lost no time in starting a second business.

For a while the authorities were ignorant of the Spinneys' activities, but it soon became evident that they were catching

on. People still bought Spinney illegal liquor, but they were holding their breaths to see how long Herm and his twin brother Ralph could keep it up. Finally it came to a direct questioning, and everyone figured that the Spinneys' free time was limited. However, they underestimated the power of the Spinneys. When questioned, they had perfect alibis, the best of which were those of Herm and Ralph. When one of them was dragged into court, caught almost red-handed, people would swear that they had seen the same man in Lewiston that night. It was almost the truth—they had seen the other twin. This ruse usually worked and kept them operating for quite a while.

My grandmother, living about a quarter of a mile from Bay Point, was witness to a remarkable episode. The friend she was staying with awakened her about three o'clock in the morning and asked if she wanted to see a sight. In their wraps they stole out on the porch and peered into the fog. There were no lights, but the low humming of a motor, the gentle dipping of the oars, and every now and then hushed voices betrayed the presence of a large boat and small rowboats handing something back and forth. It was the Spinney brothers rumrunning in the dead of night, little suspecting their surprised audience on the shore! This performance was repeated several times that summer, with no one the wiser except my grandmother and her friend.

At last the authorities caught up with them, and the Spinney brothers disappeared for a while. In the spring Herm returned, as charming as ever, bragging that he and his brothers had been wintering in the South. For a while the populace of Bay Point was envious; then it was disclosed that the Spinneys had been in the Federal Penitentiary in Atlanta, serving time for bootlegging. Herm laughed it off with his usual poise. Well, he had wintered in the South, hadn't he?

After prohibition was repealed, Herm and his wife opened a store which sold food, liquor (the legal kind), and other items of lesser importance. This was fine until the government

discovered that Herm had no beer license. Herm agreed good-naturedly that it looked as if he'd have to get one. But here the authorities put their foot down. No license for someone who had served time for an offense such as Herm's, they argued. He figured this was pretty bad. Then his wife applied for a license. But no one as closely related as a wife to someone with Herm's record could get a license either. At this point Herm lost his temper. He couldn't get along without his beer license. He raged and figured, and finally had a brainstorm.

Two months later the town of Bay Point was horrified when they learned of Herm's solution. He and the Mrs. had gotten a Reno divorce. Even more shocking was the fact that the divorce seemed to make no difference in the private life of the Spinneys, who continued living together in the happiest way possible with one difference—a beer license. This had been obtained by the ex-Mrs. Spinney who was no longer prohibited from its possession.

Another of Herm's tricks was an especially obnoxious one. An artist who spent the summer at Bay Point noticed the crude wooden bait hooks being used by the fishermen, and when he went home that winter he fashioned some beautiful metal ones as Christmas presents for his lobstermen friends. He sent them to Herm to distribute to the men. The next summer he asked one of the fishermen how he liked the metal bait hooks. "Oh," replied the man, "I couldn't afford one."

When the astonished artist asked what he meant, the man drawled, "Well, Herm was asking two dollars apiece for them."

The next year the artist made some more hooks. This time he engraved the names on them and sent them to the men personally.

Herm's brother Ralph was of the same timber, though I don't believe he was Herm's equal. His business was running a store on Popham Beach. His customers liked him, but had to watch him as he made change. Putting some sugar on the

scales, along with a heavy hand, he would announce in a loud voice, "That's six pounds, at six cents a pound; six times six is sixty-six—call it sixty-four cents."

Unless you watched him carefully and figured along with him, you went away with the impression that Ralph had done you a great favor, instead of realizing that he had been shortchanging you all along.

Such were the Spinneys. Now that they are gone, Bay Point is a more peaceful but less interesting place, and the sign over the soft drink stand no longer reads: "Pop—4¢ a bottle—2 for 9¢."

1951

She was smiling, complacent and calm, and a moment later, at his words, wrath governed her completely. It boiled up inside of her, threatening to overflow its capacity, menacing her peace of mind, tearing at her senses. She felt herself stiffen with resentment, and her brain was sent whirling in the raging circles of sharp retorts. Her anger was overpowering in its potence and forcefulness, and she felt as though she would break in two if she must control her emotions one instant longer.

Outwardly she smiled again; raised her teacup toward her tormentor, and said, "Touché," for it was necessary to retain a pleasant air. A teacher in her position could not afford to offend a bantering trustee.

1954

Her back is to me, but I know what I should see if she turned around, for I have lived with my aunt for a year now, and have grown to know her well, almost too well, considering the difference in our ages and the respect due to elders.

She is not really very old, but her hair is gray and her face is lined, not with cares, but with a less tangible expression of her years. Her expression is one of acceptance, not of real contentment, nor yet unhappiness, but an indefinable air of something lacking, something which had been almost achieved for a long time, but is slowly and hopelessly fading into the past. She often displays a bright smile which is consciously genuine but seems to me to be quite artificial at times. Her gray eyes are kindly, and sometimes, when mood permits, they throw out sparks of smoldering spirit whose presence is convincing, but seldom evident to any other than herself. Her figure is still strong and sturdy, reminiscent of the days when she could out-run any boy in the neighborhood; when she excelled in sports in high school and college. She is a likeable person, my aunt. Most people think a great deal of her, but many are puzzled at her well-hidden, but unexpected, eccentricity. There is hardly anyone who has no opinion at all of her; she has a definite enough personality to be either liked or disliked. One of her avid antipathies is toward being treated as though she is just insignificantly *there*.

Life goes too quickly for some people, and so it has been with her. At the age of fifty she has not yet done the things she had dreamed of doing at sixteen. Then her ambitions were ceaseless, her determination relentless, yet here she is, sitting in

a low chair on the lawn of her modest home, looking out across the road, past the other houses of the small, country town, into the woods where she had played as a child, played and pretended with the ecstasy of childhood to be all manner of great people: a dancer, an archaeologist, an actress, and more recently in the final and lasting stages, an artist. Into these woods she had run as a young girl with the letter of acceptance into the college of her choice. There she had read letters from numerous young men, and later from her husband. Her life had not been tragic; her divorce, which did nothing to disrupt her devotion to her career, was not painful, merely a quiet parting of the ways, well-nigh forgotten by most people now.

From the moment she decided to be an artist, her mind dwelled unceasingly upon all aspects of that career. She had planned her life even before entering college, and to the casual observer it must have seemed that she would let nothing bar her way to success. Her dreams were comprehensive; an interesting job for a while, an economical trip to Europe, fame as a painter, and perhaps most important of all, the acquaintance with fascinating people of all sorts, whose friendship would be her most treasured possession. Yet despite these stirring ambitions, she was never unhappy, nor at all discontented with her easy college life, relaxed summers, or the hours she wasted away from the drawing board. With the confidence of youth she saw no reason to overtax herself just then. Things would surely happen so that her goal would be ultimately reached. Life had always treated her kindly, why not in this respect, when she knew so well what she was striving for?

Nothing ever happened to divert her from the course she had chosen, but perhaps it is because nothing really did happen that she has never taken that one big step ahead, has never taken the direct initiative to go out and get what she wanted. Although that was what she was always intending to do, she never did. And now, after a life of apparent ease and

daily attention to her talent, and progress in that field, she has accomplished nothing. "What has happened to all that time?" she must wonder. "I have been busy all my life; I meant to go on with my art, but the only places my pictures hang are in the living rooms of grateful friends."

And I know that she must realize finally, as she sits there with that distant light in her eyes, that she has wasted fifty years, and that it is her own fault. Surely that is a burden for any human being to bear, and I wonder myself, as I watch her live each day, as I look at the striking paintings she has done, why she doesn't get up out of that chair and fulfill her ambitions. Success is so near and yet so far, and it seems impossible that one facet of the human character is powerful enough to undermine all that talent and will, which was so evident in my aunt when she was young, and still triumphs once in a while in spite of her.

She rises, and comes toward me, and I see no change in her face. I think I know now that this woman will continue to live under the shadow of what she could have done with her life, and I go forward with pity and love to tell her that I must go away—to find *my* significance. I should like to tell her that I have learned a lesson from her, that my life will not be such a mistake, but as I watch her come toward me I know I shall not. She looks too weary, too defeated, and I think perhaps she has realized the truth.

1954

Author's note: This story was written when I was eighteen or nineteen years old, about a year after the Emmett Till murder. I was partly raised in the South, with liberal parents and grandparents involved in "race relations." The story reflects my classic, white, anti-racist viewpoint. At the time, it may have seemed daring. Years later, of course, in an interview with writer Timothy Tyson, Carolyn Bryant (the model for Francis Jean) reneged on her testimony that had helped free Till's murderers.

Today, any use of the N-word is justifiably fraught. After consulting several friends and colleagues on the matter, I decided to print the story as part of this collection. They did not always agree and the decisions are my own. Thanks to Ernest Tollerson, Darryl Lorenzo Wellington, Christian Rosado, and Veronica Jackson.

Frances Jean brushed a fly from the sack of potatoes before her, but they still buzzed monotonously over the sweet, hot, already spoiling fruits. The little store was damp and dusty in the noon heat. As she moved from shelf to shelf her cotton dress stuck unpleasantly to her slender figure and to the big breasts of which she was so proud. She reached automatically for the bread, the cornmeal, the sugared doughnuts Bryant liked so much. They were sticky and blotched under their cellophane window, but there was nothing she could do about them, any more than she could do anything about the endless carpet of minutes, hours, days in Mechum after a city life of dances, men's admiring stares. Just twenty years old is too young to be buried alive but a lot of good it did to think, at all.

She picked up the bag of food wearily, left her list on the counter to be charged, and with her free hand smoothed her dark hair, curling it under with her fingers and throwing its weight back with a toss of her head as she stepped outside. Without speaking she passed the group of men sprawled as usual on the steps of the store, hearing without listening to their infinite drawl of things she didn't care about—politics, business, women. Men were worse gossips than women. How much time Bryant had spent lately whispering in a corner with his cronies, arguing, filling the room with smoke and noise for half the night, while she sat in the kitchen with dance music turned up loud on the radio. Talk, talk, talk, hovering in the wavy layers of heat over days and more days.

When somebody whistled—a real wolf whistle—loud and sharp just like the old days, she smiled a little and tossed her

head again, wishing she weren't so hot and bedraggled, wondering who it could be. She had gone on a few steps, walking slowly, her hips consciously swinging, before she noticed the silence behind her, a curious crescendo of shuffling and muttering. She turned and saw the tall boy of about fifteen who had whistled at her. Her reaction was not rage, but disappointment. He was not only too young to be interesting, but he was black.

She sucked in her breath in what she hoped sounded like an indignant gasp, gave him a cool look, shrugged, and walked on, faster now, feeling her face redden, angry not at the boy, but at herself, at the group on the porch back there for having seen, angry for the continued muttering as she moved on. She started to turn down the street toward home, but a voice called out slowly at her, sounding louder than it was because everything else was so still.

"Mis' Willman..."

She stopped and turned reluctantly. It was Frank Woods, a shiftless sharecropper, a no-count old man she didn't have to listen to, but the others were behind him. They seemed to back him up. He advanced toward her.

"Mis' Willman," he repeated, "You hear that?" He paused. "Time's come when any little meal-eatin' nigger can make a pass at a white gal, huh?"

The silence was threatening now. The group on the steps was erect but studiedly casual. Their eyes were fastened on her. Somebody lit a cigarette. The too blue sky framed the gray of the store and the faded red and white of the Coca-Cola sign. The dust of the road gritted in her shoes. The yellow dullness of the scene impressed itself on her memory as she stared. The black boy stood where he was, looking from one to another.

"What yo' name, boy?" said another voice roughly—Marl Jayson, owner of the store, head of the town council, Bryant's oldest and best friend.

"Morris Washington Burley." The boy had not moved. He spoke with a quicker, sharper accent than that of the Falway County colored people. He looked blankly at the white man confronting him.

"Sir," barked Marl.

"Sir," repeated the boy after a moment, shifting his weight.

"Where you from, Yankee boy?" It was a demand and a challenge, but spoken slowly still, almost gently.

His head came up and he stared at Marl, but the hostility of those on the steps was a wall before him and he looked away.

"Chicago, Illinois...sir."

"What you think you doin' down here in Mechum, huh, from Chi-*caw*-go, Ill-in-*ois*?" Marl emphasized the foreign syllables mockingly.

"Visiting my uncle."

"Who your uncle?"

"Moses Wright."

"Old Mose, huh?" Marl's voice rose. He spoke faster, moved a step forward. "Ain't he told you 'bout mindin' your manners round white folks, you black trash?"

The boy's face hardened. He started to walk away. The circle closed, slowly. He halted. My God, she thought, wanting to laugh wildly. Those fools, and on account of me.

She felt Marl's heavy clammy hand on her shoulder, clutching her dress. "You go on home, Frances Jean," he said loudly. "We're gonna take care of this. Bryant'll be here in a minute."

She tensed under the weight of his hand, remembering his advances before the wedding even if he was Bryant's best friend..."Kiss the bride, honey?" and his hand, like now, heavy and hot on her shoulder. She was tempted to ignore his warning, to say something, she didn't know what, that would show her contempt for his big-man politics against the teenager standing back there in the closed circle. She moved slightly so

27

that his hand slipped from her body, and with that motion, saw his eyes change, his lips widen in a sneering smile. "He's only a kid, Marl," she said lamely, trying to put her mind on the boy rather than these staring eyes.

"Yeah, but he's a nigger, Frances Jean, don't you forget that. Now what would Bryant think if he could hear you runnin' on this way for a fresh little nigger, huh?"

Looking away from his smile she saw the men at the store, watching. They seemed unfriendly, suddenly threatening her too. She too might be found guilty, like the boy. A fright out of proportion to the situation rose within her, Marl's hovering presence, his thick neck, his sweaty shirt sticking close to his chest sent her turning. Mechanically hoisting her groceries to a more comfortable carrying position, she moved off down the road, looking down, not back. All she saw were her own feet scuffing the dry dust into little clouds ahead of her, the fields with barbed-wire fences leaning crazily, spreading out beyond to her and Bryant's house. Just behind her she heard Marl chuckle huskily, "That's right, Frances Jean, you just go on home now. Ain't no place for a woman and none of a woman's business. Women got other business, other places they're better suited to be...like..." He laughed suggestively, and then she sensed that he also had turned and gone back to the group before the store.

—

It was four o'clock. Frances Jean Willman had been home four hours before she finally let her mind reflect on what was going on, had gone on, back at Jayson's store. She had expected Bryant about three, but he hadn't come yet and the radio, today, had been unable to hold her attention as it usually did. Through the languid jazz beat, and the heat which lay in wait for her every movement, she could see,

even with a consciously empty mind, the little circle of poorly dressed but smiling and superior white men close in on the tall black boy from Chicago. I ain't no coon lover, she thought to herself, fiercely, tapping her bare foot impatiently on the pink and green linoleum. What do I care? Like Marl says, it's no woman's business back there. But it was my fault, and I got no woman's business, she realized suddenly. When Bryant had drinking parties for the men and the women rocked listlessly back and forth in the kitchen and talked about children, she was silent. She had none. Bryant said she was too beautiful—she was a decoration around here. But it was tiring being a decoration with only one person to admire it. The lives of Gal Sunday and Helen Trent had become more real to her than the slowly closing circle of Mechum on her own life; the too familiar scenery—Emmett's gas station with its ugly orange pumps that she passed every day on her way to town, the near-to-collapsing tenant shacks, the sweating people in the fields, the smell of manure and motor oil she had come to associate with even her own backyard. The occasional trips to Jackson, a show, a drink at the Dixieland—these were her two married years. She'd be losing her beauty like this, wilting in the hot damp of the summer months. Her body slipped lower in the kitchen chair and her thoughts gradually ebbed. All she knew was that what had happened that day had brought suddenly into focus all that had made yesterday and all the others so unbearable. Tomorrow would be the same. She felt a vague loss, between two worlds, no part of the men and no part of the small-town women who were jealous of her and didn't know about the pulsing excitement of a city like Mobile, or even, poor substitute, Jackson, on a Saturday night, knowing men were watching her, Bryant protective, Marl licking his lips, drinking, maybe because of her.

Even Marl—something out of the day's ordinary pattern... Her passive resentment dwelled on the incident at noon.

29

Would it have made a difference if she had spoken up, firmly, right as it happened, and said, "Never you mind, boys'll be boys." She thought of the blank and astonished expressions on the faces of the men at the store if she had, and Marl's fury at being deprived of some nigger baiting. But what if she had. Her curiosity flagged again, exhausted by all this thinking. It wouldn't have done her any good, wouldn't have changed her life, nor anybody's, except maybe, she thought shuddering, not wanting to remember the rough scorn in Marl's eyes as he turned from her to the boy, maybe the nigger kid's.

She wondered vaguely what it was like up there in Chicago where kids like that could whistle at white women. She'd heard about the big Yankee cities where a girl was never half safe, where they even let niggers take jobs from white men and let them drink in the same bars. She giggled even at the thought of Bryant and Marl and a nigger standing together at the bar in the Dixieland Grill. She wondered what it'd be like with one group in stations and movies and things instead of two—always separate, like today at the store, with the white men separated by the whole of a world from the black boy alone before them, miles further away than the few feet of red dirt that lay between their shoes and his.

But no matter how alone she felt, she was white. And when it came down to scratch, all the men and Marl and Bryant were on her side, protecting her from being insulted by a nigger. That was what Bryant had been telling her. The white people had a council, he said, organized, like the government, so Yankees couldn't tell them what to do. The past few months Bryant had gotten more and more excited, talking about "plans" at dinner. She tried to remember what he'd said, but she hadn't cared. Frances Jean had wanted to go into Jackson to the show.

She looked out the window. It was getting late, almost dark. Not a thing stirred outside. The yellowing grass, scorched by

the heat, looked as if it had been painted on to the red earth in short, impatient strokes, and the heat was still there, awful even in its dulling intensity. She didn't get up to unpack the groceries. She thought idly that the doughnuts would be soggy by now, but she waited motionless, feeling a ripple of dread come up through her sweating body. She wiggled her toes, kicked her shoes aside, and waited.

When Bryant came in she was asleep with her head on the table. At the sharp sound of the screen door slamming, she sat up, unremembering, and gazed at him apathetically. "You're late," she said plaintively.

"What d'ya expect, sugar, what d'ya expect? Had a right lot of things to get done." His small blue eyes gleamed with excitement.

"You saw Marl, huh?" she said.

"Yeah. Got right over there soon's I heard." Then, quickly, he was too casual. Reaching down, he nuzzled her. "Guess what we're doin' tonight, honey. That is, if you're not too tired." He grinned at her, teasing. "Asleep with the radio turned up full blast—fine way f'a man to find his woman when he comes in round dinnertime."

"Oh Bryant," she said, glad of a sidetrack. "It was so hot. I swear to God I was meltin' in my dress."

"You look better without that old rag anyhow." Leaning his red head near to her breast he caught her tight. She could feel his heart pounding into hers as his skin stuck to hers and his mouth, wet and hotter than the day, found hers. She pushed him away weakly, sure of failure, and was surprised when he dropped her back into the chair and, still breathing heavily, went to the sink and splashed cold water over his face and neck. She unbuttoned one button of her dress and sat still in the chair, waiting for him to come to her again so that even in the terrible warmth of their two bodies they could forget what they both, in different ways, knew.

31

"Aren't you gonna ask where we all goin' tonight?" he said finally, not approaching her.

"Who's we *all*?" she asked first, with a note of fear in her mind that surprised her.

"Why, you'n me'n Marl, of course, goin' into Jackson to do a bit of celebratin'." He walked to the window, looked out into the blankety heat of the darkness, and turned to her again. She had never seen him so tense, never seen him stop taking her when the spirit was on him. She wanted him very badly, wanted him to be strong, and he walked the floor, not coming to her.

"Yeah, we got a good bit of celebratin' to do." He opened the cupboard and took a long swig from the bottle of bourbon they kept there for the meetings. Then he looked at her again, square on, and she couldn't look away from the pride in his eyes and the fear, and he said, "Marl and me fixed it all up pretty, sugar. Won't be no niggers making eyes at my wife. Matter of fact," he said deliberately, "won't be many niggers trying much of anything in Falway County f'a while."

Frances Jean stiffened slightly, giving up the slow surrender to the softness of her own body. "Bryant, what'd you do?" she whispered, but he was taking another gulp from the bottle.

"No sirree, honey, they won't send no more blackbirds down here to hanker after our women. Damn Yankees gonna learn where to stick their fat-ass noses in..."

Hanker after her, she thought dully. Was that boy hankering after her? Had he thought, had he whistled because he thought...the little bastard. But she couldn't do it. In the back of her mind she saw herself, heard the long, casual whistle, saw the surprise as he was circled and surrounded. She felt tears beginning inside her deep somewhere, but stifled them, leaning forward, eyes wide at him, but he wouldn't look at her straight. "What'd you *do*?" she insisted.

The pause was broken by the sound of a car pulling up in

front. They both stiffened, and Bryant relaxed first as the horn blared out twice.

"It's only Marl," he said. "Go on get dressed, honey. He'll be in a hurry tonight."

Her dread increased as she went dumbly into the bedroom, washed her face, powdered her breasts, combed her hair automatically, and put a blue ribbon on it. Sliding into a clean starched dress and her high-heeled white pumps, she went out to ask Bryant to zip her. Marl was there, already drinking, she knew, and he looked at her knowingly, staring at her belly and her arms. He winked at her when Bryant's back was turned as if they shared a secret. She went back to get her purse without speaking to him.

They were both in high spirits in the car, speeding through the night with the hot breeze tickling their clothes, Frances Jean, not listening to their jokes and laughter, heard her name… "And here's the doll started it all, here's the babe's makin' history," Marl said loudly, daring her not to hear him. Bryant's arm went around her and he pinched her playfully. "This woman's a real little keg of dynamite," he said boastingly. "Pretty 'nough to get her picture in the papers." She could feel Marl's eyes turned sideways at her. "She'd be right modest though, if you'd ask her. She's say she didn't want nothin' to do with it, ain't really proud at all, huh, Frances Jean?"

She giggled nervously, not wanting Bryant to know anything about what she'd said, how she thought she maybe felt. What was the point? But he had seen nothing in Marl's remark and the raucous voices went on, pounding their nearly mirthless tension into her already swirling head, so she too had a swig out of the bottle that was passed from lip to lip and gave her body over to relaxation and the roar of the land going past outside.

It was nearly an hour's drive to Jackson, but Marl was burning up the curling road. The car swung liltingly around

the curves and Frances Jean had the feeling of being hurtled through an endless dark, punctuated by gas station lights, small towns, an occasional car which they passed and lost before it could imprint itself on their night. The two men, relaxing now, nudged each other slyly. "Wasn't so bad, was it now, Bry?" said Marl smugly.

"Hell no, Marl. Fact is it was's easy's stickin' a pig."

"Easy's slittin' a rabbit's throat," parried Marl.

"Easy's beatin' n' threshin' a little barley," said Bryant daringly,

"Easy's layin' some poontang," roared Marl triumphantly, and Frances Jean, often as she'd heard that talk before, felt a little sick. The liquor had gone to her stomach as well as her head, and the frenzied voices of the two men, hinting about what she didn't want to know, yet wanted, morbidly fascinated, to know, added to her nausea.

"Reckon we done our bit this day for what's right and good, huh, Marl?"

"Goddam right, Bry. Ain't nobody goin' to tell *us* no equality bullshit. Guess we know how to stop that talk. Guess we know how that talkin' stopped fast, after alota noise, but didn't last long now, did it. Didn't take long. Niggers round here goin' to know their place now, no mistake. Cleaned up Yankee niggers talking like white men too. Guess we won't be seein' much of that round here now. Found out that one wasn't so big's he thought. Found out he'd holler and whimper like a little ol' baby, give him the chance, huh?"

"Yeah man," said Bryant, taking another gulp, then louder, "Yeah *man* . . . And even if they *do* find out."

"Whadya mean, find out? Who's goin' to do this fancy findin' out? This's white man's country down here, don't think there's goin' to be much of a ruckus overa little matter like this, do ya? Little blackbird's blood running here n' there, ain't nobody goin' to worry 'bout it down here."

34

"Not down *here*," echoed Bryant. Frances Jean, listening, hearing louder and louder what had happened even if she didn't want to know, cowered in her seat before the vision, had another gulp from the bottle.

Marl said, "That's right, Frances Jean. Lay it on, girl. We ain't done nothin' wasn't all your doin's. When a woman like you keeps on bein' and lookin' like you—whadya 'spec, girl, whadya want?"

Bryant was busy, clutching his bottle harder, only half listening to the other two, and Marl, one hand on the wheel (he never put on two, even sober), leaned down to Frances Jean and kissed her hard and liquidly on the mouth before she could, slow-motioned from the bourbon, get away, and still wary of betrayal, didn't dare look at him, but looked sideways, wiped her mouth, sat up straighter and tried not to think of what they had been saying, what was happening, tried more to think of Jackson with its lights and people and another kind of action, the rhythm of the music they would dance to and the woman she hoped Marl would find quick, before, egged on by success of violence, he gave her, or took her, away. Trapped between the two men's heavy thighs, she was at once revolted by and warming to their flesh. Her blood was racing for who cares whom rather than remember the afternoon, her unknown inward pitchings and mindful guilt that although she hadn't been accused, she was now, even more violently, to blame.

"Big night for the white South, Falway County's on the map," Marl was screaming to the whistling-past countryside as they heard, felt even, the tremors, merged as their three bodies were—a new sound, sharp and whining.

Marl didn't slow a bit, riding as he was in a parade of self-congratulation, but they all knew it was a police car. The night became freer and bigger as the car whizzed along, faster still. Marl's eyes were on the road, the road of escape only, already the eyes of the hunted. Bryant seemed struck dumb with no

realization of the wheeling cry screaming after them. Frances Jean, ready to laugh hysterically in the face of the fast-broken confidence, could think only of her picture in the papers. They took the next corner at a terrifying angle and she, silent like the other two till then, yelled "Stop!" At the same moment the dark car with the red light on top caught them up and Marl stopped as fast as he'd run. The brakes screeched and the policeman got out of his car and came slowly toward them.

His face was white from out of the blackness as he leaned in the window. Bryant's face was still paler, staring out at him, forgetting to hide the bottle in his hand because of the still greater secret hidden. Even Marl, one hand meaty on the wheel, was strained, his mouth grinning but his eyes blue with the newness of fear. She saw, as they must, the crumpled face of a tall black boy in a barn outside Mechum, and she saw more vividly than they the falling body, the beating which she knew, also better than they, it had received. They had only been present while she had all the force of her imagination to back and hold her. They were silent, the three, but Frances Jean's mouth trembled. The policeman seemed surprised. They waited for his words with vacant minds visually emptied for what seemed to be coming so much sooner than reality demanded.

"Going a little fast, weren't ya?" the voice came at last, drawling and pleasant. "Drinking a little, were you?" He smiled and they were still stiff and silent in their seats because they didn't know yet.

Marl laughed, first to realize. "Why yes, officer," he said, unbelievably, a chuckle in his tone. "Had a little something to celebrate, you see. Goin' into Jackson to see what the big city has to offer."

"I should give you a ticket," said the white face sternly. "But if I'm not mistaken, I recognize Mr. Jayson and Mr. Willman there, right?"

Marl peered closer. "Well, if it isn't old…old…"

"Wellforth's the name," said the face under the visor. "I was with you people in Mechum for a while."

"Yesssirree," said Marl. "So you were. How's life on the roads? Stoppin' many gals in convertibles? Help 'em change a flat?"

"Sure thing," chuckled the policeman. "Well, be good now. Those city men don't always see our point of view you know." His words floated into the car with them as Marl started the motor, a little jerkily, but grinning. His confidence disgusted Frances Jean as it also repealed her sins.

"Take it easy," yelled Wellforth, waving them on.

"Sure thing," yelled Marl back. "Sure thing!" as they speeded off again, leaving a plume of exhaust. "Sure thing!" he shrieked, a hand on Frances Jean's knee, and the two men laughed loud and strong as they drove off faster than ever toward Jackson to celebrate. But the woman between them bent from the waist and wept into her hands, wept louder than they laughed, and as fiercely. Frances Jean Willman wept for many deaths, future and past, as they speeded through the night to celebrate, but most of all she wept for another whistle, that wouldn't come, maybe, this time, from the wrong-colored mouth.

1956

Because the hunt, the ordeal, was almost over, Miss Berta Catlin, very aware of her age and her position as grand old lady of the hunt, let herself relax slightly in the sidesaddle, feeling her weary bones reply in gratitude. Her heavy black riding skirt was spattered with mud. Her boots, which had been clean and dully glistening when she started, were stiff and dirty up to their patent leather tops. It was just a brief check, she could hear the huntsman hallooing in triumph fairly near, and any moment now they would be off again. Over the heads of the milling riders the tawny fields stretched to darker woods, the cross-hatched pattern of the fences breaking their winter monotony. She sighed at the thought of continuing the pace which had been set. The gray mist of her own breath hovered on the air before her, and stretching her cramped hands toward Balliol's mane, she flicked a speck of foam from the martingale. A warm steam still rose from the horse's lathered neck and flanks, but he stood motionless, only his ears twitching back and forth.

Absently, she smiled at the pinched young man at her side who was attempting to attract her attention. Chester Morton was new to Kentworth and not yet quite accepted. She took a ladylike sip from the silver flask he offered.

"Miss Berta," he said admiringly, waving a gloved hand in the air as he spoke, "you're fantastic, just wonderful. How do you keep it up? Why, swear I'm about to give out myself after that last run, and here you are looking as fresh and young as Hebe over there."

He motioned at a slender woman who was speaking curtly to a child mounted on a horse from her stables, apparently berating him about the previous run. Every now and then as she spoke, she hit her boot with her crop. Miss Berta was perhaps overly fond of children. She frowned at the sight, but had to admit that Hebe Baylis was attractive in a tight-lipped, independent way. The lines in her face were unnoticeable except at close range, and she presented a vivid picture seated straight and easy on the delicate gray mare. There was a natural flare of antipathy between the two women heightened by the rumors circulating about Hebe and Berta's own son, Lew. It was common knowledge that Hebe had been trying to get him to marry her for years. Hebe—who had either been married to or had slept with every man in the Hunt Club, but Lew wouldn't do it. Lew wouldn't let a little slut who's already been Jay Baylis's and Dexter Beekman's wife get hold of his name, Berta assured herself proudly. And, besides, although she tried to avoid thinking about this painful subject, there was always the matter of Hebe having had no children and obviously not intending to, even if she married again. Someday Lew should have a real wife, heirs, settle down. And someday she, Berta, should have grandchildren.

"...and I hear that Keiths' house is up for sale," continued Chester Morton. "Why, they've only been married a year now and that's such a sweet child of theirs. Gad, Miss Berta, I'd hate to see their stables broken up. That two-year-old by Gainsayer they just got up from Warrenton...well, I don't mind saying he's something to watch out for."

"Yes, surely," muttered Miss Berta, "a lovely animal."

"Well," he went on, leaning closer, "it just seems to me that whenever a marriage goes on the rocks, I mean it certainly looks like that one has, don't you think? Anyway, when one goes there's always another around to fill the place. We all know who Kentworth's promising couple is."

He seemed to leer at her, and Miss Berta, disgusted, not knowing or caring in the least what he was talking about, couldn't resist replying in a cordial tone, "Yes, I'm sure we all know, Mr. Morton. And if we didn't you would certainly tell us, wouldn't you?" She smiled and moved Balliol on to pass the time of day with Dr. Phillips.

"That young man and his telling tales out of school. Now he's rattling his fool head off about some new affair, as if it had to be advertised, whatever it is. Tell me, Burton, was our generation really so preoccupied with that sort of thing?"

"The men were, when you were around, Berta," replied the old man, and she smiled gratefully at his tiny whitehaired figure astride the enormous heavy-footed horse. In spite of these reassurances, she suddenly felt weary; weary of being Honorary Mistress of the Hunt, weary of the talk surrounding her—talk of horses, of land, of hounds and local gossip. But there was little time for reflection. Her son was coming back, riding hard and fast, his stocky figure in the pink coat only a blur of color as his mount leapt the gate at the foot of the field. In shouting distance he paused to cry "Tally Ho," to point with his whip before he was off again. Miss Berta strained her eyes for the familiar sight of the prey disappearing into the woods at the right, the hounds fast after the fox—a stream of writhing bodies, noses to the ground, under the rail fence, cutting through the dry grass, down the dip, and gone away. She had barely time to gather up the reins before the field was following."

She had to be in the lead, had to force herself to enjoy the pounding, throbbing hooves beneath her and the rhythm of Balliol's muscles as he moved easily toward and over the gate. She saw the hunt flowing vividly before and behind her— horses, ponies, men, women—sweating, working, and exulting in the pure physical concentration of the moment. Looking back was like counting sheep, as they wound into the fence and

popped up and over the rails in an endless syncopated beat.

She had known that feeling, she thought dully as they galloped on. She had known that chill down the spine at the piercing call of the horn, the cold suppressed excitement of long early morning rides to the meet. She knew the instant's terror before an unexpected wall or the wonderful surprise of an open run, the rush of pride when your colt takes the lead—gay and strong and sure as a seasoned hunter. Miss Berta remembered, tried to respond to the joy of her followers, but her body revolted against each jarring step and each fence in its monotonous security. How many women, she thought angrily as a branch snapped back into her face, causing her to lose the rhythm for a second, how many women at the age of sixty-eight would be fool enough to be following the hounds on a chill day in November—not only one day, but three times a week? Her hands, as if welded firm on the reins, no longer felt like extensions of her arms. Her mind was separate from her body, and only the wind in her ears and the warm horse beneath her kept her in touch with reality.

The hand before her flew up. There was a quick stop and then a turn. The music of the horn rang forth haunting and shrill and she could hear the frantic yapping of the hounds at the kill. The hunt slowed and they let her come past—the young ones who had, in the urgency of the chase, forgotten long-standing etiquette and flown past her over the last few fences. As they pulled aside their blowing horses—dappled, black, and bay all dark alike with sweat, she could almost feel the warmth of their young bodies penetrate hers, mingling with the pungent odors of leather and horse and damp earth.

The whips had just rescued the remains of the fox from the pack—his body torn and his entrails dripping, dull auburn fur spattered with his own blood. Lew was off his horse, giving the hounds their reward of biscuits. His round face bore a look of superlative content and triumph and his beetling black

eyebrows were almost subdued by the ruddiness of his cheeks. He was mud all over and spots of darkening blood marred his breeches, but he and the others surrounding him were obviously in their element. Miss Berta felt lonely for an instant, and cold, among these healthy, grinning young people. The only ones near her age were Grover, a tough old retired huntsman, and Dr. Phillips, who didn't even jump anymore but knew the country so well that he always managed to be in at the kill.

The pace had been relentless, and it was with almost desperate relief that she let her son help her stiffly down from Balliol, whom he handed to a groom come up from the rear, and escort her to the car which had been following the hunt and was parked nearby. Everybody was still milling around, tired, cold, but beginning to be warmed by the flasks which had appeared with the halt. She could see Hebe possessively holding Lew's horse and whip while he coupled the hounds. Turning abruptly away from the unwelcome sight she glanced up at the sky, almost in hopes of rain, but it was a hard, pale gray and the fields below seemed to reflect its dull obscurity. Miss Berta removed her steel-lined velvet hunting cap slowly, feeling its heavy pressure let up till her head was light and free again.

Dewey, the chauffeur, a former steeplechase jockey, was dying to know all about the hunt—every check, every draw that he hadn't been able to see from the road. He expected her account eagerly as he drove her home each time, but today she couldn't summon the energy and murmured apologetically, "Later, Dewey, Mr. Lew will tell you all about it." There would be only a brief interval at home before she would have to leave again for the Hunt Breakfast, and leaning back gratefully on the rough green leather seat, Miss Berta tried to doze.

But Dewey was indefatigable and kept cheerfully talking away, something about Mr. Lew and— "He got the license today. Now that's real nice, ain't it, Miss Berta? I 'spec you're right pleased."

43

What was he mumbling about now, she thought drowsily. Had Lew lost his driver's license again and not told her? But what on earth difference did it make? The black velvet cap on her lap slipped gently to the floor as the car went over a bump, but she slept.

In the house, with the help of her maid, the boots came off for some older, softer ones, her wrinkled stock and spattered habit were replaced. Left alone for a moment's respite, she went to the mirror to comb her hair and saw with a shock the dark pouches under her eyes, the sharp line around her mouth. Quite different from the face which had stared back at her when she first came to Kentworth and first began to hunt. Quite different from the face of the young Miss Berta who had had the best seat and hand and the flashiest style of any lady who rode to the hounds in the state of Virginia. With a sigh, she laid down the dented silver-backed brush, glanced around the familiar room, and then hurried out in reply to Lew's urgent shouts to "Hurry or we'll miss the first round."

As she stepped slowly downstairs, her hand fondled the smooth old wood of the banister. She thought of the days when her son was more preoccupied with sliding down it than missing a drink here or there, and once again she reminded herself that Lew, at thirty-eight, should have presented her with grandchildren. Then maybe she wouldn't be keeping up this ridiculous pretense of being hale and hearty, and all for riding three times a week. But her son had only a reputation for hard drinking, hard riding, and hard living, and Miss Berta knew back in her mind that his upbringing around the noisy, indiscreet atmosphere of the Hunt Club had hardly been conducive to settling down. At the foot of the stairs she gathered her skirts in her hand and stepped briskly to the door over the thick red carpet which lay like velvety spilled wine.

At the Hunt Club her boot heels clicked on the hard and uneven wood of the floor. The party was as she had known

it would be—noisy, crowded, the one huge room filled with smoke from the faulty but impressive fireplace and many cigarettes. Most of the adults were drunk already and the children capered about in sock feet, having abandoned the tight boots and stocks. Miss Berta allowed herself to be escorted to the place of honor by the fireplace and plied with ham rolls and bourbon. It was only six, but this was due to go on all night. She settled down to endure it and the voices around her rose and fell in maddening crescendos.

"He just tripped on that goddam coop. Trappy take-off. I tell you he'll outjump your cornfed old hack any day of the week, carrying weight. Why, last month in a drag over at Farmington...."

The man was talking to Chester Morton, who, among other things, couldn't hold his liquor like a Southern gentleman and had reached the boastful stage. In a moment there would be a race set for the next day—a hell-for-leather race over come-what-may which might result in the ruin of a good colt. These dares all started over a few drinks but were not forgotten with the next morning's hangover. She had seen those mad chases over wire fences and cattle guards and even pig sties and old shed roofs. They didn't stop until one horse and rider went down in a pitching galaxy of legs and groans and color.

"Honey, why don't you get the hell off your high horse?" It was Hebe and they all howled with laughter. She was trying to disengage one of the men from the crowd. Her cheeks were flushed and she held the habitual tall glass in her hand. Hebe always loosened up from her usual withdrawn belligerence at a party, and now she called laughingly in her low-pitched voice, "Good God, you all're probably disgusting our Miss Berta with your silly fussing and naughty language over one friggin' little horse."

Miss Berta was slightly surprised at the open enmity, but pretended not to hear, pretended that she hadn't hated the

45

little bitch for years. She could never show her claws, for Miss Berta Catlin was everybody's sweet idol of Southern, ladylike, hardriding womanhood and she could hardly let them down after forty years of it. She forced herself to play the game.

"Hebe, sweetheart, come heah and tell me about that little roan of yours, the one you had out last Thursday. How's she going since you tried a crupper? Wasn't that the trick, now?"

The younger woman turned with little hidden impatience. "Why, yes, Miss Berta, just the thing. You ought to try something on your chestnut. I noticed him with Courtney the other day—practically fell on his nose over the in-and-out by Gardners."

"Why, I suppose I ought. Of course I'll just have to talk to Lew about it first. It's his colt and he's the boss. That boy can't stand for a woman to give him orders—not even his own mother."

Hebe Baylis's lips tightened in an odd smile at the mention of Lew's name, but Miss Berta was pleased, thinking that'd hit home all right. Offhand she wondered why the women were always after Lew anyway. Besides his unquestionable masculinity, even she could see that he was short and hard-looking and his face was always too red. He was at his best in the highly colored atmosphere of the Hunt. Nevertheless, he was a son to be proud of, and she didn't know what she'd do without him.

Berta watched Hebe amble across the room, apparently discouraged by her first prey's indifference. The men were still planning tomorrow's race. As usual, she seemed to be headed for Lew who was already good and high. Miss Berta turned away in disgust, even after years of this, as Hebe draped herself over him and he kissed her hard. He was shorter than she but his thick red hand was laid possessively on her tweed breast as he yelled into the din, "And now we'll drink—here, drink now…" He took another gulp from the glass in his other

hand. "Now we'll drink to the lovely and virginal Hebe Baylis, Beckman, née God knows what—soon to be—" he paused and grinned fleshily "—my lawful wedded wife."

The crowd laughed and Berta moved forward to watch more closely, wrinkling her forehead in worry and concentration besides an effort to hear over the harsh clamor of voices. With a grotesque gesture her son threw himself on his knees before Hebe, whose hard face was wreathed in a grin. Her hair, out of its usual neat net, was falling incongruously soft over her brow.

"…Love you, want you…will you be mine?" sang Lew in a wandering but carrying voice, then got up, still chuckling to himself and clutching his glass. He turned to Donovan, the Episcopalian minister of the country church who was not against a drop now and then when the occasion called as it obviously had this time.

"Come on, Donovan, man. You can marry us now—it'll even be legal," howled Lew, and Donovan, a gross figure in a canary waistcoat, moved ponderously forward as the room rocked with appreciative shouts from the crowd of tweed coats.

"Don't be absurd," said Miss Berta in a clear voice, but no one heard her. They had their backs to her. They had forgotten her in the throes of this latest prank. She felt a moment of panic, but forced herself to be calm. After all, what was one drunken game more or less? Donovan wouldn't dare go through with it and even if he did, it wouldn't be valid. She turned disdainfully away and even deliberately finished eating her ham roll, brushing the crumbs daintily from the front of her black meltoncloth coat. Behind her they howled and raised their glasses. Her own glass was cold in her hand and her face burned from the heat of the fire as she looked into its interchanging brilliance. She tried to forget that sixty-eight-year-old ladies were entitled to a place by quite a different fire, and tried to pretend that she could stand this life right up to

47

the end. Perhaps a fall from Balliol on a crisp autumn day, the red earth rising up and the comforting blackness which would, unlike previous concussions, last forever this time.

She felt a hand on her shoulder and again the room flared into vision in its warm smoky brilliance, demanding her attention. Before her stood Lew, pink coat rumpled and cheeks redder than ever, and on his arm—Hebe, with a smug gleam in her eyes. "My wife," he was saying gleefully and Hebe laughed too.

"Never thought Donovan would do it," cried someone who sounded like Chester Morton.

"Well, they'd already gotten the license," replied another, "so this is just a little sooner than expected, but it's legal all right. Good ole Lew. Never thought I'd see the day...."

"Congratulate them, Berta," said Dr. Phillips warmly, and they all smiled at her. Their faces, round and shiny, creased with joy, closed in on her. Hebe's husky voice saying, "Now I can call you 'Mother,'" was the last thing Miss Berta Catlin heard before she crumpled to the ground, a black heap threatened by the colorful room which surrounded her.

1957

It was his first funeral and his first taste of death. He came
upon it unaware in the living heat of the noonday. Coming
out of the barn, bridling Ginger and mounting bareback with
the aid of the fencerail, he didn't know exactly what he'd do
that day. Out past the canebrake the fields spread flat to the
swamps. The heat lay just above the ground in a shimmering
vacuum, awaiting a movement, a gust of hot wind, passing
hooves, to set it into an engulfing suffocation. Everything
was still. From the big oaks around the peeling pink barn the
gray moss hung silent and wispy, although the slightest breeze
would set it in motion.

He stood undecided in the midst of the heat and the moist
quiet. Ginger flicked an irritated ear at a fly and shifted her
weight impatiently. Not a day for a ride, but Sunday afternoon
the boy had to get out of the house. There it was cool and dry,
but unnaturally so—too still with a different intensity than that
of the outdoors where the spaces were open and free in spite of
the cloying air. He would have had to watch his grandmother
rocking spasmodically as she napped in the dim noon light fil-
tering through the closed shutters. He would have had to listen
to the mumbling undertones of his father's voice as he went
on about the heat and taxes and how bone-lazy the workers
were in the fields, and hear his mother listlessly clearing up
the kitchen. He wanted to go and play with the other children
down on the bayou near the store, but he wasn't allowed on
Sunday. His mother and father weren't Cajuns. They had
come out from town years and years ago, but they were New
Awlins, not ignorant Bayou folk.

He could ride down by the water anyway. There it would be cooler, even though the bugs were worse, and he wouldn't stop to talk to the other kids. "I'm better than them, me," he thought, and then caught himself. Talking like the Cajuns again, like the trash, his mother would say. Oh well...

He rode slowly up the dully gleaming road, hearing the oyster shells crack under Ginger's feet. They broke the oppressive heat with a sharp, quick noise, incongruously snapping against the soft continuity of the day. He saw no one as he crossed the tarred road and started down the dirt path to the bayou. Everyone was home asleep or visiting in the weekly opened parlors where the windows were closed to keep out the heat and the heavy smell of the azaleas. Sunday afternoons, though, he always felt the need to do something active after spending the morning in church, dozing under the protective flow of Latin phrases, and then the silent ritual of a family dinner. His body reacted in spite of the heat and he longed to play a strenuous game of hide-and-seek in the sheltering tallness of the cane.

Then he noticed as he rode that a stream of four or five cars all at once were passing behind him on the main road. He turned curiously to see where so many vehicles had come from in sleepy Lafitte on a Sunday afternoon. He saw that they had their lights on and were traveling slowly and momentously, following a larger black car bedecked with flowers. Maman LeFebre's boy Claude who had been killed in the war had finally arrived and this must be the funeral procession. As he watched they curved off down the road, a train of mournful beetles, contradicting the sun, the heat, the blue sky with their dark, cool tears.

He barely remembered the dead man who was much older than he, but one summer before he had left for the war, Claude had won the pirogue races on Barataria—a tall, lean fellow with a pockmarked face and an easy way with the girls. Just

Maman LeFebre's boy, but now he was dead and now he was going to be buried.

An excitement swept the boy. Here was something to do on a hot Sunday afternoon. He and Ginger would go to the funeral and he'd brag about it later, tell the Cajun kids how he'd gone to a church service on his horse. Despite the sweat soaking Ginger's hide to a dark and splotchy bay, sticking to his jeans, and tickling his own brow, he urged her to a trot down the path to the cemetery on the banks of the bayou. In the shade of a huge live-oak, it was almost eclipsed by the wild shrubs, the creeping undergrowth, the vines twisting over the stones. It was small, crowded, not well kept up. Several of the stones were completely hidden by tall grass and bushes, and some were only shabby crosses of wood painted white, with withered flowers in tin cans leaning up against them in pale defiance of the healthy threat of the surrounding grasses.

When the boy arrived, riding Ginger carefully and quietly until they stood at the edge of the bayou looking into the clearing, the people had gathered. They had parked their cars on the main road and had come down the rutted track by foot in a sad, winding procession. They stood in humble groups, dark patches of worn clothing against the darker shadows of the oaks and the underbrush. The women cried softly and the children were hushed in awe. The men's faces were weather-beaten and ill at ease in the presence of reverence and death. Six soldiers carried the coffin and they laid it clumsily in the shallow grave.

No one had seen the boy and horse looking on from the fringes of the group, but when the soldiers stepped back and fired a salute to their dead comrade, Ginger started violently. Her rider curbed her fast and the mourners turned in surprise at the sound of hooves in the brush behind them. To his astonishment, they did not seem angry, but regarded him sadly for a moment, then turned back to their grief.

51

The ceremony went on. The priest prayed in low but carrying tones. There was a hymn and the notes floated over the water in lazy progression. There was no horror, no dark cloud of death. The boy was disappointed. There were only the sounds of people praying, singing, the tap of dirt on the wooden casket. "Ashes to ashes, dust to dust." The words echoed out into the sweet, heavy air and surrounded the boy on the horse. The noises were muffled in his ears by the lapping of the water at his mount's feet. The people left slowly, walking carefully as if frightened of awakening a new source of choking heat, leaving only the mother of the dead boy.

Until then, it had not been real. He had watched, but not participated. His emotions had been sunk in the lethargy of the day. But then he saw Maman LeFebre fall to her knees before the grave, saw her weep hopelessly. Then the boy could see, as she did, Claude, tall, lean, and easy with the girls, winning the pirogue races at Barataria with the colors of the crowd and the spongy blue of the sky and the excited cheering behind him in his triumph. That was Claude there—in that box. Before it had been only a strange soldier, but now it was Maman LeFebre's boy who would lie there in the wet dirt, over whom the dank grasses would grow when the sweet-smelling wreaths had rotted into faded ribbons and empty stalks.

The boy watched in fascination. Death, the unknown, was here as he sat on his horse and watched the old woman weep more and more softly. It was here but barely recognized—an impression, a gently laid hand cold on his shoulder and in his mind. He watched her rise to depart, to go back to her old house by the water, back to her chickens and her loneliness, back to the dark little rooms where Claude had grown up. But Claude was dead, and this old woman was alive to return to nothing; to once more feel the heat smoldering in her dry old body, and Claude, cool in the earthy dampness, who would have had marriage, sons, a joy in the heat of a summer day, a

pride in his prowess, a Cajun song in the twilight...Claude was dead.

For a long time the boy sat motionless on his restless horse, wondering in the fleeting shadows of the big oak. He dismounted and went to the grave, saw the flowers already wilting in sickly indolence, saw the imprints of the praying mother's knees in the soft dirt. Claude, whom he had never known. Claude who had come into his life suddenly and changed him inside—Claude lay there beneath his feet with his eyes closed, waiting, as the heat of the day lay waiting for the cooler night. He bent to greet the shadow of that stranger, and his fingers dug into the mud. It was cold and moist. Death was here. As a damp realization it infiltrated his being, though he was only vaguely aware of its presence. He stared at the newly laid dirt while the heat held him in its vise. The heat whirled his thoughts and caressed the grave of Maman LeFebre's boy, him, who would never again win the pirogue races down on the bayou Barataria.

The boy mounted quickly and rode fast through the heat, which was worse than before because it was gray as the sun had gone under a cloud. There was no white light, only sweat coursing down him. He rode urgently toward home, toward his grandmother who sat rocking quietly in the dry, cool room, toward his parents who were New Awlins people, not Cajuns. The gray moss brushed his face and the vines clung to his body as he raced through the curtain of heat. But he could feel the briars catch and tear at his bare feet. He was not in a wooden box where the dirt was moist and the sun beat down on the bayou nearby, beat down with all its sultry weight to the murky depths of the water.

1958

II.

Failed Attempts
(1958–60)

Author's note: I have some idea why, not yet a feminist, I felt I had to write in a male first person (with corresponding sexism) when attempting commercial success. Additionally, several of the pieces written during this period were penned under the name "Lee Ryan."

I had only been in Rushton for a few weeks. I liked the small Massachusetts town. I liked my job. I liked the people I worked with. I was pleased with my bachelor's apartments, the weather, even the short stories I was slowly getting out of my system at night, with the aid of a beer and a typewriter on my balcony with a view. But this was a warm June evening with a soft summer breeze blowing, and something was definitely missing.

I knew what it was, but I hadn't met many girls yet, and none of them had struck that particular chord that one comes to expect if one is a young man with tendencies to romanticism. I stopped in mid-sentence, threw on a shirt, and slammed the apartment door behind me. I had no particular goal in mind, but as I turned the corner I found myself provided with one. The girl kneeling beside the sidewalk, apparently searching for something in the grass, was a very creditably manufactured specimen.

"Lost something?" I asked. She looked up, startled. Her face, if it's possible, was even better than her figure. "I'm sorry if I frightened you. But can you use some help? What did you lose?"

She looked me up and down and evidently I passed, because she smiled and said, "As a matter of fact you can, and I have. Do you smoke? That is, have you got a match? I've dropped an earring and it's very small."

"I smoke. I have a match. I'm glad to see this vice pays off now and then." What's lung cancer to a chance like this, I thought merrily to myself, and knelt down to help her look.

It didn't take long enough to find the thing—a little pearl set in a gold twist—so I hastily introduced myself as we got to our feet. "Jack Waring," I said. "I'm new in town and I don't know much about the local customs, but could I walk you home or something? I came out for a walk anyway. It gets very restless inside on a night like this."

She hesitated. "Under the streetlights all the way?" I added quickly. "I'm only dangerous when there's a full moon. They caught Jack the Ripper years ago."

"Oh, don't worry, I'm an emancipated woman, and an inveterate night-walker. It's perfectly safe around here. You're welcome to walk along with me If you like. I live quite nearby—on the edge of Bear Ridge Park. And anyway," she added wickedly, "I carry a police whistle. Sergeant Riley has this beat and he keeps a paternal ear out for me."

"So much for my ulterior motives," I grinned. "Now we'll have to talk about literature. Or is politics more in your line?" I was kidding, of course. This girl looked far too decorative to need a brain in her head. But much to my surprise, she took me up on literature and even admitted that she had written some children's stories.

"People without children shouldn't write children's stories," I sternly informed her. "You can only do it right when you've been totally indoctrinated into the workings of their devious little minds."

"I have a little…" She hesitated and I looked at her, startled to see her blushing under the streetlight.

"I'm sorry," I said, "I just noticed that you wore no wedding ring…"

"Oh no," she said easily, "not that…I have a little nephew. I take care of him often enough to be indoctrinated." At that, she changed the subject very skillfully and it was only later that I remembered this little episode.

Her name was Annette Hawken, and, by the time we had

walked around several blocks and stopped at the local drug-store for a root beer float, we had discovered that we shared a taste for cowboy movies, far-out fiction, the ocean, the color orange, and various other important items. I didn't even hold her hand that night, remembering the lurking Sergeant Riley, but by the time I left her at the corner of the block where she lived, there was nothing missing anymore. I recognized the symptoms. I should just have remembered in my enthusiasm that old saw about the path of true love.

But it ran smooth for a while. The next day was Saturday and we had made a date to go swimming. She met me at the same corner, explaining this by saying it was a dead-end street and difficult to turn around in. This made sense, but when we returned from a delightfully sunny and giggling afternoon in which we discovered that we had even more in common than previously suspected, she still didn't give me her address. She had to pick up some groceries at the corner and would walk from there.

"But I'm taking you out to dinner," I said. It had seemed a matter of course.

"I can't tonight, Jack," and she seemed as sorry as I was. "But I might be able to get away after...well, around nine, if... if you still want me then, that is."

"Sure I want you, but I want you for dinner too. I want you for dancing too, and tomorrow for a ride in the country, I want..." I stopped when I saw the look on her face. "Maybe I'm going too fast, Annette, but I had an idea the feeling was mutual."

She looked me straight in the eye and said that it was. But when I repeated my plans for Sunday, she said she couldn't.

"What are you doing tonight that will be over at nine?" I asked. "Do the local Romeos only last three hours?"

"I'm not even sure I can get off at nine. You're making a mountain of a molehill, Jack. I'm babysitting for my nephew

tonight and probably tomorrow too. My brother's done me a lot of favors. Now and then I can return them."

"I'll come and help you keep the vigil," I said. "I like kids. And tomorrow we can take him to the beach, if you want."

"No, I can't." And here, polite, pleasant, but firm, we left it.

"You'll call me if you can make it at nine?" I said somewhat stiffly.

"Yeah, Jack." And she reached up, kissed me on the cheek, and disappeared into the grocery.

Before I drove off, I looked curiously down the street, wondering where she lived. There was a little whitewashed brick house, set back from the road, which I was immediately in favor of, but there were a tricycle and a red wagon in the yard. Children must live there, and surely this nephew didn't bring his toys. I finally decided on my second choice—a comfortable brown bungalow with a big porch.

She didn't call me that night, but for the next few weeks, I saw Annette Hawken almost every day although I never succeeded in storming the walls of the last block in Bear Ridge Road. I couldn't quite understand myself why not. She always had some reason. We often met downtown and things drifted along like that longer than I realized. We had more important things to think about. I accepted the fact, for the time being, that there were many mysteries about her. The only thing completely clear in my mind was that we were in love. This seemed indisputable, right, and mutually agreed.

Annette told me a little about her life, which was not an extraordinary one, although there were a few gaps which I wisely did not try to fill in. She too had only come to Rushton recently, which explained my lack of competition. I learned to tell when she was hedging about something. Although she loved to talk about books, and we often discussed my writing, she wouldn't talk about her children's stories. Her little nephew was the other subject which seemed taboo. Since I never laid

eyes on the child or his parents, I almost began to doubt his existence, although she still had to babysit him all the time, and used him, it seemed to me, for most of her mysterious excuses. I am not a particularly patient man, but Annette was important enough to me to justify the marking time. I simply sat back, enjoyed her company more and more, became more deeply involved every day, and waited for a break in the cloak-and-dagger activity. At times she seemed on the verge of confidence, but then she would sigh and turn away. My fertile imagination, needless to say, created all kinds of ghastly stories to fill in the blanks, but it wouldn't have made much difference to me at that point if she had been a convicted murderer or a dope addict. I was in that deep.

But eventually, and inevitably, the tension of keeping up a close relationship within the circle of all this secrecy began to build up, and in turn got me down. I found myself purposely asking leading questions, not because I thought she was going to come out with the answer to everything, but just for spite— to watch her draw away from me, think up excuses, reasons why she couldn't be at a place at a certain time. She responded to this treatment by tightening up until it finally became almost impossible to have a normal conversation. We were at that point in the course of love where things don't run smooth. It was up to us to make or break our chances for happiness, to get over the snags. The prospects didn't look too rosy.

And I began to find faults with her. She who had at first seemed so mature now had a childish streak and it was involuntarily reciprocated by me. But we did have our good moments, the other side of the coin of love, which bound us more and more closely to each other despite the angry storms which threatened to blow us apart. One Saturday at the beach I read her the beginning of a novel which I had started the year before and had left, discouraged, in a bottom drawer until recently when, needing an outlet for my worry and anger over

Annette, I dragged it out again. When I had finished, she told me the things that every man and writer loves to hear, after which she came up with some very astute criticism which went right to the core of my problems with the thing, opened up new ideas, and, in short, put the idea back on its feet.

"Honey, you're wonderful" I shouted, and I gave her a quick hug, to the delight of some small boys playing nearby. "That's just exactly it! When I'm finished, I'll dedicate it classically 'To my wife, without whom this would never have been written.'" I said this lightly, half afraid. She did not reply, but hid her face against my shoulder. I turned her gently toward me and said the only words I could think of, they seemed so right. "Annette, don't you want to marry me?"

I could have sworn I heard her say yes, very low, but at that moment she leapt up and ran into the water. I didn't go after her, but sat and watched that slim figure moving pensively among the darting bodies of playing children and rough-housing teenagers then swimming farther and farther out.

"If she thinks I'll come out and rescue her..." As I watched her, my anger grew. "How far can this go?" I wondered righteously. "I am a man of twenty-eight. Is she playing with me? I don't think so." It did occur to me that she was afraid of marriage, even with me. This made me even more furious. She was old enough to accept the responsibilities of being a woman.

Did she want to play games, make up stories, all her life?

By the time she came out, shaking the water from her wet hair, I stood up and took her firmly by the wrist. "I asked you a question, Annette," I said quietly. "Don't you know it's rude not to answer when you're spoken to?"

She looked up at me for a second, then shook herself loose. "Don't treat me like a child, Jack," she said shrilly.

"Why can't we have dinner together tonight?" I shot back at her irrelevantly. "Why can I only see you after nine? Why can't I come to your house like very other man calling for his

girl on Saturday night? *What are you hiding, Annette?*" My resentment came pouring out, although I tried to keep my voice in control.

"None of your business," she said quietly, and I was amazed at the venom in her voice. "I guess it's too late, Jack. You wouldn't want me now. You can't boss me around. My life is my own. You can't force me to tell you anything. I'm free. I'm young and I'm free...and my life is my own," she repeated in a higher note. Snatching her bag, she ran toward the dressing room.

Angrier than ever at this unjust outburst, I went to the car, started it, and pulled out fast, the wheels screeching on the turn into the main road. I drove around the countryside aimlessly for an hour or more, forcing myself to calm down, trying to reconcile the fact that she valued her freedom more than she did our love. I found that a very strange phrase for her to use—her freedom. Her life was her own, she had said. True, she was in her early twenties, but most girls by that time want nothing better than to marry. What, I wondered, did Annette plan to do with this famous freedom. Her life was not exciting here in Rushton, where she worked occasionally on children's books and babysat with her phantom nephew. What did she mean by saying it was too late and I wouldn't want her now? I didn't know but I was angry enough to almost have reached that conclusion myself.

When my rage subsided, I returned to the beach, not expecting to find her, knowing she must have taken the bus back by this time. While I was gone, the sky had clouded over and our beautiful summer day had become gray and threatening. There were only a few people left on the sands and none of them was tall, slim, and blonde, moving with an old-fashioned grace. I would have been able to spot her red bandanna, but the beach was colorless and depressing. It was about four o'clock. I supposed our date that night was off, but

my rage had been replaced by an overwhelming urge to settle everything for once and for all. In a way, our violent argument had cleared the air. I felt calm and determined. I knew what I had to do. There was still a chance for us, but my questions had to be answered immediately. Now or never.

For some irrational reason, unknown to myself, I had never taken the very simple step of looking up Annette's address in the phone book. I told myself I had supposed that she would be unlisted, with all this mystery about her, but the fact was that it had been a kind of pact I had made with myself, and unbeknownst to her, with Annette. I had trusted her to tell me when she chose, when the time came, but this afternoon's quarrel had made it all too clear that she was not ready, and might never be ready, to tell me about herself. Now it was up to me. I no longer felt any compunction about making my own moves. I pulled up at a drugstore and moments later my moving finger stopped at the tiny print halfway down on page of the Rushton phone book. *Hawken, Annette, 163 Bear Ridge Road.* As simple as that. All this time that address had been there for the asking. My head felt light and I was extravagantly cheered by the sight of her name. This was a good omen—clear, open, in black and white, the mysterious address I had not bothered to look for. Perhaps everything else was that simple too.

I got back in the car and when I came to Bear Ridge Road, that familiar corner, I drove slowly, peering at the numbers. 163, with A. Hawken on the mailbox, was the little whitewashed brick house I had picked out the first day. On the doorstep was one roller skate. I picked it up to save someone's neck and rang the bell. It was answered almost immediately by a small boy about six years old. He had big gray eyes that were very familiar and an outgrown crewcut which stood straight up from his small head, My first feeling was one of surprise. The nephew, I thought, he *does* exist. He looked at me questioningly and I asked if his aunt was there.

"Aunt Bessie is in Chicago," he said pensively. "Aunt Nancy is in Brookline. Are you from Chicago?"

"No. I'm from right here in Rushton," I said a little sternly. "And I mean your aunt from right here in Rushton."

"Aunt *who* here in Rushton? Aunt Bessie is in Chicago, Aunt Nancy..." This time he was very positive.

"It's your Aunt Annette I'm looking for, son," I said, rather annoyed at all this hedging.

"Mommy?" he said uncertainly. "Mommy's at the store."

I felt my throat go dry. "Your mommy's name is Annette?"

"She's the only person I have ever known in all my life who's named Annette," said the child, "My mommy's name is Annette. My name is Henry Jefferson Hawken and my mommy calls me Hal when she likes me. She doesn't like me all the time. What's your name?" He stopped for breath.

Of course it was Annette's child. I should have known the moment I saw him. Not only were his features hers, but his manner was direct, serious, but with an inner sparkle. No nephew, no brother, but her own child, who undoubtedly had to be put to bed by nine, was probably in school during the day, except on weekends...The pieces started fitting together in my mind. I was flabbergasted.

"My name is Jack," I said finally. "Can I come in and wait for your Mommy to come back from the store? I'm a good friend of hers."

He hesitated, and I realized that he probably wasn't supposed to open the door at all while she was away. "Or we could sit right here in front of the house and wait for her," I suggested.

"Yes," he said gravely and squatted beside me on the step. "Are you my Daddy?"

The idea of questioning Annette's child while she was not there seemed rather backhanded to me, but after I said no, I couldn't resist asking if he didn't know what his Daddy looked like.

"My Daddy went away when I was a tiny baby," said Hal. "He will never come back again." This was stated with neither regret nor pathos. An apparently accepted fact.

"Then why did you think I was your Daddy?"

"Mommy says someday maybe I'll have a new Daddy and he'll be big and tall with brown eyes and funny eyebrows maybe. You have funny eyebrows."

I smiled in spite of myself. Annette had often traced my eyebrows with her finger and laughed. "They grow up in the middle because you're always asking questions," she had said. "Someday I'll write a book about a great dane with funny eyebrows who is called Jack the Ripper because he takes out his frustration of not being able to ask questions by chewing up people's slippers."

This came back to me vividly as I looked into the trusting gray eyes so much like Annette's. If this was her secret, why, I wondered, had she kept it a secret? Was the child illegitimate? It wouldn't have mattered to me. I love children, was brought up in a large family, and Annette knew it. I found my anger returning. I couldn't understand why the cause of all these arguments, the lies, stories, evasions, was this wonderful child whom I would have been proud to know from the beginning. I forced myself back to him. We talked about the dog he would like to have and then he produced a ball from under the steps and we played with it. I didn't ask any more questions. We switched to cops and robbers. He had shot me with a capgun and I had fallen down dead when I heard footsteps on the walk and looked up from my grave to see Annette's amazed face above me. "What a *pleasant* surprise," she said ominously. "You must come again sometime." And she started to enter the house.

I took her arm a little roughly and followed her, with Hal shouting behind us, "Mommy, Mommy, it's Jack the Ripper!"

I was trying to figure out my next move when the saving

bell of a Good Humor truck rang around the corner. I gave Hal a nickel for a popsicle. "Then play outside for a while, Henry," said Annette, and we watched him run off down the street in silence before we closed the door and turned to each other.

"What in God's name is this all about?"

"Now you know," she said woodenly, trying without much success to light a cigarette and be casual.

"I don't know anything. All I know is that you have a charming lovable little boy and didn't tell me. But you can bet your life I'm *going* to know. Let's have it. Where's his father? Is he the famous nephew? Do you even have a brother who's done you a lot of favors?" I finished acidly.

"Don't worry. My brother does live in Rushton. That's why I moved here, and Hal's father is on the west coast. We're properly divorced. I don't have the lurid past you'd like to pin on me. In fact, we've been divorced for six years—ever since Hal was born. I married at seventeen. Too young, and all it got me was Hal." As she said this, her tone became so harsh that I was shocked. But her expression remained as lifeless as ever. I found it strange to watch that animated face, usually so quick to show emotion, now so blank.

"So you married too young and chose the wrong person. That's happened to other people. Now you're older. But why all this mystery? That's what *I* want to know. Why have you been leading me up the garden path ever since we saw each other? Why the nephew story? Hal's the 'nephew,' isn't he?"

She nodded wordlessly.

"Well, then? Why were you lying to me? Why make a sucker out of me? Why not tell me about the kid?"

"Because I was ashamed of him. Because I never wanted him." Now she looked miserable, but defiant. "Everything I've ever wanted to do I couldn't because I'm stuck with him. The tail-end of a bad marriage. I wanted to be a writer. I wanted to study in Europe. I only got a half a year of college and within

a year I found myself tied down with a baby. Me," she said bitterly. "In high school, they voted me the girl most likely to succeed. Isn't that quaint? The prophecy most likely to fail. I'm still young but I've already used up the best part of my life. I don't even know why I came up with that nephew story the first night. I guess I was pretending that I was just another girl, free to date and marry, without someone depending on me, dragging me back to the sink and the school lunch. I guess that warm summer night got me down. Once I had lied to you, I couldn't tell you about Hal. I'd never have seen you again. I didn't know I'd fall in... Anyway, the time to tell you had passed. It was too late. It *is* too late."

"Annette, stop it. You're just being selfish, feeling sorry for yourself..."

"Oh you don't understand and I didn't expect you to understand either. You're a man—talented, young, you have your freedom. You wouldn't have wanted me if you'd known I had a child, would you? A child didn't fit into your plans at all..."

She was right. I didn't understand. If she hadn't spoken so angrily I might have taken her in my arms anyway, but the idea that she was somehow blaming me too was infuriating. "*I'm* not as childish as you are, Annette. You've been, you're *being*, completely unreasonable. Children, a child, that's not a burden. That's a joy. Don't you even know *that*? Don't you know that I would have loved your child when I loved you?"

"Would have! You see? Now you can say that in the past tense and act noble because you know that time *is* past. You don't want him any more than I do. Do you know that when Hal was born I almost put him up for adoption? I wish I had. Then I could have started all over again. Is it fair for my mistakes to change my life? I can't help resenting him. I'm no good to him this way, always chafing at the bit, wanting a life of my own. Sometimes I don't even know if I love him. I knew I'd lose you when I told you and I didn't tell you because of that.

It's Hal's fault that we're fighting. We could have had a normal courtship like any other young couple in love, without subterfuge. Now it's too late. I've lied to you and I've lied to Hal just by pretending that I want him. But how can I give to anyone else when I'm still wanting things for myself?" She turned away from me hopelessly. "Please go, Jack. I do feel sorry for myself. Just as you say, and I'm afraid I won't stop, especially now."

I was confused and horrified by this tirade, so different from what I had expected, this tale so cruelly down to earth. I had been ready to forgive her all kinds of wildly imagined sins, but this had never entered my mind. Brought up as one of five, in a happy close family, I couldn't conceive of not wanting a child. Without saying anything, I turned away and went to the door.

"I knew he'd come between us," I heard her saying, as though to herself. "I *am* an unnatural mother. Go away and leave me to it. I hate myself and I hate you and I hate him too."

She was sobbing bitterly now, but I didn't go back to her. Perhaps she was right, it was too late.

I closed the door quietly behind me, my head ringing with her words. As I came out into the yard, I saw a flash of red disappear around the corner of the house. "Hal?" I called, but he was gone and couldn't—or wouldn't—answer me. I heard his running footsteps in the next yard. Too tired to think or act, I climbed into my car and drove away from the house on Bear Ridge Road. Only later did it occur to me that Hal must have heard his mother's last words. He had been running blindly the way children do when they are hurt to the core. I should have known, should have gone after him. Even if I was disgusted with Annette for weaving this net of lies which had ended by excluding us both, I had immediately felt something for Hal. I wished now that I had gone after him, talked to him, reassured him—but it was finished. I would never see him again. It was no longer any of my business, just as Annette had said that afternoon on the beach.

69

I had supper in town, a few drinks. I thought of leaving Rushton. *I* was free, I caught myself thinking, and recognized a reflection of Annette's words. I couldn't keep my mind from returning to that afternoon. I told myself that it was all over and that I would do best to think about my own plans. I turned on the radio for some soothing music, but it didn't help much. The night was cool and there was a damp wind blowing that meant rain. The downpour promised by that afternoon's threatening clouds. Symbolic, I thought ironically. Thunder, then tears. The summer itself had changed character. It was no longer soft and happy. I began to feel as sorry for myself as I had accused Annette of being. Weren't we all, after all, self-centered? But could you be that way when there was also a child involved? I thought of Annette's great gaiety and en- thusiasm this summer, her apparently real happiness, shadowed only when I asked pointed questions. I thought of how trapped she must have felt when she realized where the falsehood she had told almost inadvertently, under the influence of a summer evening, was leading her. She had not had an easy time. I be- gan to realize this as my anger wore thin and memories began to force themselves through. Small children weren't much company when a person is lonely, when a person is unhappy and trying to rebuild her life. Could I blame her completely for her actions? But it was too late, I reminded myself, to think about it now. I too had acted badly. I had not helped with my own selfishness. I had made her feel that our relationship hung by a thread. I had been too carefree in contrast to the cares she felt and the burden she was bravely trying to meet. I tried to think objectively how it must be for a spirited young girl, loving and fun-loving, alone in a small town, trying to restrict her natural energies to housework and child care.

Annette had kept Hal for six years. She had not, after all, given him up. How much of that outburst had been merely a release of the tensions of the past month? Annette was

basically, I knew, an honest and open person. What a strain it must have been for her to deceive and hide things from me all this time...

The soothing music was cut off abruptly, interrupting my thoughts. An official sounding voice was saying that volunteers were requested to help search for a lost child, missing since mid-afternoon, six years old, gray eyes, short brown hair, red and blue striped shirt, blue dungarees, white sneakers... Before the address and name could be given, I was on my feet. I threw on my coat and started out the door as the voice behind me said that the search was being centered on the deep woods of Bear Ridge Park.

When I pulled up at the entrance to the park, it had already begun to rain steadily and the wind whistled in the trees. I thought of the thinness of that red and blue striped shirt and hurried over to the group of men lit eerily by flashlights and the turning red glare of police cars. The volunteers were divided into groups and assigned to different areas. As I headed toward mine, I caught sight of Annette standing off to one side, watching us leave. Dressed in an old raincoat, her red bandanna, with no makeup, she looked like a child herself. She seemed so terribly alone that I couldn't help stopping for a moment.

"You shouldn't be alone," I said gruffly.

"*He's* alone, isn't he?" She said this calmly, but there were tears in her eyes. There was also fear, mixed with self-contempt. But above all, there was love. Love, not for me, but for the child she had unwittingly sent into the dark woods. "I want nothing more from life," she blurted out, "than to have him back. All those other things are meaningless. I do love him, more than anything else. What I said this afternoon was *more* lies. Not all of it, not on purpose, but I was trying to justify myself to myself by blaming poor Hal. I need him as much as he needs me. Bring him back to me, Jack. That's all I ask. Find him. I know you're finished with me, but for God's

sake, bring back my little boy." Her voice trembled, but I was impressed by the new maturity in her manner, by a whisper of the assurance of self-discovery I heard in her voice. I nodded, too full of conflicting emotions to speak, and left her standing there as I plunged into the woods.

It was dark, and spongy underfoot. The beams of searching flashlights made eerie streaks across the shadows. I made my way deeper and deeper into the underbrush, hearing rustles, the night calls of animals—everything but the voice of a child. After two hours, I was exhausted and cold, but no triumphant calls from the other searchers announced any more success than I had had. Once, turning to investigate a noise in back of me, I tripped over a root and fell flat. When I caught my breath I got up on a twisted ankle and spent another endless period looking for my flashlight. For a harrowing moment after I found it, I thought it had broken. I couldn't bear the thought of going back to Annette with empty arms. A sharp rap on the ground cured it of its problems, but not so me. I had a growing feeling of nightmare, thinking that if anything happened to Hal, it was my fault as well as Annette's and that our love, which I knew now was as strong as ever, could never survive the memory of that little figure dashing off down the street to buy a popsicle.

My watch said three o'clock when I reached the boundary of my search area, and I started back through a different part with a growing feeling of despair. Wet, tired, remorseful, all too occupied with my own thoughts, I almost didn't hear the faint humming at my left. When I did, I thought at first it must be one of the other searches. But when I recognized the tune, my heart leapt. All summer, Annette and I had been singing "The Bear Went over the Mountain" when we went exploring in the country. She must have sung it at home as well. Even at that moment, I was surprised to feel, with a rush of pride, that the kid carried a tune pretty well for a six-year-old. As I reached

the spot the voice came from and saw the muddy, woebegone little figure crouched under the bush, my heart went out. I think several decisions were finally made in that instant of recognition and love. I picked him up and felt his wet face pressed to my coat. "Hal, Hal," I kept repeating, and when he recognized me, he said, with no surprise, "Jack the Ripper!" Then, "Where's mommy?" And then, remembering, "Take me home with you. My mommy doesn't want me at home with her anymore. And she doesn't like you anymore either, so can't we go home together?"

I hugged him and quieted him and told him that he was wrong about his mommy. "She loves you more than anybody else, and she told me so just tonight. This afternoon mommy was sick and she didn't mean anything she said." He clung to me, tiny inside my big jacket, and shivered with cold, and, I hoped, with relief. When we got back to the parking lot, a shout went up from those waiting there, and Annette ran forward, threw herself on both of us. Her eyes were red, the bandanna was gone, and her hair was wet and blown, but she was still very beautiful.

Hal grabbed her more tightly than he had me and sent up a howl of joy mixed with the remains of tears. I gave the details to a red-headed policemen who was hovering nearby and introduced himself as Sergeant Riley. The doctor examined Hal and declared him ready for hot milk and bed, and then Annette was being led toward a car and Hal was already asleep in her arms. I had known by the look in her eyes when I handed him over to her that she no longer had any doubts about herself. I had no doubts either, but she hadn't spoken to me since our eyes had met over the child's head. I walked slowly away, suddenly feeling the full fatigue of the whole terrible day, when I heard Hal say, "Jack coming too?"

I turned and saw Annette looking at me. Hal held out his arms. "If mommy says yes," I answered.

"Mommy says yes," said Annette. I took Hal from her and the three of us got into my car. "I'm so ashamed," she said, leaning against me, "but so glad."

"Me too," I said. "Some of the mistakes were mine. The only hero around here is Hal—master matchmaker. He didn't separate us after all, darling. Far from it..."

"For good," said Annette, not at all mysteriously, and we three started back. The rain had stopped, and it was going to be a good day after all.

1959

"Write schmite," said Tony to himself. "You can't start all
stories with the time-worn 'It was a dark and stormy night...'."

It was too hot to work and how could he anyway with that
noise next door. Not that it was a very loud noise, nor actually
even a noise. But on a Saturday afternoon a young man's
thoughts turn away from his typewriter even if he is dead set
on being the youngest Pulitzer Prize winner in history.

It was a voice. A female voice. A young female voice, and it
was husky and clear at the same time, and it was singing "I'm
in the Mood for Love." Tony was not unobservant and hadn't
missed the blonde ponytail, the slim figure, nor, of course,
the long tanned legs, blue eyes, and other relevant details. He
leaned pensively over his blank paper. The door, at that point,
to his surprise, opened. In sailed the girl from next door.

"I'm in the mood too," said Tony. "For love, you know."

"That's not what I had in mind. I want to know why you're
not typing."

He couldn't imagine why she should sound mad, but she
did. "Well, I'm just...not inspired. Not every little thing
will do it, you know. A great writer," he said, warming to his
subject, "needs something more than a blank sheet of paper."
He pointed majestically to his.

"I've heard that always helps for a start," she retorted.
"Please believe me. I'm not really very interested in how your
creative instincts are aroused. It's just that I've gotten used to
the noise and I can't read when it's not going on, and since
I don't eat unless I read, I am rather concerned."

"Can't you eat unless you're reading?" asked Tony seriously. "Have you thought of seeing a doctor?"

"You're not funny," she said. "But I'd expected that. My contact with writers so far has led me to realize that most of them are inconsiderate, pompous asses."

"Wait a minute. What do you know about writers anyway?" he said, louder than was absolutely necessary.

"I work for them. I'm a freelance proofreader, but only for business reasons. Otherwise I'm a singer."

"Engaged?" said Tony.

"Don't change the subject and don't get personal," she said.

"I'm not. I just asked if you were working at the moment. Ye gods—touchy, aren't you?"

And it seemed she was, for as quickly as she had appeared, she disappeared. But Tony had seen her blush before she left, and when he sat down again at the typewriter, he still couldn't work. "I wonder what she does when I'm out," he pondered. "Maybe I'd better go in and ask her."

So he went to apartment number seven, and after noting that the nameplate said "Laura Connelly" in a square girls'-college handwriting, he rang the buzzer. When she didn't answer, he knocked, and when that didn't work, he rang again, because he knew she was in there. This time the little window in the door opened and a blue eye peered out at him.

"What do you do when I'm out?" he asked.

"I don't pine away," was the reply. "Now get back in there and type 'Jingle Bells' forty times or something. I've got to finish reading this thesis today." The little window shut with a final and definite click and Tony wandered back to his room. He sat down at his typewriter again and after a couple of minutes he started to type. "Laura..." he wrote, and that was the song he typed forty times. Actually forty times hadn't seemed like enough so he did fifty-five. He went out and slid it under the door of apartment seven, and waited. Silence, and finally

what sounded like a very small giggle. Nothing more.

The next day, when he heard the singing next door, Tony started in again. This time he typed out, slowly, to make it last, "She walks in beauty as the night…" and several of his favorite Shakespearean love sonnets. An hour later he tucked it under the door. This time no laughing, but the voice started in again. This time the song was "I'm Bidin' My Time."

He stayed in that night and so, apparently, did Laura. He heard her humming to herself, but when he yelled out the window, "Want to go for a walk?," the answer was "Take a long one yourself…off a short pier."

The third day, Tony Wells, boy Hemingway, settled down to a more original masterpiece. At the top of his blank page he put in capital letters "AUTOBIOGRAPHY OF NOTORIOUS AUTHOR AND LOVER ANTHONY ELMER WELLS." Only after he'd gone halfway down the page did he realize he had used his despised middle name, but he decided to leave it. "The truth, the whole truth," he muttered to himself, admitting only vaguely what the concession meant. "Laura…" he hummed merrily, and through the partition came "Leave the singing to the professionals, frog song, and the writing too." What a blessing the walls were so thin in this building. It gives a real sense of neighborliness, thought Tony, forgetting how he hadn't appreciated it at all when the middle-aged lady with the whining Pekinese had occupied number seven.

When he had finished, he added a fatuous postscript: "Who or what is the mysterious lady living next to the above-mentioned (lengthily) famous writer engaged to?" This time he waited after he slid the paper under the door, and sure enough it reappeared a moment later. Scrawled across it was "She is wedded…to her career. No men allowed."

There was no more singing that day, but there was rejoicing in apartment number six.

However after a week of this, Tony Wells began to feel pale, languishing, and not a little lonely. The night before he had gotten a good hearty laugh from his latest effort, but since it was supposed to be a tragic exposé of heart and soul, a laugh was less than he had been led to hope for. Once again he stared gloomily at a sheet of blank paper, and just as his little heart was about to give up to despair, a piece of paper slid under his door. He leapt up, grabbed it, read it feverishly and started singing the "Hallelujah Chorus," which brought the usual uncomplimentary comments from next door. The note read: "Since you've been so good about typing recently, regardless of the eyewash you've been producing, you are hereby invited to a small, unelaborate, but well-cooked, if I do say so myself, spaghetti dinner. Six o'clock tonight at Apartment 7, 455 East 13th Street P.S. If you want a drink, bring the makings yourself."

"Accepted with untold pleasure," he wrote across the bottom, and shoved it under her door. Then, as there were still two hours and forty-six and one-half minutes until six o'clock, he dashed out to the delicatessen to invest in caviar, crackers, and the makings for his lady-killing martinis. Mr. Wells sang the "Hallelujah Chorus" once again in the street, but people looked at him and could tell, since he wasn't wearing a coat and the temperature was about twenty-five degrees, that he was either a madman, an artist, a drunk, or in love.

After his trip to the store, Tony killed some more time walking in the park, startled a few dog owners by saying to them in highly emotional tones, "That's a *beautiful* dog you have there," and going on, whistling out of tune at the top of his lungs, because everything *was* beautiful at the moment to Anthony Wells, and he was not a man to suppress his feelings. He'd read enough psychiatrists' columns in the Sunday papers and magazines to know that it was dangerous and practically fatal to suppress your emotions, that you might end up a juvenile delinquent, or, worse still, a member of the Beat

generation, if you had to let them all loose at once.

At five o'clock sharp he returned home with a shower, pants pressing, shaving marathon, and much general primping in mind before zero hour. When he cheerfully unlocked his door, he noticed another slip of paper on the floor. She wants me to come earlier, he thought, she can't wait, and opening it, read, in ominous black letters, very heavily, one would say angrily, written: "INVITATION CANCELED. Forget the whole thing and good luck on your misanthropic career."

Tony stared at it unbelievingly, couldn't make head or tail out of it, went next door and banged for entrance, noticed the lights were out and crept slowly back to his own room—a beaten and totally perplexed man. Had she just invited him for the fun of disinviting him? And what did that "misanthropic career" bit mean? Ah cruelty, thy name is you-know-who.

When at eight o'clock there was still no light next door, Anthony Wells, not singing this time, wended his way to the local bar and tied one on in classic style, promising himself and everyone within hearing distance that women from then on had no place in his life. "As a matter of fact," he declared to the tolerant bartender (who had heard this before from numerous other, now happily married, young men and whose sympathy was therefore lacking a little in warmth). "As a matter of fact, I have written, I wrote, a very good article on the subject has been written by me, about a month ago. It's called 'Love and Marriage—Society's Lies.' I sent it in to a magazine and they will no doubt publish it soon." He nodded his head solemnly. "In spite of the fact that I have not heard a word, not a syllable from them, I have all confidence in my own genius. Was Einstein recognized in fourth-grade math class? Was Churchill any good at history? Didn't Mozart die a pauper? Ah," he mourned tipsily, "my day will come. And," he added as an afterthought, "I will *show* that woman…"

About two sad weeks later, Tony Wells was just beginning to

convince himself that he could live without any silly singing next door, for although Miss Connelly had been heard pottering about her apartment, there had been no music lately, and apartment six had been strangely quiet. An outsider would have remarked that it was more like the calm *before* the storm than after, but both parties seemed quite sure of what they were doing, or not doing, and a calm of some sort reigned. Anyhow, it was a morning about this time that a large brown envelope arrived in the mailbox of A. E. Wells and was duly brought upstairs and opened. The heading on the letter inside announced that it was from *New Worlds Magazine*, and in smaller letters, "Organ of Enlightened Youth." It said in part, "Herewith enclosed a copy of this week's *New Worlds* in which appears your article entitled 'Love and Marriage—Society's Lies.' We regret that our funds do not allow for payment at this date, but we trust that you will be glad to see your article in print. Might we add that we are very pleased with the opinions expressed therein and hope to be able to publish more of your work. etc. etc.," signed "the editors."

Let it not be said that Tony Wells was mercenary. He was so pleased to see that beautiful thing—his words in print—that he gladly would have starved for a week to have it happen again immediately. "There are other things in this world beside women," he told himself with a vicious glance at the wall of apartment seven. "This article couldn't have been more timely," whereupon he sat down and read the whole magazine from cover to cover, leaving his own masterpiece till last in order to savor the sweet smell of success all the more fully. He plowed through each torrid exposé of the contemptible goings on of the bourgeoisie, the government, the church, and so on, and when he had finished he even read the small print in the front, including the masthead, which listed the staff...

At the very bottom of the list of part-time staff members devoted to copy, proof, and other menial labors, his eye stopped. "L. Connelly," it said, and something dawned

gradually on his success-clouded mind. "And good luck with your misanthropic career." That had been about two weeks ago. The magazine went to press a week before it came out. Laura hadn't picked up her morning mail that day even when he went to the delicatessen. He'd noticed a large brown envelope in her box and had figured it for another thesis to be proofed. How was he supposed to know she worked for *New Worlds*? "Ye gods, what luck," he groaned. The thing only has a circulation of a few hundred, and she not only reads it, she works on it! What did I do to deserve this?" The title stared up at him in clean new black and white: "Love...Society's Lie." Tony got up and paced the room. "Life is rotten," he thought. "Success has already ruined my life. At the age of twenty-five I'm a failure!" He ranted and raved at himself for a while and finally stomped out his door and banged on apartment seven.

"Let me in," he hollered. "You can't put me off anymore. I have to explain something. There's been an enormous misunderstanding." He banged still harder on the door.

"Shut up," came her voice from inside. "The neighbors will hear."

"I hope they do," he yelled. "I want the world to hear. I want the universe to hear, I want..."

"But draw the line at all of Thirteenth Street, will you," said Laura dryly, and convinced that he would break the door down, she let him in.

For the first minute or so the angry young man was speechless—because it had been over a week since he had seen her and her eyes had gotten bluer and her hair blonder and her face lovelier and he felt weak—but soon pulled himself together. "Why didn't you tell me," he said threateningly, "that you work for *New Worlds*?"

"Why didn't *you* tell *me*," she retorted equally ominously, "that you thought love and marriage were lies? It's just lucky for me I found out what lies I'd been hearing before I...I..."

She paused, looking at the floor, then resumed more heatedly. "I knew writers were a cowardly lot, but you're a little young to be living a double life, to be trying to seduce innocent girls with your lies, aren't you?"

"Trying to what? Seduce? Rats. I proposed forty times, in writing, if I did once."

"That's just what I mean," she said scathingly. "I suppose you realize I could have sued you for breach of promise?"

"But I wasn't going to breach my...I mean *break* my promise. What do you think I am?"

"Do you mean," she said even more furiously, "that you don't mean *anything* you say, in or out of print? You've been lying to *New Worlds* and all its readers as *well* as me?"

"Good heavens, no." He tried to lower his voice but his feeling had the better of him. "That is, I wrote that article before I met you, before I knew that love and marriage *weren't* society's lies. Now I, I think they're, well," he finished feebly, "society's...truths."

"I give up," she said coldly. "You're too two-faced for me. Wouldn't your precious public love to hear this voice from the enlightened youth speaking up for those, and I quote, 'hypocritical, old-fashioned, obsolete ideas that are ruining our present day society.' They're all very well for the boudoir, but in print it's a different story, huh? Oh yes. Wouldn't it be nice to be the wife of a man who's publicly yelling his head off about how marriage is a lie. Thank you no. And get out!"

Tony was no match for this splendid outrage. "Hell hath no fury," he muttered. Baffled as to how to get a word in edgewise, not to mention answer these accusations, he went back to his room to lick his wounds and ponder his strategy. It didn't help the state of his heart at all to hear faint sounds of stifled sobbing through the wall.

What could he do? The fact remained to taunt him that the article was a success. Even while he was struggling with himself

he got two phone calls from the office of *New Worlds* saying that some of their readers had been calling in and applauding such an enlightened attitude from a fellow enlightened soul, and he was offered pay for another enlightened article, which they wanted as soon as possible, to be printed the next week, answering letters about the first one. Even if it was a small, rather unorthodox, and not exactly widely read review, no young writer is indifferent to having his name appear not once but again and again, and Tony Wells was no exception. He sat down at his machine and started hesitatingly to compose the new article, trying to forget his personal troubles like a dedicated artist, a man grimly sacrificing his love for his principles. He rather enjoyed the weight of social responsibility bearing down on his young shoulders, but when his fingers began to type, they seemed to have a mind of their own, and when, in an hour, potential success A. E. Wells read over what he had written, he felt the weight disintegrate and he even hummed a few bars of "Laura," quietly, to himself, as he went out to mail his best effort.

"Dear Editors," it began. "It is rare that a person finds his entire philosophy altered within a fortnight, but this writer feels obligated to admit to an overwhelming change of state of mind. In reading the letters received à propos of my last article, I am forced to state here that I agree wholeheartedly with those who condemn my former attitude toward marriage as an escapist, immature, and basically anti-social falsehood."

Tony had to wait two days until the editors of *New Worlds* phoned him with horror in their voices to demand what he meant by this turncoat display and three more days until they had agreed to publish it as a reminder to their readers that many a sheep lurks in wolf's clothing. Needless to say, nothing was mentioned about further articles, pay, and such, so Anthony sadly settled down to writing short stories again. The day afterwards he saw the brown envelope in Laura's box and crossed his fingers. He heard her come up the stairs, unlock the door

to her apartment, turn on the radio, sit down—by this time he was glued to the wall—and then he heard the sound of ripping paper which meant she was opening the envelope.

He felt as though he was being opened up himself, and his heart was going so fast he expected her to complain any minute about the noise. For a few more minutes, more silence. Then he heard her get up, walk across the room, open her door a little way, go back across the room, sit down again, and finally, when he had almost burst, thought it had done no good at all, that she was still completely set on never seeing him again, she started to sing… "I'm in the Mood for Love."

With the speed of not only lightning, but light, Tony Wells arrived at the half-open door of apartment seven. He didn't knock, and he didn't ask permission to kiss the girl who stood smiling on the other side of the room, and he squeezed her so hard that she laughed and said, "Do you want me dead or alive?" There were a few more minutes dedicated solely to tender looks, sighs, and other manifestations of affection which would not have failed to disgust the readers of *New Worlds*, when suddenly Laura pulled out of Tony's arms and said sternly, "Just one more thing, my friend."

"Anything," said he.

"Call *New Worlds* right away and tell them not to publish this, this blasphemy. It could ruin your career! A writer just doesn't contradict himself like that."

"*What*? But I thought you said you didn't want to marry someone who said in print love was a lie. You didn't want me to be two-faced…You said…Wait a minute—you *are* going to marry me, aren't you?"

"Probably," she said demurely. "But what I mean is…"

"Shhhh," said her husband-to-be. "I won't hear another word."

1959

84

Various Rejection Letters

The Atlantic Monthly (1959)
Dear Mr. Lippard: We have read this manuscript with interest but regret to say that we are unable to make a place for it in the Atlantic. Thank you nonetheless for the chance to consider it. Sincerely yours.

Redbook (n.d.)
We regret that the enclosed manuscript is not suited to the present needs of this magazine. Please accept our thanks for the privilege of considering it.

The Saturday Evening Post (n.d.)
We are sorry that the enclosed material has not quite won out in the heavy competition for our limited space, and we are also sorry that, because of the hundreds of manuscripts we have to handle daily, it is not possible to write the number of personal letters we should like to. However, we do want you to know that we have examined this material with more than average interest and that we are grateful to you for showing it to us.

Cosmopolitan (n.d.)
Every manuscript that comes to this office is read by one or more editors in the hope that it will prove acceptable for use in Cosmopolitan. Its return implies no criticism of its merit—means only that it does not meet our present needs. We regret that the large number of manuscripts received makes it impossible to offer individual comment, but thank you for your submission.

Ladies' Home Journal (n.d.)
We regret to announce that the Ladies' Home Journal is no longer able to consider unsolicited manuscripts for publication. This includes fiction, articles, fillers and poetry. We appreciate your interest in our magazine, and we send you our very best wishes for success with other markets. (handwritten: *Sorry*)

The New Yorker (n.d.)
We regret that we are unable to use the enclosed material. Thank you for giving us the opportunity to consider it.

III.

Collaborations
(1969–76)

Street Works

Standing Piece
Partially executed March 15, 1969

Stand on 42nd Street and forget your name.
Stand on 43rd Street and forget your address.
Stand on 44th Street and forget your education.
Stand on 45th Street and forget your past.
Stand on 46th Street and forget your present.
Stand on 47th Street and forget your future.
Stand on 48th Street and forget your body.
Stand on 49th Street and forget your art.
Stand on 50th Street and forget your mind.
Stand on 51st Street and forget your space.
Stand on 52nd Street alone.

Contact Piece
Executed March 16, 1969
11:00 AM–1:00 PM
42nd–52nd Streets, Madison–Sixth Avenues

One person: each block in the given area; actions timed so that event status is unnoticed.

Directions:
1) Look everyone coming toward you in the eye as long as possible.
2) Walk in step with anyone walking beside you.

3) When someone is coming toward you and swerves to avoid collision, swerve in the same direction and keep it up for as long as possible (once a block).
4) Speak to one person per block as though you know him well (don't speak to people you do know).
5) Be black and do the same things (not executed).

Reading Piece
Executed March 16, 1969

In the Rockefeller Center Subway Station: read a Chinese newspaper upside down. In the Fifth Avenue Subway Station: read a Yiddish newspaper sideways.

Smells
Executed April 18, 1969
5:30–6:30 PM
4 blocks, Fifth and Sixth Avenues,
13th and 14th Streets

smoke
general pollution
gas
pizza
dog shit
strawberry ice cream
metal
cheap perfume
new clothes
cuchifritos
sauerkraut
oil

vinyl
hamburgers
urine
cosmetics
water
wet cement
exhaust
burning rubber
water
wet grass
wet paper
wet hair
wet clothes
beer

Contact Piece 2 (Aggression)
Executed April 24, 1969
Afternoon; one person; 10 blocks in Midtown Manhattan

1) Jaywalk once each block.
2) Bump into someone once each block.
3) Get into a bus ahead of someone who was ahead of you,
give the bus driver a $10.00 bill.
4) Make a face at anyone with a red umbrella.
5) Give a bus driver a $5.00 bill.
6) Drop a candy wrapper on the sidewalk.
7) Make someone pick up litter they have dropped.
8) Ask every policeman you see the directions to Chicago.
9) Pretend you are deaf and dumb if anyone asks you
directions.

1969

*The following text appeared in a
1970 artist book called Publication
by David Lamelas featuring contri-
butions from thirteen international
artists and critics. Produced from
conversations, Lamelas's book
collected their responses to three
statements.*

Response to Three Statements
(for David Lamelas)

David Lamelas has asked me (presumably as part of his own art work) to "comment," along with other critics and artists, on three statements: 1) Use of oral and written language as an Art Form; 2) Language can be considered as an Art Form; 3) Language cannot be considered as an Art Form.

Douglas Huebler has sent me a piece of his (art) and asked me to send him something (implied art) in exchange.

I don't make art. But now and then I write about artists or use their work in such a way that I'm accused of making art. Accused because it's not necessarily a compliment since I'm a writer and not dissatisfied with being called a writer since I use words as a conventional Art Form called literature or criticism, Art in this case being used as a broad term meaning any sort of not necessarily visual framework imposed on or around real or imagined experience. I don't make pictures. I don't use pictures. I don't make patterns on the page with the words (or if I do, they're conventional, random, non-hierarchical patterns and only incidental to the intention of *writing* something). The only object I have any urge to make is a pile of paper covered with words, or the ordinary paperback book. (Hard covers are pretentious and usually too big to be carried in the pocket and will therefore be read pretentiously in a pipe-smoking rocking-chair situation. Now I Will Read a Book, instead of an ongoing fragmented in and out of life and in and out of the book situation.)

Later I talked to Doug and he (mistakenly) told me he was going to publish the pieces he received in exchange as part of his exchange piece. I had thought of doing an Artificial Word

Series from a book I'm writing or just a randomly chosen page of the (unreadable) first draft of the manuscript of the book I'm writing. But now I guess I'll give him a statement of some kind to this effect:

Conventional "Literature" (first dictionary definition: "The profession and production of an author") unlike conventional visual art (first dictionary definition: "human ability to make things") is worth nothing per se before it is a book, and when it is a book it is worth maybe two bucks and is available to everybody with two bucks, or with a library, or a friend who has the book. Art can be traded and so can books, but if I trade a copy of my book for a painting or a sculpture or even for a print, the receiver of the book will probably feel cheated. My book should be traded, when and if it is printed, for a reproduction of a work of art. Maybe Doug's piece, existing in an "edition" of 50, is a reproduction? If so, what is it a reproduction of? Maybe Doug's piece is tradeable for a book printed in an edition of 50 copies and therefore "worth" two hundred instead of two bucks? Or is my book, published or unpublished, and Doug's piece, unique or multiple, "worth" whatever we can get for it? Or is it "worth" whatever is traded for it since that kind of open situation obviously has to do with the kind of piece he is making; and once our exchanges are incorporated into the piece, is it "worth" more as the sum of the parts than each part separately, or is it still worth two hundred bucks or a grand or whatever these things *are* "worth" on the market?

It's all getting distasteful. Obviously Doug doesn't care if it's an "equal" trade, only that the trade is accomplished. The point is not the monetary worth or the prestige worth of either Doug's piece or whatever I produce in return. I would like to make it a direct response to his piece rather than something that exists independently or was around before I got the request for an exchange. The point, anyway, lies in the differences between the media and their manipulability.

It's almost an oil-water problem. Can you trade art for literature? Or for cauliflower? Are languages as a (visual) Art Form and language as a (written) Art Form, i.e. literature, interchangeable? If written (visual) art is a viable (visual) Art Form how do you distinguish it from literature? Is the only difference that one is made by an Artist and one by an Author? If an Artist makes up a story and tells it in book form is it Art? If an Author paints a pretty picture is it Literature? If I borrow (plagiarize, which originally meant to kidnap) a piece (*Special Investigation*, 1969/70) from Joseph Kosuth, who has presented it as (visual) Art after borrowing it from a riddle book by another "author," and use it in my book of "fiction," does it become Literature again? (And was it Literature in the riddle book?) Is it therefore no more a plagiarism than Joseph's original act of borrowing it was plagiarism? What price is the ransom? If I put my book of fiction into an art show, *then* have I plagiarized Joseph's piece? A similar question came up several years ago when Erle Loran wanted to sue Roy Lichtenstein for making paintings after Loran's pedagogic diagrams after Cézanne; no conclusions were drawn. Does it make a differ-ence if I add a footnote to my use of Joseph's piece that says, "I would like to thank Joseph Kosuth for bringing this material to my attention"? Would it have changed Joseph's piece if he had acknowledged his source?

If that's confusing, consider this one. Is a curator an artist because he uses a group of paintings and sculptures in a theme show to prove a point of his own? Is Seth Siegelaub an artist when he formulates a new framework within which artists can show their work without reference to theme, gallery, institution, even place or time? Is he an author because his framework is books? Am I an artist when I ask artists to work within or respond to a given situation, then publish the results as a related group? Is Bob Barry an artist when he "presents" the work of Ian Wilson within a work of his own, the process

of the presentation being his work and Ian's work remaining Ian's? If the critic is a vehicle for the art does an artist who makes himself a vehicle for the art of another artist become a critic?

It's all just a matter of what to call it? Does that matter? It has to if Joseph Kosuth, for instance, is making "art as idea as idea" and not just idea as idea, if the Art & Language group are making language *about* art and calling it art. Clearly what it's called does matter, maybe more than what it is? As long as there are Art Shows and Books as Art Shows as distinguished from Books as Literature, and until it is possible to pick up a book-as-object and neither know nor care whether it's called art or literature or fiction or non-fiction, it matters. Artists want to be called artists. Writers want to be called writers. Even if it doesn't matter.

It's not the medium that counts, and it's not the message that counts, it's how either or both are presented, in what context, that counts. And artists who claim they are making non-art or anti-art should have the grace to stay out of art galleries and art museums and art magazines until those names have been obliterated. No art, no matter how much it resembles life, or literature, can call itself anything but art as long as it has been, is, or ever will be shown in an art context.

And writers who claim they are writers should stay in books and magazines and catalogues? But the catalogue part gets confusing now that there is art that may appear only in the catalogue of a show. When I wrote a critical text (not wholly recognizable as such) for the Museum of Modern Art's *Information* catalogue, it was put into the body of the book with the artists' contributions and I was listed with the artists. This confuses matters and I didn't know about it until too late. I rather like its confusing matters but I don't like to be listed as an artist. Public self-identity becomes important. Privately one tends not to bother. One of the few things I'm sure of is

that I deal with words as a writer. I like them in long relatively sequential passages and I like words that refer to other words. I can't think of any (visual) artist who does this without calling it art (which makes it art). Or who does it without referring to its structural framework. No, that's not quite right. Kosuth's investigations when they are on the page (not on wall labels), Ian Wilson's oral communication, Lamelas's interview with Duras, and the Art and Language group and its sidekicks, all prove that language is an art medium but has to be trapped firmly in the bounds of the Art container to be an Art Form. Is it habit that makes an artist keep his language within the bounds of Art? Or discipline? Is it possible that once language is not called art (or literature, whatever that is), it is no longer significant? Is it significant as art primarily because its isolation as art, its separation from life, makes people aware of language in an unexpected and therefore more powerful context? Just as painting and sculpture separate themselves from commercial art, decoration, and industrial design by that same act of self-upgrading? Are artists making their work significant as art because of a reluctance to participate (and compete) in the larger literary-academic world of language usage? What difference is there between "This sentence has five words" and "This whole has five parts"?

Or is it all a synthetic dualism, a synthetic dilemma leading back simply to the problems of one's intentions to affect the world or not? And how? If I'm all in favor of a future in which the distinctions are confused and effaced, why, in the meantime, am I so concerned to retain my public identity as a writer? I'd like to do that mainly because confusing criticism with art dilutes the art still further than its third to twenty-ninth string does. At the same time I'll do as much as I can to confuse the distinction between writing and art writing, maybe eventually between art and art writings, and to generate circumstances in which these distinctions *are*

obliterated. It probably is a synthetic dilemma, but what is there about art that isn't synthetic, when you come down to it, or writing either?

—

Everything written by me above and all rights to it belong to Douglas Huebler in exchange for his Duration Piece # 8. Global; *only with the written permission of Douglas Huebler may it be printed in David Lamelas's book, which is also his exhibition. Lucy R. Lippard, New York 25 September, 1970*

London 30 Sept 70
Dear Douglas Huebler,
Since you are the owner of Lucy Lippard's comments on my three statements, I would like to have your permission to use these comments for printing in my book.
Looking forward to hearing from you.
Yours sincerely,
David Lamelas

Dear David Lamelas,
I would be very happy to have you use Lucy Lippard's comments on your three statements for printing in your book and, as I own those statements I hereby authorize you to use them in that manner. Sincerely,
Douglas Huebler

1970

Robert Barry at Yvon Lambert
(with Robert Barry)

 Robert Barry's current show at the Yvon Lambert Gallery in Paris is announced by a mailer that reads: "ROBERT BARRY presents three shows and a review by LUCY R. LIPPARD." Ms. Lippard is an American art critic. The show itself consists of this review and a box of some 150 4" × 6" index cards which constituted the catalogues of three exhibitions organized by Ms. Lippard from 1969–71, each titled according to the population of the city in which it was held: "557,087," Seattle, USA; "955,000," Vancouver, Canada; "2,972,453," Buenos Aires, Argentina (several cards from the latter have been vehemently canceled because instructions were not followed in their printing).

 From 1968, Barry has worked in almost invisible nylon cord, invisible but extant radiation, magnetic fields, radio carrier waves, telepathy, repressed knowledge, non-specific qualifications defining undefined conditions. This exhibition is the third in a series of presentation pieces by Barry, the first two involving the work of artists James Umland and Ian Wilson. It is also part of another group, dating from 1969, which comments on the use of gallery space and the international gallery system for an art so dematerialized that it has no fundamental need of either one. The first of this group was a piece that announced: "During the exhibition the gallery will be closed." In January 1971, Lambert showed a Barry piece that reads: "Some places to which we can come and for a while 'be free to think about what we are going to do' (Marcuse)." "Reads" is the wrong term; Barry does not work with words; he communicates conditions. The newer work indicates an

overlap rather than a gap between art and life, in the sense that it attempts to define (again by circling around something) the place of the artist in the world, not socially (though social impact is implied) but as an art-maker rather than as a person. Perhaps the most important of the many questions raised by Barry's work is simply: Does the artist have a place in the world, and, if so, is it changing? Is he/she simply a questioner or is he/she the imposer of conditions upon the esthetic capacity of everyone else, without which the world would be quite a different place?

And I have some questions of my own. Is a review which is not published in a journal but constitutes part of an exhibition in itself a fake review? Can it view itself objectively? Or is it valid anyhow because people read it, because it does comment directly upon the show it is part of? Is the writer of such a review an artist even if she/he has made no art? If a writer calls what she/he does "criticism," can anyone else call it art? Is the artist who "presents" a writer's work as a minor part of his piece (the major part being the presentation per se) a critic himself? Is an artist ever not an artist if he/she says he or she is an artist? Does an artist have to make art?

And finally, it doesn't matter what this review says. Its potential is confirmed by its existence rather than by its contents.

1971

Imitation = Homage
(with Sol LeWitt)

1971

Walls, Rooms, Lines
(with Sol LeWitt)

1976

All "yours" and "yous" connected by straight lines
All "I's" and "mys" connected by not-straight lines
All "yours", "yous", "I's" and "mys" connected to "we"
by broken lines

The first wall, if you're left handed, is in shadow, the
second brilliantly lit, the third (on your right, if you're left
handed) lit at the front and quite dark at the back. The
one behind me—can't see from here—but I sense it's dark,
with the light from the hall making an angular patch on
the floor beneath me. The pink streamers decorating the
outside of the building are forgotten. The prayers in the
hallway too. Here it is. Walls, no more, no less.

The artist talked about braille but he didn't mean touch.
He talked about ideas, but he didn't mean philosophy. He
talked about art but he didn't mean scumble. He talked
about clarity and he meant it. Most people don't.

We read the same books. The walls glowed in the light left
over from sunset. I could almost read them once you'd
woven them. But went too fast. You were slow. They were
out of focus. Then you almost wrote my book. I found out
in time. Your boxes. Muybridge—your photos. My words. I
escaped to Spain and put them in my box which was my
book.

Black and white, dark and light. The colored ones still seem to me like shadows. Cages, boxes, skeletons, stretched and shrunk, dissected in two dimensions, healthy in three. The vitality of a non-vital idea, or rather the hermetic vitality of of an idea bursting out into visibility. To permute is to change, exchange, replace, rearrange. There's a solid pulse-beat that carries them on on on into life. Like unwieldy re-calcitrant characters in a novel they seem to enjoy, maliciously, a life of their own, dividing like cells in unex-pected prolificity. So you get letters from mathematicians.

In the first room, a figure sitting quietly, hands in lap, a kettle boiling, boiling over, in fact, but she does not move, smiles calmly, foam on the stove.

In the second room, no-one. Traces. Lines on the walls, not straight lines, crooked lines, wandering, looking for the other 4,999.

In the third room, chaos. A radio blares stock market news, three small children dance the hula the minuet and the hussle respectively, an iguana tries to escape, a cat who has had 35 kittens holds her breath, pages flutter, shades flap, pipes bang, the walls are not marked in orderly fashion.

What kind of logic? Why does it have to be logic? There are other rooms I have promised you. The fourth, for instance, and the fifth, where they lurk, where they wait patiently, sitting on tied up bundles of old Artforums with wet, pink covers.

Logic because straight is logical? So crooked then. But crooked has its own logic. Why logic? Why not illogic, as easily concocted.

Rooms. Rooms where certain things happened. Where similar things happened. Where similarities widened into differences.

Lines drawn from the word "walls" to the center of the page,
Lines drawn from the word "room" or "rooms" to the corners,
Lines drawn from the word "lines" to the midpoint of the sides.

Where corridors opened onto halls and halls onto parlors and
parlors onto ballrooms and ballrooms onto bedrooms and bed-
rooms onto maids' rooms and maids' rooms onto corridors.
(You left out bathrooms and kitchens.)

Rooms where when I was young I was only molested. Where
when I was grown-up I braved it out. Where at mid-dle-age I
sit, watching the walls expand and contract around me,
sometimes as I will it, sometimes not. One of my walls is
covered with pictures, pictures by friends and lovers and
children and an occasional artist I never knew. Redon.
Beasts of the Sea, round like oysters, hairy and bulbous and
darkly open. Judy's rock cunt, Charles' linear people
labelled I love you, Bob's passionate 8" square with its
orange side, Jo's delicately bordered void, Ethan's corked
bottle, Sol's lines. You got out of one book, made the
cover for another. Lines going up, lines going down (that's
one quarter); lines going back and lines going forth (that's
another); lines leaning in and lines leaning out (that's the
last two). Also on my wall, a mask, a starfish, a Nigerian
dagger, a tear-stained ERA button, a cookie fortune: Think
no shame of your craft.

Something did happen here. It's hard to tell what. An over-
dose of logic or illogic. A calm crossing of functions. An
obsessive stolidity. A line is the limit of a surface. Dead-
lines reads a card over my desk. Headlines most part doesn't
make. Heartlines maybe. Beelines people imagine. Lifelines
arrows point to on ships and high cliffs over the sea. Bylines
authors long for by and by. Eyeliner small eyes envy. Silver-
lining for those who can't afford gold. Line the word comes
from linen, thread. What's your line? Line up and find out.
Fall for it hook lyon and sinker. Outlines but no inlines I'll
draw
the line
at
that.

Vowels — ⓐ ✗ ⓘ ● ✗

105

Author's note: Kynaston McShine, an old friend and colleague and curator at MoMA, hired me to write for his Information *(1970) and* Marcel Duchamp *(1973) exhibitions and was not deterred by the strange responses. The piece for* Information, *written "in absentia" from Spain, originally included five pages of text that follow the instructions set out in Part 1, in the form of a listing of nearly 100 artist quotations and references as part of a printed addendum. Duchamp's readymades were clearly a major inspiration for all my subsequent "fictions."*

The original text was prefaced with this note: The following instructions were sent to Kynaston McShine in lieu of an Index to the Information *catalogue, for which the necessary information did not arrive in time. When I realized it would not, I decided to substitute some absentee information arrived at by chance. I opened a paperback edition of* Roget's Thesaurus *to ABSENCE, hoping to get some ideas. The book* had been given to me, secondhand, by a friend in December 1969; I had not opened it until this point (Wednesday, April 15, 1970, 3:30PM, in Carboneras, Spain). When I did so, I found not only the entry above (now cut and revised) but two red tickets, unused, inscribed as follows: Museum of Modern Art, Film Reservation Wednesday Afternoon 3:00PM Showing Not For Sale Keller Printing Co. New York; the numbers on them were 296160 and 296159. These tickets determined the initial framework for the following situation/text.

Quotations from, and debts or references, to the works of the following persons are included in it: Art Workers' Coalition, Gaston Bachelard, Robert Barry, Frederick Barthelme, D. E. Berlyne, Mel Bochner, John Cage, Marcel Duchamp, Dan Graham, Latvan Greene, Douglas Huebler, William James, On Kawara, Joseph Kosuth, R. D. Laing, Sol LeWitt, Marshall McLuhan, Ad Reinhardt, Sainte-Beuve.

$$A_1B_2S_{19}E_5N_{14}T_{20}E_5E_5$$
$$I_9N_{14}F_6O_{15}R_{18}M_{13}A_1T_{20}I_9O_{15}N_{14}$$
$$A_1N_{14}D_4 \quad O_{15}R_{18} \quad C_3R_{18}I_9T_{20}I_9C_2I_9S_{19}M_{13}$$

ABSENCE: 1) withdrawal, nonexistence, nonresidence, nonpresence, nonattendance, disappearance, dispersion.
2) emptiness, void, vacuum, vacuity, vacancy, depletion, exhaustion, exemption, blank, clean slate, tabula rasa.
3) absentee, truant. 4) nobody, no body, nobody present, nobody on earth, not a soul, nary a soul, nobody under the sun, nary one, no one, no man, never a one.

Be absent, absent oneself, go away, stay away, keep away, keep out of the way, slip away, slip off, slip out, hold aloof, vacate. *Colloq.* hooky, cut, not show up, not show, French Leave, Spanish Pox, make oneself scarce. *Slang*, go A.W.O.L., jump, skip.

1) absent, away, missing, missing in action, lost, wanting, omitted, nowhere to be found, out of sight, gone, lacking, away from home. Absent Without Official Leave, abroad, overseas, overlooked, overseen, on vacation. *Colloq.* minus. 2) empty, vacant, void, vacuous, untenanted, unoccupied, uninhabited, uninhibited, tenantless, deserted, abandoned, devoid, forsaken, bare, hollow, blank, clear, dry, free from, drained. *Colloq.* Godforsaken.

Nowhere, elsewhere, neither here nor there, somewhere else, no there. *Dial.* nowheres. Without, wanting, lacking, less minus, *sans*.

SEE ALSO PRESENCE

Games are situations contrived to permit simultaneous participation of many people in some significant pattern of their own corporate lives.

1311819811212 13312218114

Part I

A. For each artist in the exhibition whose name begins with a vowel, proceed as follows: go to the Museum of Modern Art Library and look under the artist's name in the general card catalogue. From the first book or article entered under his last name (whether or not it is his own name), transcribe the 24th sentence (2+9+6+1+6+0 = 24.) If there is nothing under that name, take the first name occurring in the catalogue that begins the same way and has the most beginning letters in common with the artist's name (e.g., for Barthelme: Barthelm, Barthel, Barthe, Barth, Bart, Bar, Ba, B, in that order).

For each artist in the exhibition whose name begins with a consonant, follow the same procedure taking the 32nd sentence (2+9+6+1+5+9 = 32) of the first book or article occurring in the most recent full volume of the *Art Index* . If in any case there is no text, or no 24th or 32nd sentence, reproduce in its place the 8th picture or the picture on page 8 or the picture 1/8 of the way through the reference (8 = common denominator of 24/32).

B. Make an alphabetical list of these artists, each name followed by the quotation arrived at above, with full bibliographical source in parentheses after it (i.e., author, title of book, publisher, place published, date, page no.; or, in the case of an article: author, title, magazine, vol. no., date, page no.).

Part II

A. If it is true that the artist possesses the means of antici-
pating and avoiding the consequences of technological trauma,
what then are we to think of the world and bureaucracy of "art
appreciation"? Would it not seem suddenly to be a conspiracy
to make the artist a frill, a fribble, or a Miltown?

13312218114 171914

...The logic of the photograph is neither verbal nor syntac-
tical, a condition which renders literary culture quite helpless
to cope with the photograph.... For most people, their own ego
image seems to have been typographically conditioned, so that
the electric age with its return to inclusive experience threatens
their idea of self.

9294

For art as either action or idea, memory, or the absorp-
tion of some referent to an art work or an art idea into the
observer's consciousness, is instrumental. By memory, I mean
less the retentive, the fact-storage faculty, than the associative
faculty. From the arts we are learning to make connections,
jumps, through cues and clues that come to us in fragments.

1212022114 71855145

It is not so much for you, my friend, who never saw this
place, and had you visited it, could not now feel the impres-
sions and colors I feel, that I have gone over it in such detail,
for which I must excuse myself. Nor should you try to see it as
a result of what I have said; let the image float inside you; pass
lightly; the slightest idea of it will suffice for you.

19191420 – 2521225

A good third of our psychic life consists of these rapid premonitory perspective views of schemes of thought not yet articulate.

23912129113 10113519

Philosophy makes us ripen quickly, and crystallizes us in a state of maturity. How, then, without "dephilosophizing" ourselves, may we hope to experience new images, shocks which are always the phenomena of youthful being?

7119201514 21385121184

Fragmentation can be a highly effective artistic or critical approach to much new art. It is closer to direct communication than the traditionally unified or literary approach, in which all sorts of superfluous transitional materials are introduced. Interpretation, analysis, anecdote, judgment, tend to clog the processes of mental or physiological reaction with irrelevant information, rather than allowing a direct response to the basic information.

71855145, 1516. 3920

We think we want creative children, but what do we want them to create?

18.4. 1219147

No one will take No for an answer.

14 1i59148118420

Chance brings us closer to nature in her manner of operation.

1015814 3175

It is, in fact, quite possible that before the next one hundred years are up our thought processes will have led to our extinction, in a way that would be quite impossible for lower animals that are incapable of thinking.

4.5. 25181225145

B. Provide errata sheets in the exhibition space where visitors can correct any inaccurate information, spelling, etc., in the material on view or in the catalogue. Edit out facetious comments and publish as a review of the exhibition in an art magazine.

Émile Durkheim long ago expressed the idea that the specialized task always escaped the action of the social conscience.

1331221814 171914

Part III

A. Match the name of each artist in the exhibition who is or will be in New York or environs with that of a Trustee of the Museum of Modern Art whose last name begins with the same letter (use procedures similar to that in Part I/A, going to the next letter in the alphabet if still incomplete); ask each Trustee to spend at least 8 hours talking to that artist about art, artist's rights, the relationship of the museum to society at large, or

any other subject agreed upon by the two of them. This should be executed within 6 months of the opening of the exhibition and can be applied to foreign artists if individual travel plans are known far enough in advance.

B. On the first afternoon after the opening of the exhibition (preferably a Wednesday) that this is statistically possible, give the holders of film tickets numbered 296160 and 296159 lifetime free-admission passes to the Museum (valid any day of the week). If the holder is Black, Puerto Rican, Female, or a working artist without a gallery affiliation, give him/ her in addition a free xerox copy of any piece or pieces in the *Information* exhibition utilizing *Roget's Thesaurus*; if there aren't any, or if the artist refuses, give a free copy of the catalogue of the Museum's permanent collection.

C. Show no films glorifying war. Ask the American artists in the exhibition to join those willing on the Museum staff in compiling and signing a letter that states the necessity to go A.W.O.L. from the unconstitutional war in Vietnam and Cambodia; send it to 592,319 (296160+296150) men at armed forces based in each state of the USA. (If this is impossible, to 56 major newspapers.)

D. Purchase one work by those artists in the exhibition whose names appear first, second, fifth, sixth, ninth, nineteenth, and sixtieth (if it goes that far) in the alphabetical list of exhibitors; donate one each to seven (or six) independent museums all over the world which are located in low-income areas, outside of major cities.

E. Xerox and publish as an insert to the catalogue of the *Information* exhibition all available information on any extant proposed reforms concerning artist's rights, such as rental fees, contracts, profit-sharing, artists' control over works sold, shown, etc.

1970

The Romantic Adventures of
an Adversative Rotarian; or,
Alreadymadesomuchoff
(collated by Lucy R. Lippard)

I.

"He had the advantage of seeing the beautiful mechanism
in Mr. Chance's works, and that which struck him most was
the cross-stroke in the polishing; when there was a ring lens
to be made, the cross-curvature was not given by grinding[1]
in a bowl, but by the cross work of the polisher; and by some
small adjustment of the mechanism, which Mr. Chance had
arranged, there was a power of altering the degrees of curvature
which would be given by that cross-stroke. Upon that every-
thing depended, and he looked upon it as the critical point
in the construction of these lighthouses. He arrived at that
conclusion because, when the light diverged from a lamp and
fell upon the prisms, the intention was that it should emerge in
parallel beams with reference to the vertical plane.

"During the Exhibition of 1851, he had an occulting light
placed on the roof of his own house, with a view to experiment
upon its adaptability for telegraphic communication, and
subsequently he received a communication from America,
requesting him to visit that country to establish that system
there. He thought he might be permitted there to state a curi-
ous fact relating to the effect of these very rapid occultations so
quickly succeeding each other that he was aware of their being
double occultations before he was enabled to put into mental
language the expression of that fact."[2]

On his arrival, he met, of course, Mr. Chance himself, who
tut-tutted in kingly fashion, "If your idea of a bicycle is one of
these balloon tired, heavy frame, unwieldly jobs that kids ride,

you ought to drop by a bicycle shop and see what *real* bikes are like. You can pick one up with one hand and hoist it on your shoulder, so you can easily carry it up steps, onto stools, into buildings, and so on."[3]

"Should the rear wheel run crooked," his new friend joined in with enthusiasm, "it can be adjusted by screwing up the nuts until it is straight, or in alignment, as it is called."[4]

At this point, Mr. Chance's flowing scarf was temporarily caught in the spokes of his monocycle, through which he saw as he chose, and as he extricated himself he suggested ruefully that the wheel might be "a symbolic synthesis of the activity of cosmic forces and the passage of time. The allusion is, in the last resort, to the splitting up of the world-order into two essentially different factors: rotary movement and immobility—or the perimeter of the wheel and its still center, an image of the Aristotelian 'unmoved mover.' This becomes an obsessive theme in mythic thinking, and in alchemy it takes the form of the contrast between the volatile (moving, and therefore transitory) and the fixed."[5]

Rolling this around in his mind, Mr. Chance's new acquaintance absentmindedly tweaked a thread loose from his waistcoat (a plaid one of which he was very proud; it had once had five buttons spelling the initials of his first five mistresses—L.H.O.O.Q.—but with the loss of the H, the Q, and an O, only a cheery greeting remained). No sooner had he pulled this one thread than another appeared, and that one, breaking, produced a third, which occultation he took as a sign: "The mass production of machinery by modern manufacturing methods is possible only because of strict standards of measurement. Varying degrees of accuracy in measurement are required for different purposes. It should always be kept in mind that inaccurate and careless measurements are worthless, and may often cause waste of time and materials."[6]

Here they were briefly interrupted by a French widow

whom Mr. Chance had met when they both befriended a blind man taking the wrong passage from New York to Zurich, via Barcelona. Once introductions had been made, the conversation resumed.

"The process of measurement itself alters the very thing we are measuring and there is nothing to be done about it on account of the quantized nature of radiation, and since position and motion cannot be resolved into simpler terms."[7]

The visitor fielded this in fine fashion: "A third type of 'uncertainty' lies in the limitations of perception. At first signs this might seem to be no more than an instrumental inefficiency, comparable with the inaccuracies of our wooden ruler. This is not really the case, however, since we can go on improving the accuracy of our measuring rods whereas we cannot very greatly improve the acuity of our senses."[8]

To their surprise, and even pain, the widow broke in afresh with a new and extremely feminine theory of random networks, cagily attributed to Zachariasen, who was being lionized at the time: "The atomic or molecular arrangement in the glasslike state is an extended network which lacks symmetry and periodicity...oxides forming the basis of a glass are known as *network formers* and those which are soluble in the network are termed *network modifiers*. Some oxides cannot easily be glassified in this way and are termed *intermediates*."

"Nonsense!" of chorused both men. "If the structure of glass lacked symmetry and periodicity in contrast with the crystalline state, then a new surface created by fracture would possess in its outer layer a statistical distribution of the constituent atoms."[9]

Meanwhile, Rrose, undisturbed by their vehemence, "watching the great white flakes falling over bare woods and gray lake, looking neither to port nor to starboard, felt the benediction of its quiet. She had come, after weeks of turmoil, into a peace which was not happiness but which was at least a

115

working basis for living. She had actually, she felt, prayed her-self into acceptance of life as it stretched before her. Perhaps, in time, she might comprehend the triumph of sacrifice."[10]

By then, Mr. Chance's friend, tortured by her wintry gaze, was hopelessly enameled. "When the victim was securely fixed on the rack, the questions to which answers were desired were put to him. Failure to reply satisfactorily was the signal for the two executioners to commence operating the levers. The result was the stretching of the victim's limbs and body."[11] "Courage," he muttered to himself. "The witness, however, is never questioned, in *modern* practice, as to his religious belief. It is not allowed, even after he has been sworn. Not because it is a question of tending to disgrace him; but because it would be a personal scrutiny into the state of his faith and conscience foreign to the spirit of our institutions.... The law, in such cases, does not know that he is an atheist."[12]

Thus reassured, he turned black to the widow and, braving another cold shudder, realized with relief that "nearly every business enterprise is in some way dependent upon the removal of snow. Unremoved snow may become a real menace to the health of the community because of the inability to remove garbage and refuse. Unhealthful conditions are almost certain to result when garbage is not collected for several days and there are many accidents due to icy, slippery streets."[13]

He folded in his arms in advance, but when she left, his mind, etc., was already made up. Hidden in his green box, making a curious sound when rattled, was an unspeakable object, attached to his secrets by the ball of twine which so resembled the hair of his beloved. He realized this could be the source of a new and immeasurable standard of measurement. Whatever Mr. Chance advised, there was no stopping now.

"On reaching home, [Apolinère enamored] would feel ashamed of what had taken place; but the wish to possess hair, always accompanied by great sexual pleasure, became more and more powerful in him. He wondered that previously, even in the most intimate intercourse with women, he had experienced no such feeling."[14] Could it be that "since the comb is the attribute of some fabulous female beings, such as lamias and sirens, there is in consequence a relationship between it and the fleshless tail of the fish in turn signifying burials (or the symbolism of sacrificial remains)"?[15] Actually, he made this connection only some years later when his fancy was struck by the sweet lines of a cuttlefish bone that made his temperature rise alarmingly.[16]

Feeling himself in need of being pulled together, it was with relief that Mr. Chance's friend closeted himself with a chessboard at hand. But his thoughts continued to follow a sad train. He recalled an early trip to Germany: "The formation of waterfalls is due to a variety of causes. For instance, cascade falls are due to the fact that Nature is constantly at work wearing away the surface of the earth by swift denudation. In Europe the finest falls are those of the Rhine below Schaffhausen, where the water plunges over a succession of ledges of hard Jura limestone."[17] "All lip urinals," he mused, particularly queens', "should be of the flushing rim type. The flushing rim allows the entire surface of the interior to be thoroughly cleaned at each flush. The lip urinal may be flushed with the flush under direct pressure and operated by means of a urinal cock attaching to the top of the urinal. Owing to the conditions surrounding the use of the urinal, the known carelessness of many people using it, and the character of the waste entering it, the partitions, backs, and flooring should never be of wood or any material which may corrode. One form of urinal is the

waste-preventive urinal, which works in a manner similar to that of the waste-preventive slop-hopper. The fixture is of such sensitive action that the entrance of urine into the trap acts to form a vacuum which produces Independent syphonage and the immediate operation of the flush."[18]

Mr. Chance's interpretation of this cleansing dream was as follows: "Jung has devoted much time to the study of fountain-symbolism, specially insofar as it concerns alchemy, and, in view of how much lies behind it, he is inclined to the conclusion that it is an image of the soul as the source of inner life and of spiritual energy. He links it also with the 'land of infancy,' the recipient of the precepts of the unconscious, pointing out that the need for this fount arises principally when the individual's life is inhibited and dried up."[19] This can be remedied by a rapid infusion from Walter.

No longer racked by conscience, though still a bit limp from the ordeal covered, our lover acted upon a deviled ham under wood (then didn't know quite what to think of this slip over glass), applied his corkscrew to a good rosé, and wondered if the widow was really his type. Her name he found affected, her shape less than curvilinear, her surface slick. Since meeting her, he had been a shadow of his former self, but now A. Klang of the inner bell brought him to his senses. He couldn't think why he had found himself hanging on her every word, why she had so tripped his imagination. After all, "decorative racks for various purposes are found in *many* styles, and possess charm and interest for collectors typical of such minor furniture. A conscientious observance of considerations of utility[20] in equipping a room or a house is one of the surest means of attaining the fourfold desirable result of *individuality*, *restraint*, *comfort*, and *economy*, qualities which even the most uncompromising utilitarian will unreservedly recommend. It is well to remember that a single piece of *good furniture*, well chosen, is better than six pieces of *poor furniture* ill chosen."[21]

III.

"The value of photography to mankind depends almost entirely upon the truthful records which it gives of different subjects as the eye sees them. Leaving out of these consider-ations the question of photographic manipulation for artistic or impressional effects, it will be evident that the ordinary flat photograph *does not* depict the subject as the eyes perceive it but only as one eye does. In the case of solid geometry, the stereoscopic method will be found most valuable. Nothing is more disconcerting to the student than a mass of intersecting lines, intended to represent planes with different inclinations, when studying rectilinear solid geometry. In the stereoscope method, however, the various planes stand out in their natural positions, exactly as if they were made of thin glass sheets with wire framings. The stereoscopic model has the advantage over actual models that everything can be seen at once, and objects can be shown suspended in space, with their reference, or co-ordinate planes in the back or side-ground."[22] "Still better instances of the power I refer to," he continued to his transparent witnesses, "because they are more analogous to cases to be explained, are furnished by the attraction existing between glass and air, so well known to barometer and ther-mometer makers, for here the adhesion or attraction is exerted between a solid and gases, bodies having different physical conditions, having no power of combination with each other, and each retaining during the time of action, its physical state unchanged."[23] All of which reminded him, once again, of the open windows out of which he stared while humming a famil-iar lay, or air, he had heard on the wireless. ("I love Paris in the springtime, I love Paris in the fall, I love Paris, why oh why do I love Paris...," etc.) Dragging himself back to the present, he scribbled dutifully on a slip of paper: "With reference to (2), it will be seen that the tests dealt with the total transmission

through the combination of the following successive regions, glass, glass-air contact, air, air-glass contact, and glass, with the addition of the two waterglass contacts in the experimental procedure (which replaced only two of the air-glass contacts found in practical conditions)."[24]

Suddenly he was distracted by the arrival, in the teeth of the gale, of Mr. Chance himself, who stopped for a moment to check his attire (he was dressed to the nines, except for the four pins which held an extra pocket to his broad chest, a peculiarity he had affected since a Czechoslovakian childhood). "I have in this day, seen, professionally," he announced regally, "Josephine Boisdechêne, and, in relation to the legal question referred to me, hereby certify that although she has beard and whiskers, large, profuse, and strictly masculine, on those parts of the face occupied by the beard and whiskers in men, and, although on her limbs and back she has even more hair than is usually found on men, she is without malformation. Her breasts are large and fair, and strictly characteristic of the female."[25]

Aghast with pleasure at the news proffered by his jocund friend, the unhappy reader maintained a silence misinterpreted by the other, who virtually threw the book at him: "Caution! This need not be the same as $[(x_0, \ldots x_d) A]^*$, i.e.,* and A need not commute! Be careful when deciding whether or not the collineation * leaves a point $P = [x_0, x, \ldots x_n]$ fixed. There is always one set of homogenous coordinates of P left fixed by the semi-linear map *, but not all sets of homogenous coordinates are left fixed if * is nontrivial."[26] "I can recommend a fine polish for leather. Dissolve enough beeswax in turpentine until it is about as thick as the cream you get if you live in New York, that is thin cream, and you will have a polish for leather upholstery that can't be whipped."[27]

"One would expect that the easiest way of producing a clean glass surface would be to fracture a piece of glass,"

observed the other, somewhat recovered from these unex-
pected solutions. "A simple method of removing superficial dirt
from glass is to rub on the surface with cotton wool dipped in a
mixture of precipitated chalk and alcohol or ammonia."[28]

Mr. Chance now became impatient at his acquaintance's
inability to see through the lady in question. "No, no.
Sometimes you are stupid as a painter, unnecessarily opaque.
Sometimes you have the breeding of a dirty young man." But
then he repented and invited the expert out to dinner with
himself and his nephew Alain.

IV.

As they neared the battlefield on which the restaurant was
located, the two cronies carried on a witty barrage of allusions
to the landscape and to their mode of transportation: "You
know about the Arrangement of Exciters in a Station, do you
not?" said Mr. C. "Attempts have been made to build self-
exciting alternators, but they have been failures, as evidenced
by the fact that there are practically none in service, except
an occasional machine of very small capacity."[29] "An intersex
develops completely as one sex for a period of time and then
changes and develops as the other. If the turning-point of
intersexuality occurs early enough, it will bring about a total
sex reversal: a conversion of potential males to normal females,
or the reverse."[30]

"But sometimes," the other followed handily, "sometimes
each alternator is furnished with its own exciter (either belted
or direct-connected, the exciter in the latter case is often built
into the core of the alternator), but in large stations there is
generally a set of exciter bus-bars on the switchboard, and two
or more exciters (each equipped with its own driver) furnish
power to these buses. In all stations at least one of the exciters

is driven by a steam turbine or engine, or by a separate water turbine, to insure excitation for the alternators if the entire station has shut down because of an accident. If the exciters are driven by motors obtaining their power from the alternators, their motors cannot be started until the alternators are excited."[31]

Dinner was lively, with the bel Alain demonstrating his own wares and discoursing on his trade: "To an increasing extent the sale of fabrics for dresses is being supplanted by the sale of ready-made dresses. The shift in purchasing habits in this matter is indicated by the fact that while thirty or forty years ago the ready-made trade was negligible, in 1921 there was placed on the market more than 167 million dresses representing a wide range in quality of fabric and workmanship, as well as character of design."[32]

"I'll bet," said Mr. Chance with a veiled glance at his friend, "you can't name the manufacturers of the following perfumes: Sinner, Blue Grass, Mais Oui, Nuit de Noël, No. 5, Breathless, Tapestry, Danger, Emeraude, Tabu, White Shoulders, Aphrodisia, Tweed, Duchess of York, Shocking."[33] Alain's score was perfect: "Adrian, Elizabeth Arden, Bourjois, Caron, Chanel, Charbert, Mary Chess, Ciro, Coty, Dana, Evyan, Fabergé, Lenthéric, Matchabelli, Schiaparelli, Polly Perruque."[34]

But in the midst of all this gaiety, Mr. Chance's friend's pain became increasingly visible, and spirits sank.[35] For across the room swept the widow herself in the attentive company of an infamous bachelor.

"The false French seam is so-called because it somewhat resembles a French seam," whispered Mr. C. consolingly. "It is used as a finish for a plain seam in thin or medium-weight material, for the armhole finish, for silk garments, and as a finish for the lapped seam."[36]

"I know," said the younger man ruefully as they walked out into the street. "Some of the sinkers currently in use for any

water are the Bank lead (these have holes at one end to fasten the line) and the Pyramid lead (these are solid lead sinkers equipped with a ring on the top for the purpose of fastening the line to the sinker)."[37]

"Maybe she doesn't know she's Wanted," suggested Alain, sensibly.

"I'll have her by hook or by crook. There are four positions for the eye of a hook: Ringed or straight Eye; Flat Eye; Turned-up Eye; Turned-down Eye. And then there's the line Dreier, a device constructed with open spokes on which a fishing line may be quickly run off to dry it."[38]

"Nevertheless," put in Mr. Chance fortuitously, "there are gamblers who are convinced that they can devise 'systems' to beat the roulette wheel. The manner in which reasoning may become corrupted by gambling is well known. In trying 'systems' which they hope will outwit the bank, players ignore the fact that the prediction of roulette sequences is beyond skill. One and the same probability, if it relates to success, is subjectively overrated, and if to failure, underrated. Thus, a 1 in 7,000 chance of winning a prize would be thought by many people to be favorable, whilst these same people would regard as negligible the chance of being killed in an accident on the roads, though the probability is about the same."[39]

At this, our hero said farewell to his companions and set out for home, grinding his own teeth (which needed a check-up), looking at the single star above, and thinking of his close shave. As he turned into Larrey Street, a veiled figure appeared out of the cold mist to his left, saying, "Sometimes a sticking door can be made to work by rubbing *French chalk* on the places where it strikes the frame."[40]

His heart fluttering, he locked her in his arms and, before the door opened and the spooning began, somewhat ambiguously described to her his intentions: "Being assured that there will be sufficient depth of sand over the pattern, sand is sifted

on the pattern as it lies on the mold-board by means of the riddle until the pattern is completely covered. The molder then tucks the sand around the edges of the pattern with his fingers, but does not press it down on top of the pattern unless there is some special reason for so doing. The drag is next shoveled full of sand and heaped high. The sand is then rammed around inside of the flask with the peen, or sharp end of the rammer. The rammer is held at this time with the butt inclining toward the center and the flask, so that the blow is somewhat outward in direction, compressing the sand at the edges of the mold. After placing the bottom-board, the drag is rolled over, so as to bring the pattern, and also the joint, to the top. When there are a number of molds to be made from a pattern, it is frequently advisable to use a molding machine for this purpose. Molding machines are made in a number of varieties, each designed for some specific purpose. Thus we have the power squeezer and the hand squeezer, the split-pattern squeezer, the jarring machine, also known as a jolt-rammer, and the roll-over machines. Each machine has its particular field in which it will do better work than any of the other types."[41]

The widow, never at a loss, looked him straight in the eye and replied: "On every pattern there is a balance line. This line is always marked on the pattern part and should be looked for and found before attempting to use the pattern. If the pattern needs altering, pay special attention to the balance lines so that their position is not moved when making the alterations. The size of the pattern must be tested, and any necessary alterations made before the lay is attempted. Study the lays given on the instruction sheet of the bought pattern and mark the one provided for your particular size of pattern and width of fabric. A vest should always be worn next to the skin to absorb perspiration. Winter vests are absorbent and not bulky if they are made from fine wool, a fine wool mixture, or a spun yarn of one of the new synthetic fibers."[42]

Mr. Chance's friend "had no criticism to offer on the subject; but he thought this beautiful apparatus was capable of being rendered of still greater utility. Most lighthouses were upon the revolving principle, some revolving with more, and some with less velocity; and others had temporary eclipses; but there were circumstances which were greatly influenced by the state of the weather…"[43]

1973

1. The bachelor grinds his own lenses.

2. James T. Chance, *On Optical Apparatus Used in Lighthouses*, including "an abstract of the discussion upon the paper" (London: William Clowes & Sons, 1867). The research for the following essay has been carried out at the NY Public Library with Marcel Duchamp the librarian in mind at all times, as well as his mistrust of books: "As soon as we start putting our thoughts into words and sentences, everything gets distorted. Language is just no damn good; I use it because I have to, but I don't put any trust in it. We never understand each other. Only the fact directly perceived by the senses has any meaning. The minute you get beyond that, into abstractions, you're lost" (Duchamp). The Readymades in this text are almost without exception unassisted.

3. Ernest Callenbach, *Living Poor with Style* (New York: Bantam Books, 1972). "Style is just what the French must get away from and the Americans cease to strive after; for style means following tradition and is bound up with good manners and a standard of behavior, all completely outside the scope of art. Under such conditions, no new norm can be reached" (Duchamp).

4. A. Frederick Collins, *The Home Handy Book* (New York: Appleton, 1917).

5. J. E. Cirlot, *A Dictionary of Symbols* (New York: Philosophical Library, 1962). "René Guénon says in relation to Taoist doctrine, that the chosen one, the sage, invisible at the center of the wheel, moves it without himself participating in the movement, and without having to bestir himself in any way."

"Use *delay* instead of 'picture' or 'painting'" (Duchamp). "This sentence gives us a glimpse into the meaning of his activity; painting is a criticism of movement but movement is the criticism of painting" (Octavio Paz).

6. Wendell H. Cornetet, Head, Dept. of Vocational Science, Huntington East High Trades School, Huntington, W. Va., *Methods of Measurement* (Bloomington, Ill.: McKnight, c. 1942).

7. G. W. Scott Blair, *Measurements of Mind and Matter* (London: Dennis Dobson, 1950).

8. Ibid.

9. L. Holland, *The Property of Glass Surfaces* (London: Chapman and Hall, 1964).

10. Mary Synon, *Copper Country* (New York: P. J. Kenedy & Sons, 1931). "I've decided that art is a habit-forming drug" (Duchamp).

11. George Ryley Scott, *The History of Torture Throughout the Ages* (London: Laurie, 1941).

12. S. G. Weeks, *Remarks on the Exclusion of Atheists as Witnesses* (Boston: Jordan & Co., 1839). "As a drug [art] is probably very useful for a number of people—very sedative—but as religion it's not even as good as God" (Marcel Duchamp, M.D.).

13. *Snow Removal from Streets and Highways* (New York: American Automobile Association, Winter 1926–27).

14. Richard von Krafft-Ebing, *Psychopathia Sexualis: A Medico-Forensic Study*, rev. trans. by F. J. Rebman (New York: Pioneer Publications, 1947).

15. Cirlot, *A Dictionary of Symbols: Trois ou quatre gouts d'auteur n'ont*

rien à voir avec la ssovacherie.

16. Soon after which he would find himself on his knees (Latvanna Greene).

17. Ellison Hawks, *The Book of Air and Water Wonders* (London: George G. Harrap & Co., 1933).

18. R. M. Starbuck (used judiciously), *Modern Plumbing Illustrated* (New York: Henley, 1915). "It is a fixture that you see every day in plumbers' show windows. Whether Mr. Mutt with his own hands made the fountain or not has no importance. He CHOSE it. He took an ordinary article of life, placed it so that its useful significance disappeared under the new title and point of view—created a new thought for that object. As for plumbing, that is absurd. The only works of art America has given are her plumbing and her bridges" (*The Blind Man*).

19. Cirlot, *A Dictionary of Symbols*.

20. In the case of Duchamp, *une utilité très bougée*.

21. Henry W. Frohne, ed., *Home Interiors* (Grand Rapids, Mich.: Good Furniture Magazine, 1917).

22. Arthur W. Judge, *Stereoscopic Photography* (London: Chapman & Hall, 1935). "I would like to see [photography] make people despise painting until something else will make photography unbearable" (Duchamp).

23. Holland, *The Property of Glass Surfaces*.

24. A. Norman Shaw, *Transmission*

of Heat Through Single-Frame Double Windows, McGill University Publications (Montreal), Series X (Physics), no. 18, 1923.

25. The Biography of Madame Fortune Clofullia, the Bearded Lady (New York: Baker, Godwin & Co., 1854). (New York Public Library card for Alfred Canel, Histoire de la barbe et des cheveux en Normandie [Rouen: 1959]: "pp. 65–86 mutilated.")

26. Paul B. Yale, Geometry and Symmetry (San Francisco: Holden-Day, 1968). "[If] linear perspective is a good means of representing equalities in a variety of ways, [then in perspective sym-metry] the equivalent, the similar (homothetic), and the equal get blended" (Duchamp).

27. Collins, The Home Handy Book.

28. Holland, The Property of Glass Surfaces.

29. John H. Morecraft and Frederick W. Hehre, Electrical Circuits and Machinery, vol. II, Alternating Currents (New York: John Wiley & Sons, 1926).

30. E. B. Ford, Moths (London: Collins, 1955).

31. Morecraft and Hehre, Alternating Currents. "The work of art is always positioned between the two poles of maker and onlooker, and the spark that comes from this bi-polar action gives birth to something, like electricity" (Duchamp).

32. Alpha Latzke and Beth Quinlan, Clothing (Chicago: Lippincott, 1935). "In Paris, in the early days, there were seventeen persons who understood the 'readymades'—the very rare readymades by Marcel Duchamp. Nowadays there are seventeen mil-lion who understand them, and that one day, when all objects that exist are considered readymades, there will be no readymades at all. Then Originality will become the artistic Work, produced convulsively by the artist by hand" (Salvador Dalí).

33. John V. Cooper and Raymond J. Healy, The Fireside Quiz Book (New York: Simon & Schuster, 1948). Because a rose by any other name smells like quite something else: "Women found wit in Duchamp's conversation, elegance in his man-ner and masculinity in his gray eyes, reddish blond hair, sharply defined features and trim build" (New York Times obituary, October 3, 1968).

34. Ibid.

35. See Louis Napoleon Filon and H. T. Jessop, "On the Stress-Optical Effect in Transparent Solids Strained beyond the Elastic Limit," Royal Society of London, Philosophical Transactions (London), Series A, v. 223, 1922.

36. Latzke and Quinlan, Clothing.

37. The Wise Fisherman's Encyclopedia (New York: Wise, 1951).

38. Ibid.

39. John Cohen, Chance, Skill and

Luck (London: Penguin Books, 1960). "The museums are run, more or less, by the dealers. In New York, the Museum of Modern Art is completely in the hands of the dealers. Obviously this is a manner of speaking, but it's like that. The museum advisers are dealers. A project has to attain a certain monetary value for them to decide to do something. As far as I'm concerned, I have nothing to say, I don't hold much for having shows; I don't give a damn" (Duchamp).

"I've forced myself to contradict myself in order to avoid conforming to my own taste" (Duchamp).

40. Collins, *The Home Handy Book*.
41. R. H. Palmer, *Foundry Practice: A Text Book for Molders, Students and Apprentices* (New York: Wiley, 1926).
42. Margaret G. Butler, *Clothes: Their Choosing, Making and Care* (London: B. T. Batsford, 1958).
43. Chance, *On Optical Apparatus Used in Lighthouses*.

.

IV.

New York Times
(1975–79)

Disintegration. At a time when there seems to be less official concern over environmental quality, the faculties of the Episcopal Theological School, General Theological Seminary, and Divinity School declared jointly that "masculinity as such constitutes no necessary qualification for ordination to the priesthood. The basic qualification is not masculinity but rather redeemed humanity." The corner of Church and Canal is a concentrated center of pollution. This example should inspire contiguous countries to establish a similar burden on their alienation. It is a grotesque misuse of language to term as "highly moral" a national leader who has prisoners of war executed on television. Migration, without higher costs, we say, is all very mysterious. The air there at the corner is not satisfactory when breathed in unhappiness. We might all be happy female priests in pollution-free Scandinavia if we could afford to migrate. Instead we are con artists in a high-pollution esthetic with no religion to opiate out of society on.

I keep my typewriter in a wastebasket for fear someone will steal it/me. I throw away time to use it. The sole of one of my boots is edged with dog shit and I sniffle constantly. Not junk, just junk. Everyday living. Not all the soap in the operas could clean these little sidewalks rushing with blood at run hour. I am out of touch with Watergate, the Gulf of Tonkin, Bay of Bigs (*sic*), Pearl Harbor, Tiffany's museum air. A wino nourished on typos. I was more afraid of Hitler in the dark than of Hirohito even though my father was in the South Pacific. Couldn't take the buckteeth seriously. And I'm out of touch with my current way of life, based as it is on working my ass off to support a system I do not believe in, for the sake of those victimized as I am by enthusiasm for some of the System's products. The System, the System, the Wicked Wicked System.

To most migrant birds, this whole continent is "home." I have lived in New York for Times immemorial. I am trying to say something. I like it here. I keep my head high, squinting through the smog, I knock the shit off my heel with a rakish kick and stride to the registered letter line in the

133

Post Office with bands playing in the back of my brain. To block everything else out. I gave up the Staten Island Ferry for a loan to save the city. Despite walls of discrimination that keep women from anything like equal opportunity in public or private office. I have supported myself and my kid for a decade here. The older women waiting in the doctor's waiting rooms do not read. They stare into vacant space. Mass movements among animals, fish, insects, are not unusual; among people they are virtually impossible not to fuck up. En masse. Eight o'clock isn't early enough. Theologically we women beg to differ with logic. My irrationale insists upon the threat of unhappiness. At home lies a man with the covers over his head in a darkened room. He cannot face it but I stride on, tripping over my lost apron strings. My women friends are less prone (Stokely Carmichael notwithstanding) to corner funks, black pouts, and depressions. They just flip out. Noisily, silently, drunkenly, dizzily, dismally. Gone. I saw her yesterday and she seemed fine. Gone. A little edgy maybe. Gone. She missed the assembly where her kid got the citizenship prize. Home lying under the table. Still alive.

Said a woman who runs a giftshop in Hinsdale, a heavily Republican suburb, "I'm appalled at what a weasel he is. How he thought publishing those transcripts could ever help him I'll never know." The new ecology law vetoed last night would have supported weasels too. The shop carries salt and pepper shakers in the form of little wooden "privvies." A face appears at the window of each. His and hers. Yours and mine. I have no separate options. I would miss him too much. A slightly more grotesque version of these salt and pepper shakers can be found at the general store on Canal near Church Street where you can also pick up an erratic watch for NY times, miscellaneous rubber tubes, a plastic Davy Crockett hat, or brown suspenders. If I could change the world, where would I start? Canal Street is the end at Church. Once a stream ran along it but it became a sewer before the Civil War. The War Between the States.

Maybe I've lived in New York too long. A woman of considerable breadth and scope. Once I traveled. I backpacked around the world and camped in jungles and swam in the Ganges and climbed the highest peak in Iceland and braved the Horn in a small boat and got pregnant in Nairobi and came home. Once I lived in foreign countries and spoke fluently several obscure languages I no longer remember except when I dream in them. I can make hot sausage spaghetti with fennel, a good beef stew with cloves, curried macaroni and cheese. My family wishes

I cooked better. I wish they cooked at all. I can sail a boat by myself and have supported a husband and have screwed around and can fix the toilet and lift heavy weights and walk home very late in the dark Manhattan streets sighing for the shadows sighing in the doorways.

1976

Eleven beginnings. Forget the end. A dime with a center and a mask that opens to another masked face. As far as can be seen is across the street. Donors are lured by hard candy and set in display windows with determined courage and deshabille. Watching the numbers run around and the pages flip by, to show the passage of time in a time-honored mannerism. The women shove and haul their shopping carts. Four out of five do not think as they tilt at the curbs. The fifth escapes, groceries tumbling into the gutter as the bells peal and bras vanish. As mud rolls through the streets, as the glass in the tower windows shatters but does not fall. As a cloud of poison lurks prettily above, mocking sunrises. As the colored chips of nail polish collect on the counters. As snot collects on sleeves. As children don't come home from school and dogs are not fed their favorite puppydope. As sugar cereals are banned and. Through the gaping orifices of every edifice, aged to tenement status overnight, comes the crackle of music. Hymns and hearses. Carols and roundelays. The city's sex is exposed, not pink and dripping. Too many sly fucks, not enough absurdity. Too much absurdity, not enough time. The neediest line up for the cataclysm unheard, the needier next, and the needy last. At the corner of Bowery and Delancey Lyons houses roar. The fifth escapes. The eleventh does not. The new world trips fractionally into existence despite philosophy, without science or grace, forgetting epistemology, triumphing in logic. Sitting in the park, drawing no conclusions with a pink ballpoint pen.

1975

Love, save the desert till last when
the snow pudding melts and the
swimming greens begin the plunge
again into people. The city races
into us noisy heels wheeling on
asphalt turn on the radio and rock
a month without stopping. I heard
she was he said they couldn't. Talk
again. The news, wails, overlapping
from windows with the dirt, shit,
drains, who what when impossible
quarrels don't answer the door a
scream a siren a crash a screech
a morning a broken window a
dawn threw stoned a straight head
left watching the grass grow into
blades. The train they wait for isn't
coming. Equestrian statues bird-
bled white. Park cardboard flowers
Grand Army Plaza Burrow Hole
dropped again in the bucket of
excuse me. Do you have the time?
No time. A match? Matchless.
A minute? No bigger than a sorry.
To Myrtle Avenue in Brooklyn?

I don't know I've never had to go
to Myrtle Avenue in Brooklyn.
A gutter full of Legion poppies the
weather was bad for flowers and
soggy sadness past Grant's Tomb
the Palisades while several men
went up in flames on the Bowery.
Boys will be boys. Will be men. Are
better than women. Ask more, ask
less, the city grows its sewers green
chokes its gas lines up yours and
mine. Three Old Ladies Locked in
the Lavatory protesting pollution,
plugging parks, damning rivers.
Tap your city's resources. Tap the
pink princess phones and work out
a nevermorse code. The mayor
said the mayor wept as they took
him away to a private line and the
elevators all went down at once the
escalators went up and I was left
empty in between. Greater New
York. When the prayers settled and
the smoke lifted it was gone.

1976

"Even after years of residence in a big town the Aries subject will feel the call of the wild, will have an innate longing for fresh air, the wide open spaces, the 'feel' of nature... ardent, passionate, quick-tempered, given to volcanic love affairs of short duration... can't stand the meek, secretive and servile.... When life becomes dull and placid, you'll be inclined to stir up mischief, quarrel just for the hell of it..."

Looking down into a long oval bathtub at the naked body of a woman stretched full length under green water, feet braced at the far end under old-fashioned ornamental faucets in the shape of spitting heads. Her arms float loosely at her sides, her breasts, nipples erect, lifting to the surface, are a different color pink above and below the water. A rectangular piece of amber soap floats to the right by her knee. Below it a dark patch of pubic hair grows up toward the surface like a sea plant; her stomach is distorted by the moving water into a freely contoured oval.

Fucking somebody else hasn't changed my feelings about him, but intensified them. At the same time, it was a direct and instinctive reaction against him, his possessiveness. Even now he isn't so much hurt as in a primitive rage at his own vulnerability, at being lied to. No attempt to understand the love involved in the lie or the restrictions on me that led to it. I know he's been "unfaithful." I don't want to know how or with whom. I don't want to dwell on it because it would give him too much power over me. His lies haven't been told and mine have. So much easier to not lie, to simply *omit* betrayals. Why can't I explain these things to him? I'm a writer. I'm supposed to be able to express myself. But I say things I don't mean in the process of trying to say what I do mean well enough. If words weren't "easy" for me I would say less things wrong. He freezes everything I say and won't let me try to say it better. I'm always held to the half-formed and inaccurate. You *said*, he's always yelling at me. Yes, I said, but I didn't say it right and so I'm trying again. It's so bleeding hard to say anything right, so anyone else can understand.

Putting myself on paper.

Putting myself down on paper.

Putting myself down.

Keep writing and maybe I won't

have to talk. I can feel him lurking back there. Everything physical between us is humiliating. The faces I make when I cry. The moves toward each other and then the rejections. The faces he makes when he doesn't cry. I wish I knew how to stop it. I wish I knew if I were afraid of our coming apart, or of defeat. The Waverly Place apartment—fifth floor, small and prim with a kitchenette hidden by louvered doors always left open, a pink tub and green tiles, a large window in the bedroom. I slept on the couch in the other room because once when I was sleepwalking I almost climbed out of the bedroom window. Shared with two other women. They didn't like my friends, who were bums, but literate. I wasn't as clean as they were, and left soon.

(If I love D as much as I think I do, why am I risking so much by sleeping with O? Sexually there was no need for it.)

The Seventh Street place. Eighteen dollars a month. An outside bathroom shared with a drunken Puerto Rican seaman whose wife was flipping out and wouldn't let him in the apartment during the day. He read the newspaper and drank beer and smoked in the toilet. I had chronic diarrhea and had to bang on the door and plead. I shared my phone with the guy upstairs who had a stove, which I didn't have. The woman who got the seaman's apartment after they left shared my phone too but she didn't have anything I needed. She had an ironing board but I'd given up ironing. Except she read out loud from Joyce better than anyone I've ever heard. My parents didn't like to visit.

(The need, more likely, was to assert myself, to convince myself I was or am independent, relatively free to choose for myself. The first time I saw him needing me more than I needed him I felt trapped.)

Four tiny rooms on 14th Street. A little better. We sat in the sink and showered with a rubber hose. When I moved in with him the cabinet under the sink was overflowing with hundreds of filthy socks. Once someone broke in and took only a radio, a can of beer, and a pair of sunglasses. (I liked and admired O for a long time but wasn't particularly attracted to him physically, when I realized we were going to have an affair, though, I had waves of overwhelming desire at odd times, like sitting next to him in a taxi after a good lunch, or running into him on the street. These were stronger than anything I ever felt in bed with him.)

Avenue C. I always enjoyed showing off how I could fix up these holes in the wall with no money and a coat of paint, furniture from the street. Junkies broke in at least once a week but we had nothing worth taking. I hid the typewriter in the kitchen bathtub under a counter of dirty dishes. They threw my poppit pearls

all over the house in a rage. A poet friend jumped out of the window of the top floor apartment that we'd found for him. I saw him go by.

(O's odd wisdom is particularly sympathetic in someone who so clearly doesn't know how to use it for his own contentment. He answers everything in me D rejects and dislikes. I pity O for his weaknesses but admire the way he fully acknowledges them. It takes a certain courage.)

West 25th Street. A short stay. The Excelsior Hotel. "Transients Welcome." Greasy stove and icebox. Window on an airshaft. D left my typewriter in a cab. The shower was miles away along a pale-green corridor lined with salesmen and curious stains. The Broadway Central—another hotel, much later. I ran away from home. Huge broad corridors patrolled by rats. A room with 15 foot ceilings and paper curtains covered with obscene roses the size of grapefruit. No bedspreads. Stained sheets. Beautiful old woodwork around the unusable fireplace. Scary elevators. Later several welfare children died in them. Graffiti on the bedroom walls. One floor closed because of a fire a decade ago. A few years later the whole thing fell down. Making love his toenails scratched me.

(Sometimes, more often now, I feel lousy and inadequate for loving D. I've told him I don't know whether I love him or whether he is just a challenge. At the same time, my feelings for him haven't been affected at all by seeing O. Men won't believe it's possible to love two people at once.)

Broome Street loft. We were alone in the building. Something mysterious and Chinese went on three nights a week on the ground floor. No hot water in the living space so I pushed a sink on wheels with a bucket under it for a drain to the back to wash the dishes. Potbelly stove and Jean Shepherd. A Hotel Butter advertisement printed on the bricks across the street. Great sunsets. Too many flights up. I was getting tired of supporting him and he never read what I wrote. These overemotional scenes prove he still wants me? Sometimes I feel him ebbing away from me and I force the tensions simply to make him acknowledge that I exist. I wish there were a pleasanter way of doing it. "…few women have knotty fingers, for few women are gifted with the talent of combination…more tact than science, more quickness of conception than strength, more intuition than reasoning. It would be otherwise if they had strongly knotted fingers; then they would yield less easily to the inspirations of fantasy…"

Maps of places I've been and haven't seen yet. Projections at best, and all too close to home.

1976

7 AM: Lie in bed for a few minutes listening to the steady breathing beside me and watching the light come through the plants and tensing up with all the things that have to be done/won't get done today. The main thing is to get down to writing the preface for the ARC show—*A Day in the Life*. It's a good idea, but since I won't see the show and know almost none of the work, I miss the stimulation I usually get directly from the art. Of course this isn't as much about art as some shows are. It's also about life. It's about art feeding into life and life feeding into art and (the way I see it) about the positive fragmentation that structures the passion of women's arts and lives. A cup of coffee and some thinking about it. This peaceful half hour is my favorite part of the day. My son and my lover are still asleep and I'm having ideas. I mull this time, in time, on time. Decide to divide the preface into 24 parts.

8 AM: I've made Ethan's school lunch, eaten breakfast with him, sent him off. I take my next cup of coffee to my desk. The phone starts ringing. I dread looking at my list

of things to do. If only I could just settle down to the ARC piece. But first I have to plan a quick supper for friends coming from Washington to see some slides, call the printer who screwed up the margins of my novel and fight about the bill again, call CAPS about the grant application, get the Printed Matter window shows scheduled, read an article for *Heresies* #9, make a draft of the press release for my British political artists show, call *Art in America* to see if I can review the *Colorado Women in the Arts* show...

9 AM: Some of these things actually got done, but my lover has just gotten up and I have to stop and compare our schedules for the day. Who's going to replace the slide projector bulb and who's going to do the shopping? Phone rings. A friend who has cancer is in bad shape. I try to be sympathetic but firm. Today there isn't a minute I can get away. Torn, as usual, between being a good person, good friend, good little girl, totally human being—and all the other obligations. If I go see her I'll be angry at her because most of today's list will drag over to tomorrow and

there is no time tomorrow either and the pressures building are like a monster in the corner slowly chewing through the bars of its cage. It's always about time. Who gets my time? Why do I dole it out in such chintzy doses? Lucky you. You get five of my precious minutes. When I answer the phone, people say I sound out of breath. Time should be a medium in which we float, live comfortably. (Life as amniotic fluid?) Instead it's a commodity. Having made the insane decision to be all things to all people I have no right to complain. It's nobody's fault but my own. My friends all agree that the hardest thing for a woman to learn is how to say no.

10 AM: Finally beginning to write, but still distracted. I'm alone in the house now. I can sense the emptiness, the dim space that reaches beyond my desk (which is in the front corner, by the windows, by the bed) back through the chaos to the airshaft 80 feet away. Time and space coincide, temporarily.

I see that my house is my diary for the last 11 years. It's a compost mound of memory, dead ideas, and those still struggling to get born. Literally tons of paper with words written and printed on it, overflowing boxes of reminders of projects undone. Old and new photographs, thousands of slides of art and places. Pebbles, stones, and rocks everywhere. I can't resist them. I could build a stone hut within these walls. Postcards, offering associations that drift me past the day's work—waterfalls, geysers, volcanos, flowers, people, dogs, and fields, a golden labyrys, a button that says "Failure Is Impossible" and another that says "Dare to Struggle Dare to Win," photos of prehistoric stones and sensuous caves, a quote from Thoreau that says "Beware of all enterprises that require new clothes." A Lucy Stone stamp, lists of lectures to give, articles to write, calls to make, letters to answer, a root coiled like a snake, a compact with tiny cows grazing in it, a sleeve ironing board made into a flower with a shell and ruffles. Atlases and maps. A matchbox containing a book made specially for me and another containing tiny bricks. An Indian shield with the moon and stars on it, a rose, a ring with an amazonite stone, a nest, a corn dolly, a little girl's drawing of flowers, fossils, recipes not yet attempted, friendships not yet cemented, trips not yet taken, a great number of scraggly plants still growing, a card admonishing me to "forge simple words that even the children can understand."

I love my accumulations and I wonder what they have to do with my sense of time. I'm against consumerism and spend very little money on things or clothes, but I'm a pack rat and live in a gigantic nest of clutter. I build these nests around

me wherever I go, thinking each time that I'll make *this* a clean, clear, sparse space, an undistracting environment, and looking around a week later to find it's disappeared. Like the time to clean it up and start again.

11 AM: Not bad. A half hour's work with no interruptions, but I'm hungry. Stop for a piece of toast, more coffee. Won't go get the mail yet; that would mean another half hour gone opening, reading, filing away and another psychological barrier because letters have to be answered or added to the pile that should have been answered months ago. Another wave of guilt. And glimpse of the deadline list makes it worse. Dead line. A dismal term for sending writing out into the world. Writing should be live flashes from one head to others, a way of keeping ideas alive, not burying them in print.

12 NOON: So what does all this have to do with art and feminism? Everything and nothing. The fabric of our lives is where our art comes from—a fact which for me has consistently substantiated the claim that women make art that is different from art by men. Because women's lives are this fabric, woven of so many different strands and often with little sense of what the final product will look like. How many of us are working from subconscious patterns? How much of the art you will see in the ARC show is marked by obsession, or by painstaking detail, or by marks themselves? Or do the differences surface in other ways? I've come to doubt the wisdom of being as specific as I once was about how women's art differs from men's, though I've in no way rejected the idea itself. At the beginning of the feminist art movement, around 1970, there was an unavoidable flood of conscious and unconscious imagery that was biologically or autobiographically associable with women. It was mostly unconscious until a couple of years later, when the notion of a female imagery began to be adopted by feminist artists searching for sources of our own. Since then there has been the inevitable crystallization, stylization of that imagery (some would say orthodoxy). However, it should be obvious that this does not invalidate its contributions to an expansion of human experience. We are just beginning to find out how the non-male half of the world experiences life.

1 PM: Calls start coming in from people who know I work mornings. No, we can't come to dinner. I have meetings almost every night this week and I have to see my family sometime. No, I can't meet so-and-so from Europe; I haven't got time to discuss art anymore. Yes, I'm

still working on the manuscript and will bring it tomorrow. No, I can't come to your studio because I have a long list and have to go down it in order to be fair and there's never time to go to studios anyway because it's all I can do to keep up with the women showing in galleries now. (This should be cause for celebration, not paranoia.) The telephone always depresses me. I begin to drift. When I came back from England this fall, my sense of time was totally disoriented. There, for ten months, I had lived the perfect life. We were on an isolated farm. My son was in school all day. My lover was in another country. In the mornings I wrote fiction and in the afternoons I walked in the fields and moors with Gnasher the black and white border collie. At night I read and watched TV with the kids. I knew only a few people and the phone rarely rang. The farm family next door became my family. When I got back to New York I was still clinging to that life. I was terribly homesick, and for several months I simply lived both lives simultaneously—the one described here and my English one. As I sat at my desk around one o'clock I was also putting on my Wellington boots and setting out with Gnasher barking and leaping in excitement. As I answered the phone I was deciding which direction to walk today and as I wrote letters I could feel the earth firm and soft under my rubber feet, the damp wind blowing on my cheek, the brambles pulling at my sleeve as we scrambled through a hedge, my muscles stretching as I climbed a gate and the dog leapt gracefully through the bars. I took these walks and lived that life somewhere *underneath* my New York times, close to my body, a secret, and for a while it was realer than the life I'd returned to. This is probably as close to madness as I've gotten, but it was pleasant, and I needed it, and it only faded away when I knew I was going to be able to go back to the farm in the spring. Mad it may have been, but it was a successful if melancholy way of having *two times*, of possessing two spaces, of getting what I needed but couldn't have. I suppose writing is another way of stretching time. It takes time to do it but you are also creating another space which will be time at hand when necessary. Making time and marking time. The less people are around the less I feel time leaking away. But I like people! I like too many people! They take so much time! As I write this I notice a note in my son's lousy handwriting across a page of my phone book. It says, "If the characters are not human do they act like humans?" What does it mean?

2 PM: Lunch with Charles. Read the mail. Skim the paper. Try to concentrate on him but it's hard to

tune out work when there's still so much to do. He resents it. I resent his obsession with *his* work, which is so much more concentrated and leisurely then mine. After seven years together we have yet to resolve all this but for some reason the relationship is still a strong one. We figure no one else could put up with either one of us. After lunch is my foggiest time of day so I go shopping, do errands, to the Grand Union which is not such a grand supermarket, to the wine store, the bread store, the post office, the *Heresies* office. Quick chat with the women working there, both of whom I like a lot, both of whom I'd love to know better so I'm always about to stop and have lunch, really talk, but never do. My time is never open-ended the way other people's seems to be. But then, neither is life. Maybe all this anxiety about time is merely intimations of mortality. I dream of drifting away, bound only by delicate cords of timeless love and affection. Stones piled one on another to make a shelter, steps placed one after another to make a path, words paced across a page to make a thought, though the thoughts I like best are more like mounds—some words shooting up here, some there, like blades of grass and flowers at different seasons. Once I felt a flash of pure hatred when I saw a friend's datebook and it was almost empty. "Want to see a movie this week?"

she was asking another friend. I never get to go to the movies. Yet she thought of herself as busy too. Degrees, as usual. Some of my friends are night people and they seem to have more time than I do, though surely that's an illusion. Back to the art show. What are the connections? This text is just another of the threads which, when woven together, make an image of woman's time. Woman's time as a blanket to crawl under.

3 PM: A few galleries on the way home from stores. I like one show I see but increasingly I resent the time I spend shuttling back and forth between galleries because I really don't like all that *much* of what I see and then I feel bad that I don't because I know how much work and hope has gone into each show whether or not it's my personal cup of tea. After 21 years, you really *have* seen a lot of it before, which is nobody's fault, but a product of the incestuous nature of the art world itself, with its lack of outreach that affects the art that is being made as much as it does the audience that sees it. I want feminist art to change this, but it's just beginning, just being nurtured, and it'll take time to mature. What I look for now in women's art is an overt concern with feminist issues and the search for visual images consonant with the importance of these issues. This seems to be

happening more often in film and performance and public art than in other areas, but no medium is or should be closed off. (That's another art world ploy; remember "painting is dead"?) Feminism and women's art have provoked and/or expanded a number of new directions that have influenced men and women alike—among them a new interest in opening "high art" up to the decorative arts and the fiber media, politicized performance, and—especially significant in this context—autobiographical art. Ethan comes home from school, dumps his bag, raids the icebox, and reminds me I said I'd take him to Canal Street to get some jeans. OK, OK. Just let me finish this, I mumble.

So one of the major questions confronting the feminist movement today is exactly to what extent the personal is political. When is it necessary for the personal to be enriched by a broader politics dealing with the lives of others, especially those the world is cheating? In art, as in the rest of the women's movement, it seems crucial to integrate what has been called "cultural" or "spiritual" or "radical" feminism with the Left, or Socialist Feminism. Socialism and feminism are in many ways the same thing. Their ideals are inseparable, though their current realities are separated by an abyss. Both presuppose a collective approach and support system, nonhierarchical leadership,

joint responsibility for all aspects of the world. Because *everything* is a "woman's issue"—not just equal pay and reproductive rights. And while it's true that art may not be able to change the world singlehanded, we mustn't underestimate the power of the image as a vehicle of change. By the same token that a woman can hardly avoid making "women's work" because her social, political, and biological experience is so different from that of a man in this society, a feminist artist can hardly avoid the effect of feminism on her art.

The personal is political because if we don't know who we are and where we come from we are going to be singularly ineffective at knowing anyone else, at working together for change. On the other hand, the danger in an overemphasis on the politics of the personal is yet another wave of bourgeois narcissism—the trap into which women have already been plunged by a consumer society. Our emphasis on autobiography and self is not, hopefully, about self-indulgence, but about an expressive feminist analysis of our common lives as women. Art can reflect to a larger audience the best that feminism has to offer—not just esthetic "quality," but caring and content too—elements without which so-called quality is "merely" esthetic. The days in the lives of the participants in this show will be very different, but knowing our

own days will help us to recognize similar threads in others' lives, and once this is recognized, it will help us to shed the sexist and classist and too often racist conditioning that has built obstacles between women. Taking responsibility for one's own images and their effect (whether those images are "abstract" or brutally realistic), deciding for oneself whether contact is being made—these are important aspects of artmaking that the feminist consciousness-raising and self-criticism techniques make more accessible.

I'm not saying that feminist art must be propaganda (although I do think that art can be propaganda and "quality" too) so much as I am arguing for a feminist sensibility as consciously and intelligently employed as any kind of formal sensibility is normally employed in making art of any kind. There is an analytic thread in even the most "expressionist" or "realist" art. Art in fact is all about choices. And choices, in turn, are all about how to use time, so that analysis of one's own life and the society in which one lives offer the means by which to know more about the connections between art and life, and by doing so, to make art a part of the lives of others.

4 PM: Typically, I'm running out of space. The day begins to unravel. We buy Ethan's jeans and the salesman says he is lucky because his *own* mother was very strict and I'm obviously a pushover. He gets an extra T-shirt and I get myself a turquoise vest on sale so we both go home happy and he changes into his new clothes and rushes off to Washington Square to hang out with junkies, musicians, kids, comedians, lushes, cops, child molesters, and tourists. One advantage to having no time is that I have no time to worry about dope, rape, flunking school, arrests, creeping teenagism. I make a salad of rice, green peppers, shrimp, and curry and a fancy frozen dessert. I'm wearing down. Phone call from friend who has more troubles than I do. Why am I complaining? Can I make this supper stretch to lunch tomorrow, when another friend from out of town is showing up? At least the tour of babble is over for this year. I've given at least a million lectures to recoup the money spent on "my own year" in England. But I'm a writer, not a teacher.

5 PM: Doorbell rings, friends are here. Charles reluctantly turns off the TV. We drink, talk, see slides of prehistoric sites. I try to sew the strap back on a shoe, wonder if my company notices how filthy the house is. I've just done a fast job on it, but they probably can't even tell, because there's still grime in the corners of the bathroom and bits of food on the kitchen floor and the stove

is black and greasy and the coffee table is overflowing with books so some inevitably fall to the floor if you try to put a glass there too.

6 PM: has gone by already.

7 PM: We eat. We talk about traveling.

8 PM: I kiss everybody goodbye, nag Ethan about homework, go around the corner with Charles to a friend's first myth-telling performance. A luxury—to sit passively and listen, watch, while ancient tales of women and magic and good and evil are spun before me. No wonder oral history is a thing of the past. I don't have time to listen instead of reading, skimming, at my own mad pace. Afterwards I'm talking to another friend who says she doesn't know where the year has gone. Neither do I. We realize we don't even know where the *decade* has gone. It seems the seventies were just beginning and now they're over. What have we been doing all this time? Both of us have "made it," but was this what we wanted to make? This layered life so dense, so intense that distinctions get lost—not to mention friends and loves, books and paintings? We've overaccomplished, both of us. What then are we commiserating about? Nothing much has changed, is what we're saying.

11 PM: Home. Watch the news with Charles. Ethan to bed. Me to bed. Nothing left of me. I avoid looking at the phone messages lined up on the desk. Maybe tomorrow I'll be able to cope. Read five pages of a political biography of Shelley that's been my nightcap for months, and sleep.

12 PM – 3 AM: Wake several times to tune of screeching wheels, sirens, calls on the street. The bakery workers who load pies all night holler to each other at the gleeful top of their lungs, crashing metal carts into each other. At three comes the garbage truck, louder and louder. We both wake every night at this hour, tussle with the blankets and each other's bodies, curl up tight, drift back to sleep as the noise slowly subsides down the block.

3–7 AM: Dreams. I dream a lot. Dreams too expand time. I don't waste time asleep either. I dream that there's time to dream.

1979

Lunch I

We certainly expected to like each other.

It was just a matter of meeting. Feminists like and admire each other; I am familiar with the psychology of expectation. Clean the round white chipped table, the toilet, straighten the piles of unread books and magazines, make a salad with Boston lettuce hardboiled egg tomatoes leeks lemon juice, add herbs and sherry to a can of shrimp soup, lay out sour cream, cheese, bread, white wine—a big bottle for a long talk. Brush my hair twice. Change my sweater again. Answer the bell. Hear footsteps slowly climbing five flights.

We kiss before we get a good look at each other.

She is smaller, older than I expected. Am I older too? Frail, worn, flamboyant. Long dark hair and long jangly earrings. Other jewelry. I never wear jewelry except two heavy rings. On strong hands. Dark deep-set eyes. Lines, wrinkles. Smallboned, intense, open but anxious. We like each other's looks. She is not like me. Her writing is not like my writing. She is not afraid of overstatement, sentimentality. I am. I dole out my romanticism in very small doses. She is Jewish. I am a WASP. We are both generous. She is culturally and politically involved in Latin America. There is even a febrile Latina quality about her. I am Northern, unwillingly hermetic. I don't notice her breasts. Matronly? Childish? It is a body that could house either. We beam at each other over purple pottery plates.

She has written about women's conversations. As patchwork. The things I've recognized in women's lives and artmaking. Open ends. Unraveling. Interruptions absorbed. No need to finish sentences. I. You. Trailing off unfinished as soon as the other

153

understands. Then another trail laid. Conversation as a chain of clues. Open to interpretations. No need to spell it all out. Yes. Eyes. Hands. Right. I know. And the… Yes! You know. Me too. Patchwork cover. Knees humping up under the quilt. Not enough time to search the inches for scars or blemishes.

She is a faience bead. A shard from Copan. A hank of hair caught on the ladder. Thin knotted fingers. Graceful gestures catching in the fringe. The plump silhouette of Silbury Hill cut down to bone. She is fond of hags, crones. She is a believer in healers. She is probably a witch. As she sits across from me she is aware of a lump in her breast, unexplored. Picks at her food. The table is strewn with crumbs, drops of wine. We babble excitedly. Wave our hands. Interrupt each other to get at the necessary sequitur. Tangle each other in the webs of lifetimes. We talk about our sons. Find it difficult to describe our lovers. We never quite get through to each other. We never quite satisfy our need to know the other through the interstices of projecting ourselves.

No. She is tall, fair, slow to talk. Moves with clumsy deliberation as though she were outdoors. Eats everything in sight. Listens, nodding. Finally talks too. Slightly singsong. Hard to focus on what she is saying. Blushes when she says she is religious. On the streets men follow her. She is afraid and wears sneakers when she walks home alone at night. She is gentle and opinionated. Knows a lot. Modeled once for a living. Big bones, bad legs. Doesn't seem the type.

On the contrary, she is my height with curly brown hair and small pale eyes. A large chin, beautiful full pursed mouth, nondescript nose and long shapeless fingers like melting candles. She squints when she is excited about what she is saying. Leans forward and breathes on me. Her breath is sweet and sour, tobacco and lemon juice, love and rancor. She is argumentative. Doesn't want me to think I have the upper hand. But will grin at the familiarity of it all.

Perhaps she is extremely plain, as they had told me.

A coarse orange poncho doesn't help. Her skin is mottled from teenage troubles. Not so long ago. Luminous eyes hidden by glasses the wrong shape for her long pointed face. An accent I can't place and a voice that moves in heavy waves over intelligent perceptions. Lank mouse-colored hair like mine. Nervous laugh entirely at odds with the resonance of her voice, her words. Big hips. She sits comfortably and picks at the skin on her face when she listens.

Then again, she is gracious, abstracted. I can't get her attention. Our correspondence did not parallel our encounter. Ran counter to the lines, the words thought out ahead of time. She has style. She is much taller than I am but makes me feel large and awkward. She is the kind of woman I used to dislike because of envy. Now she may respect me. Her gray-green sweater has wide flowing sleeves, one rolled up above her elbow, the other falling over her wrist. Her arm is smooth and white and invisibly downy. She wears an antique gold ring with a tiny emerald, tiny ruby, and tiny sapphire in an inverted triangle with the ruby at the apex. I have never seen anything like it before and stare at her left hand. Her nails are cut, shaped, maybe even polished. Mine look like they are bitten. In fact they are clipped.

She admits that she is tired. By way of apology. I can feel my own center diffusing. Rambling. Not talking in staccato fragments—each implying more than said—but in blurred resigned flat patches torn from the same dull cloth. Accepting defeat, lacking energy. Across the round white table. She can't eat the cake. I am piling crumbs in nervous patterns. She has cleaned her area. The crumbs must be in her napkin. They will end up on the floor but her part of the table will be clean. We will try again another time.

They are all my friends.

1970s

155

She says she didn't feel alive till after she was thirty.

She says she would commit suicide before she would go to a shrink.

She says that her older brother is famous and so she can't be.

She says she learned to swim when she was three.

She says that her grandmother would have been one hundred this year but she died.

She says that she has never been so happy as when she was an adolescent.

She says that summer depresses her.

She says she is marking time.

We agree that travel means something different to men and to women.

She says that she puts raisins in her tunafish salad.

We think we are funny.

We despair of the lines cast out and uncaught.

—

She says that when he smashed the glass underfoot at their wedding she had a terrible premonition. That her favorite typeface is Futura. That she began to menstruate at twelve. That she got an A in math in the eighth grade.

We argue about the extent to which middle-class women can communicate with and share the goals of working-class women.

She says she is not that kind of feminist. She says she finds out about herself by working with others.

She disagrees with the prevalent notion that one has to wallow in the self before moving out. She dislikes self-indulgence. She makes me feel selfish and inadequate.

I say that knowledge of self has to precede communication, but I know it can be extended in the process of communication.

That's what she means, but more so.

We agree that to sleep in clothes is to set up obstacles to our dreams.

We agree that logic is only logical if one chooses to subscribe to it and that otherwise it is illogical.

Yes.

—

She says that her mother died when she was fourteen. They fought a lot and once she threw a chair at her mother. Guilt has made her superior.

She says that she hated the movie *3 Women* but she likes Sissy Spacek and the other one, the one with a French name all my men friends are hung up on. Shelley Duvall?

She says that she has read all my books and I am her idol. The word "dolly" comes from idol. I am embarrassed.

She says she is all for women but won't call herself a feminist.

She says why can't I call myself a Marxist? I'm too lazy to read more Marx.

She says that he makes her nervous because he expects too little of her. That she isn't as good at doing anything when he is there as she is when she is alone. She says that she held him up and he held her down.

We talk about our sensual attraction to rocks, hills, animals. We speculate about whether our grandmothers could ever have met. She says her psychiatrist is white and can only offer white solutions. We agree that androgyny is an evasion of the issue.

She says that to claim every private act is political is a cop-out.

She says that poets can write prose but prose writers can't write poetry. I say that the only plot I can write is a life.

She says that Lacan would have been a better model than Freud.

That the parameters of epistemological hooha will be stretched.

That systems theory can be applied to the emotions. She says she is allergic to talcum powder.

I confess to a romantic conservative nostalgic reactionary reformist core which I am constantly trying to exorcise. She senses I don't want it confirmed.

We analyze trivia. We avoid value judgments.

We compare the things that make us angry. We discuss the vice of holding grudges and the way men sulk and how women can't afford to.

We agree that we are lucky.

We disagree about what the next step should be.

We wonder what will become of us.

—

She quotes Dorothy Richardson from a little blue notebook with a postcard stuck on the cover—a photograph of three Victorian women with their hair down almost to the floor; they seem to be three generations; the youngest has the longest hair: "That was feminine worldliness, pretending to be interested so that pleasant things might go on. Masculine worldliness was refusing to be interested so that it might go on doing things. Feminine worldliness then meant perpetual hard work and cheating and pretense at the door of a hidden garden, a lovely hidden garden. Masculine worldliness meant never really being there; always talking about things that had happened or

making plans for things that might happen." I had nothing to say.

Warm running water. A band of puffy clouds around the horizon. Blue sky above it so the sun only shines at midday and then slips down into the mist.

She says that when she lived alone in the country her happiness was totally unselfconscious. Nobody was watching. It just was.

She says that she always liked to dance to the Rolling Stones but when she saw them on film she hated their brutality and arrogance and could never dance to them again.

She says that all the time they were married he said "I" and she said "we."

We agree that we are lucky.

We disagree about what the next step should be.

1970s

Far and away the most wholesome thing to take at this time of life. Bouncing up and down on Daddy's knee was nothing like it. The point is to expand relationships, to blow them up bigger and bigger, to stretch them out wider and wider and to forget about the breaking point. What kind of pain is that, anyway? It's more like being born than being dying, so he says. But she disagrees. In principle. We're at a stage when disagreement is compulsory. Or compulsive. You sit across the table from me and I see tears come to your eyes. Don't cry. Don't cry for me. I'm going to be fine. Just Fine. As soon as I.... We hadn't meant it to be like this. I was supposed to comfort you. I hadn't told anybody and wasn't going to. All these tenses past now, because I seem to have told you. What happened to my stiff upper lip? It was fattening. I don't want anybody to feel sorry for me, I just want oceans of sympathy, compassion, respect, affection, love. That's all. Just leave it by the door when you go out and I'll take a look at it when I have a minute. But if you pass it up I'll kill myself.

Don't look so alarmed. That was a joke. Let's change the subject. I'm on the Brinker tears, my shining blades poised on the icy edges reaching for the National Velveeta, well processed, like me. I have my own bottling plant. You didn't know that, did you? Under high pressure. Please don't cry for me. I'll survive. We're both survivors, aren't we? You did, I will too. It's only the children I worry about. Want some coffee? I never complain. I have my own boiling point too. I'm sick of your sympathy. Shove it. Back to where it came from and if there's no room there buy a palace. The boilermakers are pounding

at my doors but I think I've swallowed the key. Crafty of me. You'll have to go now. I can't take anymore. I have to give for a while. You understand of course. But don't call me. I'm going to be very busy for the next few millennia. You should never have let me know you knew.

<div align="right">1970s</div>

V.

Placings / Replacings
(1975–78)

For reasons of their own, women are suspicious of diving and frown on their menfolk going down. D——, who has starred in several underwater films, has never received a fan letter from a woman.
—Jacques Cousteau

We are already down there. We have already gone down, our breasts bumping the boulders struggling to rise. Our menfolk don't know where to send the fan letters. Can dive, but not delve. Perhaps far down are boundaries between layers of water not obvious at the surface of the sea and quite independent of surface phenomena. Not just still waters. Rapture of the depths. At a town called Headtide there is an old white church unconsciously marking with its spire the spot where the Sheepscot River, short and wide, a tidal estuary, comes to an end in a stony brook and then goes underground. The term "tidal wave" is loosely applied. Some rivers braid long plaits of sand with thinning streams, and others—always full, muddy, and sated—lag in fat banks. Tides are most marked when the sun is nearest the earth. Tides thigh tickling, oozing over the edges and hummocks, a band of foam, making liquid land. Creeps up me toward immersion. Hold your waters.

Making waves, seeing red. I flow she flows we flow. Lunar and solar tides coincide, are fully cumulative only twice each lunar month. While fans unfold, snap shut, and leave the flowers no escape. Underwater, irregularities rise and, cursing, fall. Two or more wave patterns at the same place and time. There can, however, be independent waves. And long rivers pass

167

through different landforms like changing lovers. Impatiently
cutting gorges, willing waterfalls and rapids to flatness.
Unfamiliar bodies hurled at each other. Beneath the rumbling,
boulders lurk and lurch, needing a pool.

—

My traveling dreams are washed in foreign waters. In one
I swim along a beach. The water is warm and the same pale
blue as the sky—bleached but not burning. Behind me swims
a large black dog and before me floats a group of exotic birds,
brilliant pink feathers wet but still light, raised above the
water in a tangle of wings. The end of the beach is distant; all
sand, no rocks or trees in sight. My swimming is leisurely but
purposeful. In another dream I wake alone and rush to find my
lover. He is in the bathtub and I yell desperately at him: Did
I sleep alone last night? Did I sleep alone last night? Another
night, my child, my lover, and I are going to see a lighthouse
through a swamp. The waterway is not very wide. Trees hang
dense over the edges but in the center where we swim it's blue,
unshaded. A long trip to make boatless, but we are swimming,
accompanied at times by a fat friend. I'm not struck by the fact
that we are swimming so much as by the length of the trip, not
tired so much as a little bored. Once again the water is tepid,
body temperature, lulling. The lighthouse when we get there is
on a broader bay, still inland, mountains in the distance. There
is some talk of leaving and returning in the afternoon. But
there isn't time.

—

The waters broke with no warning. Lie still, pretend
while it crests. Above our caves the divers' forms pass dimly,
unaware. Destructive advances of the sea upon the coasts have

168

two distinct origins: dreams like sunwarmed flats when the tide comes in very slowly, visibly; earthquakes and storms. Neither related to the tide, and often not actually waves. Floating, I am a fleshy layer between sea and sky. Why go down? Letters melt and corals build. Why go down and not feel the moon in the pit of your stomach? Or hear ripples whisper on the floor? The ocean's bedrock blurred. Unexpected, the cold and purifying northern channels. With no warning, water on the brain, the belly, breast, and buttock. Internal waves stained pink affecting everything below above. Doesn't hold water, that's all. Divers ring their bells but fail to reach us, cannot pierce the bubbles that contain them. And we are already down there, friendly, calm, constructing small places in which to wait, making room for others, settling in, exchanging disguises, rearranging caves and mountains, waiting until they stop pouring oil on the waters, till they stop throwing rocks, sinking ships, turning our tides.

1976

The seed, traveling, passed by ignorant ships, growing up on another shore. Scientists wonder. Eleazar Cornbear was born in Aspect, Wyoming, was married in Paris, France, and died in Oklahoma City at age 98. These weeds, curling over that rock, under these waters, again. They tell her she looks like someone from another century. Is it a compliment? She recalls her grandmother's lean face and covered wagon stories. Maybe. Saltwater moving over these rocks in the same place but not at the same time, not the same way it moved the day before over the same rocks. Your great-great-uncle passed through town, but they didn't meet; he wore a red scarf which he lost a month later when it caught on the branch of a pine tree as he rode by.

—

It couldn't have come from here. Maybe it was carried in a pocket, smoothed by hand for a lifetime, then dropped here, to start all over again. I knew he'd say that, because I'm his mother. A smooth yellow rock, almost egg-shaped, nudges for an instant a flat gray slab. Never again? My grandmother did his laundry. He didn't pay. We don't know about it. Glaciers carried them from as far away as 300 miles. Fragments of the same matter, with different histories. Fourteen cousins who never traveled more than 50 miles from their birthplace. He met them too, casually. Their names all began with the letter D. The sea always looks the same, but changes according to the shapes and surfaces over which it rolls, the barriers

171

it attacks, what it takes and kills, what it nourishes and is poisoned by. This Frenchman's aunt was a governess near there. Really? Yes. Why not? Found a red scarf in the woods and used the wool to knit mittens for her sickly pupil, who later took a hoe to history. One son was a marine, a fisherman, an oceanographer, drowned. A compound of very different kinds of rocks making a new kind of rock if they stick together long enough. It was a grand affair. Ended only by war and cataclysm. The same tornado that wiped out your distant cousin's crops and caused him to go to the city and meet a Russian governess who taught French badly. This grain of sand lay next to that one once before. Under the feet of the first amphibian.

—

1875–1932. We felt as though we'd known each other forever. The longer we knew each other, the further apart we grew. We were very much alike except for…Then there was a midpoint, when our backs were fully turned to each other, and we started to move around to the beginning again. Best friends in grammar school. Class of 1901 Colorado College. Died within a week of each other within a few miles of each other in the state of Massachusetts. Hadn't seen each other for 56 years. These black roots that look so much alike have never touched before, but now I have taken both of them into my pocket, near my skin. True? I am the great bringer together of all things. Give birth to new combinations of everything. Might be brother and sister, might not. Only spoke Russian at their deaths, communicated very little with the youngest generation. These weeds curling over that rock under these waters, again.

—

I liked his looks. Put myself in his body, with a soft weight between my legs and a floating torso. Cried when he left to seek his fortune. Kept a mottled stone in my apron pocket as a talisman. Threw it in a raging stream when I heard of his marriage. Me too. My god, me too! It must have happened when the continents were closer, before the drift began. The closed faces of men making love. Making connections in a void. It's a lovely shape, isn't it? Like a melting snowflake, like a vulva, like a vegetable, like a starfish, like an opened book, like a double shell, like a boat, like a house, like a beetle, like a map. I put myself. I put myself in her place. Damp, and cried. That one isn't natural. Couldn't have come from around here. He never found an arrowhead, though he looked in the dirt all his life. Mnemonic devices that don't work. This one I found when I was a little girl, in Maine. That one came from New Zealand, 30 years later. This one, I can't remember. Did she bring it to us from New Mexico? Is that scratch handmade?

—

This undistinguished lump of once-earth has circumnavigated the globe. Used to be on fire. Used to be fluid. Used to be part of a majestic form that attracted attention. Used to be part of a pleasing shape that inspired affection. So it's only a matter of weaving rays together. The times and the places, the identical emotions and same situations and similar positions and parallel motives. Almost the same again. Scars invisible. A globular mass made up of all the vortices from all the people in this room at this moment, entangled. Their pasts, where their pasts passed each other in the streets somewhere, in the night, on the waters, seeding.

—

I know exactly what you mean. Do you? Yes. He was re-
lated to one of them, stayed in touch. The one with the funny
name. Began with a D, or was it a C? In the cities. The rocks
under the cities. And the courthouse is built of stone from an
island quarry near where I grew up.

1975

In one month, in another country, I slept in 17 different places; all but 4 were people's homes. I wove myself in and out of 13 different lives and pairs and groups of lives. A different self stretched 13 ways until I hardly knew which one to pull back toward the center next, which conversations I'd had with whom, what anecdotes opinions fantasies I'd told already where. From these points I peered out at this land too vast for photographs descriptions or reasonable generalizations. Dreamland. Its natives exist between Dreamtime and nightmare. They know the topography of the places their lives take place in, and they know the distances between now and then. Skies and emptiness and trees spaced precisely across endlessly unfolding contours waterholes and watercourses for the thirsty. Ancient trees with peeling bark and white skin and rusty trunks and branches so heavy they crash back without waiting for death. Green muddy rivers with broad slow banks of red sand. Gray yellow hills and foliage. Black stumps where weeks of burning did not reach the core. Perverse and poisonous and pathetic spaces. Convict built.

Rich fruits and stinging insects. Aboriginal people awake by fires in cold dawns. A gap in time. Tin roofs and termite castles and cockatoos and taipans. Lush and fearsome. Dry and distant. Caves of memory ochred into the skin of the rock. I only saw the surface. But would I have seen anything else after years in the bush?

A house with red walls engorged on paintings. Dancing? Downstairs at five in the morning. Covered sidewalks. Rain. The sensuous narrative maps of the Papunya painters retreated

175

from bark to canvas-board. A red-faced man in tie and blazer threatening to break our window with an iron bar. Warmth, women. Social ineptitude. Invasions of publicity. Rolls-Royce. Seeing my lover and friend two years younger on black and white film and wanting to reach out. Synopses. Blue mountains out there somewhere. Three Sisters draped in fog the Paradise Café and grilled bream.

Invisible Tibetan fighting fish and Captain Cook's footprint retained in sand. Spaghetti and intimacy wondering if I were there longer.... Security insecurity public private chauffeured cars and pinned up pants.

Airlifts chocolate bars noise wooden fan in ceiling, Norfolk pines, yellow brick suburban incongruous Glasshouse mountains. And a wave, more than one, broke over us as we walked home along the beach in the moonlight before I got sick from social exhaustion and couldn't eat the lovely prawns and threw up and slept a fevered sleep and was ok the next day. Home Warren movies grayhound tenting Ayers Rock looms. Holy Joe's Queensland—home of the flying art school. A kiss from a woman critic who is supposed to be a terror, a ring from some students who didn't altogether agree with me—a green Australian touchstone that is the same color as my Zuni turquoise. Applause, repetition, smiles, hysteria, escape. Miraculously a long white empty beach a swim (slimy underfoot). "Only tree snakes here," a mattress on the floor while in a flowering tree outside the window all night long the fruit bats squeal and feast. Behind the beach the rainforest and walking at sunrise the moon and the sun at equal strength reflected in a murky lagoon. I fly in a tiny plane over the rainforest and over the dry forest and into flatter land and hills and yellower trees and Quinkan country—spirits and gold and betrayals. A 19th-century man. Tin sheds, red roads, and the generator's rhythms with 20th-century ideas. Sitting along the river at night talking about the future of this place.

I think snakes. Hear a crashing on the roof. At breakfast they say it's that old carpet snake. A rotting dilly bag made with love and tiny patterns found in the corner of a cave—a few beads, a Chinese silver spoon, the beginning of a new bag, a yam stick abandoned. All she had. After we wade across the river where the crocodile watches he takes out an ancient gun found in a limestone cave from gold rush times and wears it in case of wild boar. Clambering up steep rocky inclines. What if? Stand behind me and hope I shoot straight. But what if it's behind me? Frown. We never see the boar. Instead the caves, shelves in the bush where life was lived on a grander scale than we can understand now, undulating serpents flattened crocodiles striped fish and dissected kangaroos and the Quinkans with their arms raised, mouthless motionless purposeful.

I shouldn't be here. Women not allowed. Dark and cool and eerie. They're helpless now. I'm sorry. Crossed arms and gaitered ankle over shorted leg I'll just stay in your photograph to give it scale. Satyric enthusiasm. Layer after layer, images from the ice ages on, how life went here, and has stopped. Chill. Grasses green ants stumps and rock piles seductive rivers filled with reflections to the brim and clear and potable. Clusters of Black women just beyond the light not at the bar but waiting outdoors. Whispers and bargains and disappearances into the bush. Fires near the sterile government hot boxes. I'm invisible. Meals in kitchen silent and businesslike. Man's world. Those two are prospectors. That Black teenaged cook has a child by the schoolteacher who is going to marry her in one year. Why in one year? That one lost his stock, his station, runs the pub. Bleary but kind, uninterested belly hanging over beltless shorts. Whitehaired skinny old man barefoot in ancient truck, toothless, plays with the Black baby. Dust. Heat. Four mango trees for shade pink bedspread and a knock on the door at night.

Flying away again. Mysterious time. More airports. The Royal Soldiers Home—gin and tonic, old men and fish. Purple bedspread over unchanging desert landscape. But it does change. Recognize the color borders from the Papunya map-paintings, see the pattern and expanses they know how it is to fly from the ground. Red, pink, gray-green nothing. On and on and on. Women's places Laura, Alice Springs, and Adelaide. Drunk despairing natives staggering the few streets a new post office the women saddest small flat faces giant brows slim bodies "it smells of abos here" an anthropologist who lives from picking at their past says. Coral and Nilita survived the Darwin cyclone, knew it was real because the animals were frightened, hid in the pantry, and the cockatoo screamed survived.

Ayers Rock off film is real and steep and I force myself to petrified climb and looking down dizzy will fall there are plaques where people have but I don't and I have the top, the long walk across its spine, all to myself. Alone on Uluru, which is the center of the country and a history. Alone one rock in the desert. Why? Once a sea, a waveformed cave with paintings. The largest rock in the world a single solid lump of presence. A magic place. I walk back down its face with utter confidence exhilaration; a different walker. And chasms and gaps and red rock and strange agglomerate magnetized by unimaginable forces too long ago and almost missed the plane and camels and Pichi Richi exploiting history in cheap facades like teatowel controversy. My own time over. Dread the onslaught of auditoriums again. I am seeking approval? Love? Needing to please? Spreading the word and the imagery. (Needling to please.)

Out of the center and into the "center" where the government sits on its ass and has its problems every morning punctually at 10. A bland city of public servants too pretty too patient too pallid, no poor to set off the rich, no squalor to set off the

luxury. What's the use then of having luxury—compared to who is one well-off? Remember: "Even if they say that you never had it so good. That is still a slogan of those who have much more than you." They are thinking of painting the walls, but not as a protest, but maybe as a protest against that blandness created by themselves? A warehouse full of treasure trophies from elsewhere very little from here altho in other places churringas and toas and warmeras and shields are also much sought after. Some beautiful things on shelves. A million-dollar painting made by an anguished poor man. Corroboree on tapa cloth. Such a nice smile, easy, crisp hour's drive. A fat man with a red face and a cap capable of meanness making windows, making garlic mayonnaise in a plundered brick hotel with highest ceilings, frequent fireplaces, old guests' graffiti pigs geese ducks and cats and green hills and gum trees and a creek and in an empty room upstairs. He comes to play his fiddle and his wife her concertina. Old faces, old tunes, since the truck smashed the wall of their house but luckily they weren't home. Winy jigs and singsong 3 am click click click boys through the 'ole in the elephant's bottom and I sleep on a cozy mattress under a cozy comforter next to a cozy fire too drunk to enjoy it for long. Sun in the morning a walk along the creek and two lectures, make it through, well worth it. Another earth woman as real as Sydney's and I can thank the *Woman's Weekly* in this case.

Learning how to take 15-minute naps sitting up if necessary pleas for rest not heeded, everybody else feels fine, feebly I'm right but I'm hitting the proper pace now, enjoying most of it only the repetition that gets me down. Pleasant house but in wealthy suburb too bad for radical explanations and apologies unnecessary because affection obvious. My third borrowed bathrobe, not the last. Terry cloth appropriately and blue while Tina's is purple my favorite color but that's OK it's just to get in and out of the bathroom with. Vermouth keeps me talking.

In the Q & A, a sculptor with a double name says all the slides are homely and wifely hisses from the audience some other man says retrograde. It's not news to me but going from white delicate scratched paintings and number mirrors to object people prints to horses dogs and people to patterns moving into landscape to waves of color also moving into landscape and good interiors sandwiches wine by a woman vintner tinted photographs of standing by the sea and windows looking in and out at women gingerbread houses and a marriage myth and an abortion and a train scream and a naked girl and questions with no answers and painful canvases of loneliness and earth worry and a mad old lady holding her skirt over her head and lickable lollies of portrait and rainbows and arches and sensuous folds and dolls. Bright black eyes a kiss, more dolls and stories and crowded life and a boy for my girl to keep company. How do women stay young and strong and beautiful and lonely and old and still so soft? I'm being imprinted by so many lives. Learning not to resist that gentle touch which means someone is making their mark on you.

And a dark ride to a pool table and past giant boulders and into a wood and blue balcony and early morning walk along the billabong which I always thought was just an ordinary stream. More gum trees different, a boat to Barmah and poor boatmen back in the rain and dark lost near a brush fire and emus and more gum trees and muddy snake trail of a river and I'm on a horse alone around the red sand hills sitting on yellow ground why? Men of the Murray transposed on the tribes' lands and flood marks on the trees.

Tasmania sounds exotic but is more familiar than the mainland except for the light, the weird red light at sunset (Glovers Gold), the ubiquitous rainbows. The weather changes in flashes and chases other weathers across the sky all day and I suppose all night. Spreading old brick manse on top of hill with topiary and white gingerbread. New fruits and vegetables

180

yellow stone houses and lunch on the beach at Penguin.
Glorious forests mountains skeletons only left by mining,
logging devastation, thousands of gray toothpicks—towering
deaths and holes torn in hillsides and sulfur-harried growth
and red pink purple black ochre lurid lovely Queenstown
with brawling bars and glowering skies. The west. I skid too
fast past rainbows and end in the ditch twice very very far
from anyone or anything. Mists like velvet vapor and sudden
clearings swamps and rushing blue mountain rivers and yellow
hills and green ones and nobody and nothing near. Eerie ride
exhilarating, dangerous dazzling delightful doubtful daring.
I love the moment when I have my avian vehicle and a couple
of violet crumbles in case of fatigue and take off alone into the
wilderness stop when I want, take walks, whistle sing think
shed people get lost, down to the almost very tip of the island,
as far as roads go and walk on Robinson Crusoe beach leaving
names of my lover and my son in the sand. Pick up shells, pee
in the bush, always with a flower on the windshield—first
yellow, then brilliant pink nothing I've ever seen before, hair-
raising turns on little dirt roads and get there in time to eat,
give lecture mussels musclemind. And afterwards wine, un-
escaped interview in lowceilinged old old house with original
wood and not too decorated and sleep in bed with a bright red
blanket and a morning view of the sound right out the window
climb down and dabble in it though winter. Old stone houses
yellow gray and quaintness almost out of place that far away
from world but settled in.

Tall dark, not quite pretty Belgian and Chinaoriented man,
two wives they seem so ordinary at first. By now I'm used to
shocking fragments from passersby the casual confessions of
the traveler sympathetic. My own tales to tell, but no time.
All the women seem to work, even the most housebound
pretty conventional in appearance "do something" even when
I forget to ask, pig that I am.

Sniffling, sore, and feverish at one end, bleeding at the other, make my way through two more airports, two almost blissful hours doing nothing in muzak padded yellow upholstered blueish ill-defined space 4 more talks to go. Half dead, reject reporter, revived by amazon who feels big when we dine with little people though 2 days later I feel little when traveling with her and Terry in sneakers and unaccustomed uplooking. More warmth there's no end to it almost wish I were meeting some horrible people. C says I'm too easily pleased but I like! I like! Almost love in some cases—not sexual but nearly total identification. Strange being dropped so intensely into others' lives; feel I have some effect there but probably wrong. Sweet jelly in a dingo's cap wingeing and grotty and sure what he wants. And weavings and romantic intrigue and politics and chauvinism (male) and a song about attempted rape translated as pro-female and an anti-American skit where I get stepped on justifiably and a good feeling of camaraderie and old-style caring politics but where does it belong here and now? I love them and worry for them. Not so young and noble and willing and then what? Poetry and prisons and practical questions a kind of innocence at the ramparts. I wish I too, oh I do. But I'll go away and things look different over there, worse probably. Crowds at tables drinking wine nice people, how many as strong as those two who aren't speaking? Not many, not anywhere, like or dislike I may.

Several times marooned in puddles on an island, seals and greenblue water surf under gray clouds and momentary changes rain and sun and sun and rain in dizzying succession, and from caves and flinders and wallabies and koalas and emus and hermetic platypuses we flee to not fly, miss the plane. I'm sitting on an empty airstrip—just a patch of grass, no lights, no buildings, sheep overrunning it, it's getting dark I'm in an abandoned truck alone, happy. True I might miss a talk tonight would that be so bad but it's the women's one

and while I wouldn't miss the talking I would miss the women,
feeling the support and the doubts and wondering what each
slide provokes in each mind. American women's eyes let loose
down under. Seeing things the same? Or not? How much of
my own disappointment is visible through the equally genuine
enthusiasm that's much more fun to dwell on? Caught and torn
between politics and art and my own irritation of unreason and
the great density of others' needs and the fascination they hold
for me and my own needs...

I saw her in turquoise boots taller than the crowd I saw her
waving and waving as I left and felt sad to find a friend so rare
and then march on to new ones when I'd be happy to stay.
Go away with my admiration for her life and how it's lived,
a better model than most; I'm taken for a model too, alas.

Last stop and English witty not so fearsomely eccentric
younger I realize and talks about his lady friends but is kind
and clearly devoted to his Susie and very too bright pacing
the placid uniwalks of the most distant city. Last lecture and
euphoria in young talk afterwards. Everybody is good and
everybody is smart and nice and if I could stay I wouldn't want
to see any people but back to the sunny dangerous slopes of
Laura. One last guest stop to tin house on hill with horses and
dogs and spotted mare and gum trees burning out for breeding
and almost stagnant peace shattered by nervousness and horses
dancing Spanish steps a little bit of old Andalusia on the weird
westernmost of Australia. Why not? Why anything? Why not
a costumed rider and a horse who bows and scrapes? Why not
a blacksmith from Ivy League Connecticut and a blonde bush
girl on a hill in Wooloroo? I am after all the oddest thing in the
landscape.

Finally the ferry, manly Aborigines, sponge + milkshake
souvenirs, Peter Barbara Vivienne full circle.

1975

183

I.

A great wrinkled animal crouching to drink from a small stream, its face hidden beneath a helmet of stone hair, water falling from its open mouth. Both front legs are in the water, the right elbow resting on the edge of the bank. On its hunched shoulders sits a small turtle. The creature's belly is partly off the ground and its skin is elephantine, aged, falling in folds at the rear. Behind a curled back leg is a bushy tail as large as the body, or it could be some monstrous growth—atrophied flesh and skin.

—

A small weathered house, seen close up, with an open door to the right, two stools sitting on the bare ground to the left of the door. A tiny window is placed curiously high to the left of the door, and beneath it is a dark space where the wood covering the basement has been torn away. The facade of the house, unpainted, is gray and streaked with a few white patches to the right of the door. The sun lights the interior at the left, but the right half is black.

—

A winding corridor with walls of rotting pink satin. The ceiling is very high and to the right of the dark recess a small ramp leads up to a rounded podium behind which an open

185

door leads off to the side. To the left a strong light exposes the runs and tatters in the fabric, the irregular color changes giving an impression of dampness, and the stained ceiling. Where the corridor turns to the right at the back, a large stiffly folded purple bag has been left leaning against a fleshy wall.

II.

III.

The surrounding landscape is craggy and vertical. Soda
Springs is round and horizontal, curled over itself, feeding into
a stream with a real waterfall bursting from beneath the one
frozen in stone. Steaming crevasses along the road announce
it. C is asleep and E is playing with cars in the back. I stopped
at once, climbed down the steep side of the road, and saw the
inside of the creature. Drawn to it, into it, with its soft-streaked
outside like an inside, its lumpy walls layered and porous.
A place to curl up and dream....

This is what the entrance to the River Styx would look like.
It's not a real cave, just a hollowed-out rock.
No, it goes on.
I'll wait here. It looks all slimy. It smells funny.
Come too. I want you to come in with me.
There's no place to go.
Then why won't you come?

...about crawlspaces. A cave meant a breathing place.
A globe and a hole at once, formed above ground by dripping
waters. The process that made it continues underground.
"A sinuous cave," listening to the sounds that sheltered it. Or
an eye, deep-set, watching itself be built, an eye finally hidden
in the recesses of the mind-womb, seeing in. Like bones, a
skeleton, a skull, built around an emptied core, the remains of
a growth cycle. Accretion. A bowl of chile, an argument, a lost
map. Time to go home. I develop my photographs, peer back
into that gaping hole, wonder why it haunts me.

1976

Why haven't you ever touched me before?
I didn't think you wanted me to.
That can't be true. For weeks I've been trying to...
I know, but I didn't know *enough*. I was waiting.
What for?
I don't know. Some kind of sign.
From me?
No, from...I can't explain it.
Please try. I have to know. I have to be able to tell
how we communicate or don't, what you respond to and
don't—everything.
Sometimes it's like I can't make a move until I have this
kind of sign. How can I describe it to you?
From inside yourself. A green light inside yourself.
No, no. It's always from the outside. Something ordinary.
How do you recognize it?

I can't think when you're that close. Don't move.

Everything in me—head, body, everything, has been moving toward you for so long. I can't understand why so *long*.

I wish I could tell you. I really do. What was the sign this time, then? Touch me there.

Here?

Further back.

What was it?

I wanted you first when I saw you with Randy. I wished I were him.

A child?

God yes, a child. Don't you ever wish you were a child?

Absolutely not. What was the sign?

It's ridiculous.

I won't laugh. What?

You're already giggling.

You're tickling me. What do you expect?

You feel so good.

What *was* it?

I wish you wouldn't push me so hard.

I'm sorry, but it feels very important that I know. Can't you talk around it or something?

Do you like it when I do this?

Mmmm.

You're not responding, though.

I'm sorry. I just can't stop wondering what....

You can't let it go, can you?

Why did you say that if you weren't going to tell me any more?

I shouldn't have. It didn't occur to me that you would....

Just hold me.

I can't anymore.

Why not?

I feel very pressured.

What do you think *I* feel?

What?

You tell me all this, how you wanted me, we've waited so long, it was so good, and now you're withholding, keeping back, not giving.

I can't give without wanting to.

If you can't talk to me, can't want to give, we shouldn't be here, like this. I want more from a relationship than that.

We've been together two hours and you want to know all my secrets.

Not all your secrets. Just this one damn sign.

I'm sorry I ever mentioned it.

I know you are. God knows I am too, but now I *have* to know. I have to know if you can give.

Well now you know.

Where are you *going*?

c. 1976

I.

The first thing I noticed was the stone lying in the path.
What stone?
This one.
What's so special about it?
Look closely.
Huh? How'd you know it wasn't natural?
It didn't look like it belonged there.
What was different about it?
Too smooth, too round. The others weren't.
A glacier or something?
Not around here.

II.

They could have been handholds.
Sideways?
Holes for beams?
Not regular enough.
They must be natural then, potholes.
Pebbles can't be thrown against a vertical wall regularly enough to make potholes. Maybe it happened when the walls weren't vertical.
Stone's too soft. They would have been washed out before this.
Well what, then?

III.

It reminds me of when we drove up the coast that time,
remember? The foggy motel?
Yes. And the dinosaur footsteps.
And the chocolate mousse that turned out to be jello.
Were you scared then?
The first time it happened I was.
We were thinking very clearly that weekend.
I stopped feeling so precarious. You held me a lot.
Sometimes I felt like I'd never touched you before.
We were intimate. Yes, intimate.

IV.

Now we know what it is, do you still feel good?
A little tired. No, actually exhausted.
It's still steep. I can't tell if it's my legs or head that's tired.
Kind of a letdown.
It was too easy. But I can't help wondering what would have happened if we hadn't found out. After all we almost didn't. I mean it was just an accident.
Maybe we didn't find out. Maybe that's the wrong explanation. A lousy time to crack jokes.
I'm not cracking. What if it really was natural? What if it had to stay there? What then, if you're so smart?
Even if it was real we wouldn't have affected it. Look at the size of everything.
I suppose.

V.

I did it because I was lonely.

That's no excuse.

How would you know?

I've been lonely. I just don't whimper about it all the time.

Do you admit it when you're lonely?

Who should I admit it to? Myself? To make myself more miserable? I'm no masochist.

You're hurting yourself by repressing it.

Bullshit.

I don't know why I bother to say it. You know exactly what I mean.

You've turned everything around again. What are you covering up?

Clever, clever. I always said you were the clever one. I wonder if it's cleverer to be clever yourself or let somebody else be clever and creep around doing what you want to on the sly.

It's not difficult to be self-effacing with so much help from the outside. I'll let that pass. Why *did* you do it?

Because I was lonely.

VI.

Are you sorry?

It's too late.

Not if I tell, it isn't. Then you'll be sorry all over the place, won't you?

A threat?

No, a prediction. You'll deny ever having said you're not sorry. The air will rumble with regrets. Everybody will be treated to some. I can see it now.

How can you talk about it like that?

I'm not the one who did it. It's not my worry.

You're responsible for me.

How did it happen, that I'm responsible for you? I'm the *clever* one.

The meek shall inherit the earth.

VII.

Something struck me about the way he looked around the room.

How?

I don't know. As though...the room were a cave.

What does that mean? Brutally? Dumbly?

No. He made the walls. He made the windows...I'm not sure...close in.

On you?

Not precisely. But that was part of it. The room changed as he looked at it. Not the actual scale, but the closeness of it, the space.

Is he a big man?

Middle-sized, average.

Was he frightened, frightening?

Poised, maybe a little on edge. Nothing extraordinary.

You think he felt trapped.

Nothing so obvious. On the contrary, he seemed to see the place more as a refuge. But the association's already buried. It doesn't make sense anymore. There's no point in trying to pin

me down.

There's a difference between burying something and analyzing it. You persist in surfaces.

I find out more from touching than from falling into a single pit.

You don't have to fall. You can control your movements, can't you?

VIII.

Now that you've done it, now what?

Nobody has to know unless you tell.

It's not that easy to hide, you imbecile.

Don't call me names. I was lonely.

Lonely! How can you be lonely?

You said you understood.

I did not. I said I was lonely sometimes too. But I don't run around doing things like *that*.

It's worse here.

IX.

They spoke to each other?

Just hello. I was surprised at how casual they both were. But they didn't go on talking. She went to the kitchen, to get coffee. Then he looked around the room.

Nobody said anything?

He was talking steadily the whole time. As soon as she left he started a monologue about Cape Horn. A subject from the blue. Nobody had asked. It had nothing to do with the expression on his face. He was off-register—what he said and how he looked. Like seeing a movie with the wrong subtitles.

Well, at least it all went smoothly.

It didn't. When she came back in the room he gave a piercing scream and ran out the door.

And she giggled. Stood there with the coffee pot, giggling. Then she laughed. Louder and louder. Right?

1978

VI.

Unpublished Novels
(Excerpts: 1970s and 80s)

Friends on a
Black and White Set
(For H. P.)

1967

They met in the adjacent stalls of a prison ladies room.
Crystal with an upset stomach. Embarrassing noises and
smells. And no toilet paper. Hears sounds next door. Peers
down and sees combat boots like her own below the
partition. Hey, excuse me, but could you send some toilet
paper over here? This thing's empty. Silence. Sounds stop
abruptly. Annoyed voice. I'm about to finish this roll off. Oh.
Desperation. Thanks a *lot*. But I'll get you some from the
next stall. If you've got another dime. The voice is husky. Uh,
I don't have any dimes. I crawled under the door of this one.
A hoot of laughter. Listen, sister. I'll treat you. Running water.
Footsteps. A roll of toilet paper appears under the door. The
hand holding it is dark brown. Crystal is surprised. The voice
didn't sound...Thanks. More running water. Her deliverer
is standing by the blower waving her hands at it impatiently.
Damn things. Yeah. They make you all sticky too. Glances
meet in the mirror. Older than me. A nice face. Eyebrows
raised warily. Guarded. Quite dark but the hands seemed more
so. Do you work here? Upstairs. Oh. She's not an inmate and
doesn't look like an off-duty guard. Another pause. You too?
Mmmm. Sort of. In the arts program. Oh. Crystal is touchy.
Another white girl doing a little Cultural Good. Well, they've
sure got leisure time. Might as well make baskets, huh? Ice
breaking a little. What do *you* do? The other laughs. Arts
program too. Crystal laughs a little too loud with relief. My
name's Crystal. Crystal...Laitonovic. (Still stumbling over this

name she's disinterred from where Adam's father lost it on Ellis Island. It's awkward anyway. Why does his daughter want to be a Laitonovic instead of a Laiton? Of course he knows perfectly well why, just doesn't like what he knows.) Mine's Gen. As in *Gen*-evieve Pineapple. *Pineapple?* Crystal forgets herself. Well, I figured I could give an alias too. Oh. How did you know? I've done it myself. Blower shuts off. She turns to leave. Crystal picks up her bag too, drying her hands hastily on her jeans. It's really not an alias, just a regression...

<p style="text-align:center">1970</p>

That hurt, Crystal. That *hurt*.

But aren't we good enough friends so I can joke about racism now and then? I mean not that racism is a joke, but...you *know* I don't think it is.

Precisely.

Oh shit, I'm sorry. I just don't want to be one of those holier-than-thou liberals who never says a wrong word. Who tolerates every damn thing. I mean how can we be *friends* if we have to watch ourselves all the time? I don't mind it when you make cracks about WASPs. Everybody does.

So maybe we can't be friends. If it's a matter of watching ourselves. That just means that underneath you're as racist as the rest of them.

Wow. *That* hurt too.

You want to be honest? That's me being honest. Take it or leave it. You can't relax with me till *all* your friends are Black. You can't even picture that, can you? It's real nice to be able to say One of My Best Friends Is Black. Even Some of My Best Friends—which would be an exaggeration for almost any honky. But if you were always alone with us, if you were the token *white* all the time, you'd be uneasy, wouldn't you? You'd feel

out of it. You wouldn't be able to relax. Even if we shared your politics and your beliefs and you *liked* us all real well, you'd never be able to share our background, our history—or our foreground. The color of our skin. You'll never know about being Black in a white society. You can feel guilty as you like but you'll never *know*. Like I suppose you were brought up to think we're all sistern brethren Under the Skin. Like skin color makes no difference, huh? But it does. In white America it *does*.

You don't have to take me back to kindergarten.

Right. Shit. I know you're OK, Crys. After all, I can even say One of My Best Friends Is White! But so often I can see you thinking, oh, oh, here come that good ole *Paranoia*. Humor her. That guy didn't *really* look at her funny and there really *wasn't* any place in the restaurant and there really *wasn't* no job there. Her photographs just *wasn't* really good enough, that's why the editors wouldn't take them...But don't you ever wonder why they won't even *look* at them? After they see *me*?

Listen, I know that paranoia just from being a woman. I do believe you. It's there. Mea culpa. It's a racist society. The nicest people make absolutely unconscious racist remarks all along. My Father. Even my Mother...

And you.

Ouch again. I'll let that one lie for now. What I wanted to say is...at least what I do about the gender thing...is to think, like, *screw them*. That's their problem if they can't accept women. I'm going to go ahead and do what I want whether they like it or not. If it's not in their ballpark, it'll be in my own. Yeah. Segregation. Separatism. I wouldn't trade being outside in the feminist community sniping at the insiders for being inside kissing ass or even having my ass kissed.

Spoken like a true product of the privileged classes.

Oh, Gen, don't go rhetorical on me.

But it's true, honey. It's just plain and simply true. You can't enjoy being outside till you've been inside. You can't enjoy not

belonging till you've belonged. You people, you middle-class radicals, you *wonder* why the working classes aren't catching on to some version of prole pride. The great separatist Ethnic in the Sky. Pie and Oh *My*. You could call it the Work Ethnic. Well, the fact is, working-class people (that's mostly white people, who can get jobs. We call the Black poor the *unemployed* class. The welfare class). Anyway the working-class stiff isn't a woman. He isn't Black. He sees no *reason* out there why he shouldn't be getting his piece of the pie like the other white men. Capitalism rests securely on the competitive instincts of the white male who's not getting his. He don't want to identify with no broads, no niggers, no spics, no wops. He sees his role model—the white banker in the designer sweatshirt. The Ex-e-cu-tive with his doll.

Yeah, yeah, yeah. Not to change the subject, Gen. But how come you start using Black English sometimes? This is something we should get on the tape too. Sometimes but not other times. It's not exactly natural. You never lived in the ghetto. You went to Yale.

Whooeee. You got me *there*. I went to Yale! The Man's never gonna let me forget it. Ah bin raised to Heights Unseen by Kinky Eyes Before. Hallelujah. She went to Yale, so now she's been neutralized. But on the other hand, you just cain't teach them niggers to be lak real white folks, can you now? You can lead a sow's ear to the silk purse factory but you can't make it turn coats.... I use that lil ole Black English number when I remember to. I use it whenever I can reach down to that ole *rage*. I use it whenever I can forget my parents and their nice professional ways. And their fears. Ah yes. Their fears. I use it because I'm afeared of being afraid all the time like my parents are. I use it because my parents *didn't* talk like that. Couldn't talk like that. Because they didn't dare.

The rectangle's edges are suavely rounded. The images are
blurred. Still, all the little dots come together in black and white.
And that's what it's all about.

Hello out there. Genevieve speaking. Do you read me?
Probably not.

(I started a videotape for you, Crystal, but I sounded sort of
hysterical and it freaked me out, at which point the tape broke.
Maybe this one will be easier.)

Sure, you're using me, but I can use the situation too.
I thought about what you said about my biased sociology and
it pissed me off, but then I realized that some of the things I've
experienced could never happen to you—obviously because
you would not have the visual cue (skin color) that would
tick off that side of people. I was thinking about it last night
when I saw a dwarf on TV—a famous one, no less, who said
his greatest problem was dealing with what people project
onto him because of his size. It's the same as my color. Like
my friend Albert, who's been in a wheelchair since the war,
he says: "I *am* a costume." We serve the same social function
as soap operas. I know that my skin color will attract certain
types to me, to work off their number.

In Paris, just a couple of years ago, there was this woman
who kept following me around. I was the only Black tourist
type at Notre-Dame and the Sainte-Chapelle. She was South
African and crazy and had to find her a nigger to put down.
I was minding my own business, just being a tourist, and she
would pounce and I would split and go back when she wasn't
around. But she'd catch me. Strange and extreme example,
but if I'd been white I'd hardly have attracted that kind of
attention.

When I was in London, a white friend had made a reserva-
tion for me at a boarding house near Belsize Park for a week,

and when I showed up, the woman was clearly upset and shut the door in my face. I could hear her say to her husband, "But what will the other guests think?" She was French, married to an Englishman. He apparently felt it was OK so they let me stay, but she watched me like a hawk and was quite rude.

A picture of a postcard of the Sainte-Chapelle, then quickly Notre-Dame, then quickly the Houses of Parliament, then quickly the Soweto uprising.

(I know you're going to say that's too obvious, but if it were obvious I wouldn't have to be telling you about it and you wouldn't have that expression on your face—that expression of concern and bafflement.)

When I was in first grade, I was the only Black kid in the class. My mother didn't believe me when I said the teacher didn't like me. And she didn't believe me when I said she said I was stupid. And she didn't believe me when the teacher tied me to a table and threatened me because I was stupid. My mother was afraid to complain because she didn't want to make waves. She'd rather blame me than the teacher. I must have been doing something bad. As if anything a first grader did was bad enough to be tied to a table. Finally another little girl told her mother and the teacher was fired. No thanks to *my* mother.

A picture of a saccharine Virgin Mary holding a fat Christ child, followed by rapid images of old-fashioned school buildings with white children lined up outside, getting more modern as the pictures go on, and ending with a picture of a bombed-out Harlem high school with Black kids lounging against the wall, making faces, giving the camera the finger.

My mother was the darkest of ten children and while her brothers and sisters passed for white and sat on the ground floor in the movie theater during segregation, she had to sit alone in the balcony. My father was the lightest of ten children, so he got the jobs over darker Blacks and his brothers and sisters hated him for it. His half-brother was very African—

212

my uncle Edward, to whom I owe my love of books—but my mother wouldn't let him visit because he was so dark. And if I had a Black boyfriend—I mean *Black*—I was reprimanded. If I had some half-witted light-skinned Black it was OK— great—only the light skins wanted white-looking girls with straight hair, so they usually weren't interested in me. And if I brought home a white boy, my father would cry.

My mother sent me South in 1963 to meet the Black rich upper-class light man of her dreams. Destination Greensboro, North Carolina. On the train down, a college-age white girl tried to be friendly to me and all the whites stared at her with hatred, and at me with intense hostility. She braved it till she got off. Then they glared at me. All projected on a teenager they'd never seen before. But once I got there, to the ghetto, and was wined and fattened on the other side of the segregated bog, I met several men of color who were dark but would have nothing to do with me because I was too light.

Telling you this is hard for me. It feels like matricide, as my mother always forbade me to have friends. Why, I'll never know, but she just couldn't stand it, and would read all my letters, never gave me messages when someone called, etc. So on with matricide...I'm feeling intensely lonely this week and may not be able to tape much. It gets me close to crazy, brings all the feelings too close to the surface.

Then *don't* tape, please. I don't want you to associate that pain with me.

Too late. But all the harsh feelings these tapes bring up aren't aimed at you. Don't take it personally, like you're always telling me. I hope the pictures you're working on are just as nasty. I want this collaboration of ours to stink, to leave a stench, a taste they can't whitewash out in their ivory fucking towers of galleries. I want it to be unforgettable, not just art. And if you were Black too we wouldn't be showing it. So this is my chance. Don't make it any harder than it has to be.

213

Pictures of art. Pictures of pictures of white people through the ages. Pictures of pictures of Black people interspersed toward the end. The Black people are not all dressed up. The Black people are being studied. So are the Red people and the Yellow people and the Brown people. They tend to wear costumes.

Once one of the trustees of that Great Cultural Institution where I earn my daily bread invited me out to the Rockefellers', yet, with a visiting group from Europe. Then she uninvited me. Then she invited me again, but said I'd have to work. I said, do you want me to take hats and coats? She turned red and tried to clear it up by saying I was just like Kenneth—the only other white-collar Black in the museum—which of course made it worse.

Having a Black in an art gallery is like being part of the family. It's also like lowering the property values when a Black moves into the neighborhood. And what Black is welcomed into the white American family? As anything more than a servant or an acquaintance to be trotted out in generous moments?

Picture of Genevieve glaring tearfully at the camera.

(I don't want that last stuff in. It's too close for comfort.

I don't know. It comes down to whether we want this to be a sort of portrait of you or a more detached analysis.

How come we're still having to make those choices? I thought the personal was finally supposed to be the political.

All we have to do is focus on *ourselves* here and them as don't know that yet will say what we're doing isn't significant because it's only about an individual...All women are narcissists anyway...)

—

214

Gen and Crystal are making a videotape about friendship. Gen and Crystal are making a videotape about racism. Gen and Crystal are making a videotape about class in which they ask their friends to improvise situations and then they do an unannounced class analysis of their friends' responses to these situations. Everybody hates it. Crystal makes a videotape with the image of a hand beckoning with four fingers like a cop's "come ahead" gesture. Then she slows the speed of that gesture gradually. Then she holds up her flat palm: Stop.

1977–78

*Author's note: The following is the
first chapter from an unpublished
novel called* Islands, *written during
the 1980s*

It begins in a mist. Under the mist lies the solid prose of rocks, hard rocks and flowing water. Rough rocks, motion frozen to the touch, thorny black volcanic piles, a vein, an aggregate, a channel worn away, a pit blown or swirled out, grains, knife-like vertical edges. And smooth rocks, covered with pale and slippery algae, soothed to a fine old gentleness, the patterns of waters and ancient mud's slow curves.

The island lies on its side, a small harbor between the bent knees and belly, sheer cliffs at the back of the shoulders, the head almost sunk into the dreaming depths. No other land is visible. The barren rock suggests either recent birth or imminent extinction. Submersion. In fact, it is very old. Most of it is dark, almost black, with occasional dramatic streaks of quartz. Finer horizontal lines of pink sandstone, nubbly white extrusions of porphyry-dotted granite, batholiths of grays. All, except the patches of bright-yellow grass near the stone house, is bared to the touch. The gray, mustard-colored, red-orange, blue-green, black, and brilliant blue lichens reproduce rather than disguise its contours.

She was alone with her parents, the rocks, the Southern Sea, the birds and reptiles, a few hardy plants. Boats from the mainland brought books. One of her worlds was bound by the sea; it was tiny, though teeming with life and events on cosmic and microscopic levels. Her other world was bound only by the imaginations of writers who had seen more than she had.

She has learned that the heavens were once studied from a hole in the ground. She has read in an old book that it is a "fatal delusion" which presents the earth as the lower half of

the universe and the heavens as its upper half: "The heavens and the earth are not two separate creations, as we have had repeated to us thousands and thousands of times. They are only one. The earth is in the heavens. The heavens are infinite space, indefinite expanse, a void without limits; no frontier circumscribes them, they have neither beginning nor end, neither top nor bottom, right nor left; there is an infinity of spaces which succeed each other in every direction." She floats in time as the island floats in the sea, rooted to an invisible core. She picks a bright star for her own, only to be told years later that the brightest stars are the shortest-lived. She watches the mosses, the lichens, the rough grasses continue their struggle for survival and feels cut off from life after the survival point. She watches the lizards move between land and water and knows more about the contact between their dry underbellies and the wet rockweed than she does about her own kind. Life on the island is abated, waits, is suspended in a time she would like to reject. Time is the ocean, extending back beyond memory or record. Interval, period, duration, moment, instant, occasion, rhythms against time ahead of time behind the times in no time. I look across when I think back to the beginning. What does that space *look* like? What is the landscape between me and my childhood, my ancestors? What are the landmarks? Surfaces, tables of content. Revisitations. In "primitive" worlds, a person or god or symbol reappeared each year; "civilized" holidays do not revive, but simply commemorate, re-establishing death.

Maren did have a friend when she was a child. A few hundred yards out to sea, just southwest of the island, a pile of eroded rock had been cut off from its source by violent wave action. At high tide, all that was visible was a head shape, constantly washed by surf. It stared straight into the island, skull-like, with its five deep crevices easily read as features. When the tide fell, its body was revealed and its character

changed into that of an awkward, bulbous animal form, back hunched, gangling knees up. The skull turned from threatening to wistful. This daily metamorphosis from foe to friend cheered her. She called him Urgoyle, after a Northern fairy tale. She talked to Urgoyle and imagined playing with him. When the tide rose again she sadly watched him disappear and turned her back when only the head remained, so that she would not see his final demise. He rose and set like the sun, but he was always there, which the sun was not.

A still day, so the boat's engine is heard when it is still far from the island. Invasions. This is not like a book, which can be opened and closed at will—if one has enough will. She thinks these word in English, beginning the process of change. Two figures at the rail. She imagines with a first sympathy that their postures must be as tense as her own. Where they are coming from is not like this. She hovers dispassionately above the island. The ship is an old one, its wide hull and rusted gunnels rock comfortably on the swells. She is watching the three people from the boat shake hands with the three people from the island, watching one person return to the boat, watching two people return to the house, watching three people alone.

Menstruation came late. She was almost fourteen. Until then, she had read and she had walked, she had thought—rarely talked. When the inside of her body began to trouble her and demand attention, absent-minded stirrings of unfamiliar feelings discovered gradually in terms of the roughnesses and smoothnesses of the rock and prose which surrounded her became an obsession which the imagination of other writers failed to satisfy. Suddenly, there was no one else in the world who could think what she did or feel as she did. So she began to write.

First she wrote about the rocks and the sea and the stars and the sky. Then she wrote about the plants and grasses and the few tree-like shrubs that could survive an island winter.

Then about life in the sea and the insects and the small animals who lived in the crannies of her world and the birds who visited the island at various times of the year. Then she wrote her mother's story, and her father's story, pestering them for details they had never thought to resurrect again, until their memories of before the island refuge lay dry before them. All of this took surprisingly little time. These things were so important that it wasn't difficult to be precise and simple and loving and know them. The more information she absorbed, the more unique she found herself to be. So she began to write about herself and her own experience of all these things and she got nowhere. It took a great deal of time. Nothing was known. Soon she did almost nothing else but write and destroy what she had written. Later she began to keep everything and doggedly continued to get nowhere.

I want a nest in infinity. A mountain chain is an effective barrier. The slow movement of underground waters forms quartzite, the slow movement of underground waters carrying silica into sandstone. Limestone metamorphosed is marble. Bedding planes obscured and mineral impurities drawn out into swirling streaks and bands, swirling streaks and bedding planes obscured. His hands will be too soft to grasp the sharp holds of ungenerous cliffs; his body, unlike her father's, seems unformed. His sister approaches things with a firm and wandering touch. Cold tar will shatter if struck, but will flow downhill if left undisturbed for a long time.

The twins' first day on the island was typically volatile—sunny, then rain clouds, then bursts of brilliant sunlight, rainbows, flashes of light and shade. When the dark clouds moved over the sun, the bare rock was bleak and forbidding, its facets a single mound, dark and absorbent of all light and life. When the sun came out, the water sparkled and the rocks seemed to rise from their own caves, defy the all-encompassing mass, and respond to the sky and the sea with new contours.

Every time Derek, the geology student, saw this happen, he felt he was reliving Genesis, while Laurel, the biologist, saw the sun bring creatures scurrying from cover. Little brown and scarlet lizards sleep under the sand. Purple and yellow sea urchins, giant thorny lobsters in mosaic colors, petrels, shearwaters, albatrosses, hawks, herons, curlews, stilts, mockingbirds, oystercatchers, fork-tail gulls. Fearless birds, as curious as she is. Yellow sulfur butterflies, blue water-striding insects, pale wine-colored doves with blue faces and red feet, seals and seaweed and spiders and jeweled gobies, blennies, scarlet-backed and yellow-tailed and orange-bellied azurefish, sea fans, sponges, serpent stars and sand dollars. Little black crabs and giant red ones. Long-petalled white flowers with thorns. A pink and black and white moth.

What does Maren do all day? She seems to do what we do, wander over the island. She has secret places. What does she do there, do you suppose? She writes. How do you know? I've seen her carrying a notebook. Writes or researches? I don't know. Writes, I suspect—probably poetry. After all, what could she research? She's very well read. Is she? She never initiates anything, but if you hesitate, she can fill in almost any gap. Really. Then you've been talking to her. Trying to. Her English is getting better. But she's so shy.

During the silent dinners in the stone house over the hill from their smaller quarters, the twins choked down unfamiliar food and stared at her covertly. She held some key to the substance and the history of this outrageous place and with-held it from them. On her part, she felt their presence more concretely when she was alone, when she could conjure them up before her as she had been accustomed to conjure up the invisible world beyond the island. The candlelit nights are long for them. Their eyes tire from reading in flickering shadows. The books are old, with cramped print, in many languages. The parents are kind but impregnable. How had they come

to be here in this desolate spot so far from their homelands? It was what God brought us.

She wants to touch and explore and absorb the twins the way she had come to know the island and its creatures and, later, herself. But when they meet on the rocks, apparently by accident, she goes rigid with formality, treating them distantly, even sternly. They respond as though their roles were already familiar to them, as though nothing will change. She is studying her English grammar each morning, with mounting frustration. Each midday, when she brings their food she says a few more sentences, systematically, but warily, always on the lookout for signs of disapproval, irritation, dismissal. Finding these signs some days, she goes back to the rock, to Urgoyle, to the notebooks. Other days, the three touch the same tiny leaves and rough lichens, the same sharp barnacles and slippery rockweeds; hold the same warm egg in their hands and feel life quivering inside. They began to touch each others' fingers, tentatively. A gradual process. Intimacy from detachment. Derek's bizarre intensity, extreme moods. Laurel's nervous acquiescence and Maren feeling her way toward people. The vulnerability of opening needs. The last shreds of afterbirth being pulled belatedly away. Seeing and sensing things as others do? Not yet. Not in the second month.

They have glimpsed the shelf of notebooks—innocuously colored, old fashioned, sewn not spiral bound—in her room, her featureless sanctuary that is a shelter within the outdoors (her real home). The number has grown since they came. I wonder what our effect has been on those mysterious notebooks. We'll probably never know. Prose, not poetry. Its tentacles reach in more directions at once, from a more solid base. The pace is natural, not inflicted or compressed. It circles and radiates, has a core and a skin and a network of capillaries instead of arteries alone. In the third month, their times are merged. Maren becomes their helper and, from that lower rung, their

mentor. She could be more of a biologist, of a geologist, than we are. But she is not. She has no discipline, no methodology. She doesn't seem to need it. You make too much of her. His querulous note, soothed sometimes by Maren's solemnity, or by her stubborn disregard. She's absolutely someplace else, isn't she? It would be terrible if we changed her. We already have. They already have. Maren is moving differently, the timbre of her body is changing. Even her voice is settling into foreign inflections. Quick, who does she remind you of? Standing Waters. Exactly. You don't hate her? I don't hate him. Laurel pulls away from the pain she harbors for her brother. The maturity of the creases indicates that the topography has been completely reversed. In some alpine mountains high above the timberline, sheets of frost-shattered rock fragments creep slowly down the valleys making curious tonguelike forms. Her mouth. Maren's tongue makes love to her mouth, searching its cavities for the softest, wettest places to fondle, sliding past and over the hard sharp teeth so that it hurts a little, overlapping, lapping its own roughness, slipping across the toothmounds under the gums and falling into the dark throat. Craving in.

Will you come back with us? I don't know. It's your chance. You have to take it. What else have you been waiting for, after all? I don't know. I wonder. Your parents want you to go. They know you can't stay here forever. I should think you'd be dying to see the real world, off of paper. It won't live up to what she's already imagined it to be. It is real here. The island is real. This place is real. You can't compare it with anything. You can't even tell if it is real if you haven't anything to compare it with.

There is always sound on the island, the waves, the winds, raucous avian chatter. The city is like that too. But there are other places, places where there is stillness—stillness as quiet and stillness as immobility. Maren will be baffled and uneasy when she goes to these places, will begin to be interested in

223

music for the first time, become attuned to the slightest sound, like a desert animal. Under the glass bell. Throw rocks and break it. Sleeping, waking. Light and foam-like pumice, pored and wrinkled like skin. But the crust is brittle, granite absent over ocean basins, sound absent on the plains. Tell me what it's like there. There is no there. Away, there are millions of places, all different. Here it's all different too. On another scale. You can't stay in this scale forever

A friend of mine. Someone who used to be a friend of mine. He speaks very fast or very slowly and she listens, intently. Says that Western civilization has broken the natural cycle—that man is not something else, superior to nature, but simply another cog in the wheel that rolls back and forth. Mother Earth surrenders, takes back. The Lord giveth and the Lord taketh away. Not the Lord, the land. Says Anglo humans have no place to go because they have forgotten their place. Says we are all wandering Jews. His hand strokes the other unconsciously, as he talks to her about this friend. Once you leave, you won't ever come back here. I will too. She won't be able to come back, not really. Nonsense. She'll just come back and see everything more clearly. She already sees so clearly. Only because there's so little to see. No, think of all she knows. All she's learned. How can she know it yet? What do we know, then? Whatever we don't know, we still have some sort of basis, a vantage point, more than one rock. But think how she knows the rock. Sometimes she seems wiser than . . . It's peasant wisdom, limited. All nature, no culture, like standing waves. But Derek is changing that.

One reason I want you to go with us is so that I can be there to see what happens. What happens? How you change. Must I change? There'll be choices to make. You have none here. You'll choose friends, a man, a way of life. In that order. I have that here. Not chosen. Given. Is that so bad? If you stayed here, you'd always be a child. Is that so bad? There's

no one here to marry. Marry? Be alone with another person all my life? Maren does not think so. Looks at him from beneath long white lashes, makes him aware of her sturdy body as it sits trustingly before him. Makes him compare it to the body of a man, its layered strength compared to the litheness of a green bough. You have to have the choice. Does everyone marry? Only the strongest ones don't. The unhappiest you mean. Society doesn't approve of being alone, men or women, especially women. Not just society, nature too. Being un-coupled is unnatural. It's a matter of survival. The same matter between two. Protective coloring. Doubling back, unnatural woman isn't yet. Doesn't sense disguises fluttering around her shoulders. The geologic record is fragmentary for the oldest ages. Each major time unit was brought to a close by orogeny, also called revolution. Disturbance, disruption, disintegra-tion, under pressure. Even the strongest rocks may develop fractures. Deep decay and rotting of igneous and metamorphic rocks, from blocks to egg and sphere shapes. Water entering into union with minerals. You two are already coupled, born coupled; I should probably stay alone.

Derek and Maren scale the yellow wall very slowly, each hand and foothold emerges only after scrutiny. The ends of their fingers are as sensitive as safe-crackers', forcing the surface to offer pits and hollows, black and white dots that deceptively make yellow. She moves faster, on her own ground. He hurries, almost loses his chisel. You'd be better in bare feet than shoes. Not according to the experts. Irritably. He's the expert. She slows—partly in kindness, partly scorn. Straddling the facade below her, he too is ambivalent. They reach the ledge, the vein. He hammers into the rock's flesh with short, vicious strokes. The shelf is just wide enough to allow them to crouch next to each other, almost touching. She gazes out to the horizon as he works. Feel his hand on the inside of her thigh before it actually arrives there. Never takes her eyes from

the horizon. Can't move, stiffens, would have moved away, maybe. No one has touched her there. She doesn't remember her mother touching her there when she was a baby. His hand is rough like the rock beneath the other leg. It is harsh like the hammer. Abrupt. Its rhythm ragged like that of the birds below, screaming and dipping erratically after a school of fish. Not a rhythm she recognizes, not the waves of recent dreams, but with the same effect. That hand is still rough and urgent. The other places hers on his swollen crotch with antique gentleness. The birds flash, and splash. The horizon bows. Climbing down, her dizziness is not from heights. On the path, she almost clutches at the thin arrogant shoulders before her, almost pulls them down to her knowing there must be more.

He is not walking fast and so his voice surprises her when he speaks. It is high and rapid, disjointed. I wonder who *will* have you. Would you know what to do from your books? Your books. Maybe you should stick to writing. If you come back with us you can't do what I do. You know that, don't you? It's true you're good at it, but I couldn't have that, could I? I must have something, mustn't I? You would never be good with me. For me. I only get off thinking of you with him. Meaningless chatter. Her senses are too weighted for her mind to operate. And that's only because I don't want to think about me.... And what happens when we all go back? You're coming. You can't not come. His high laugh is wild, incongruous. She thought at first it was a bird, but knew their calls and this was unfamiliar, caught in her ears and filled them. More trouble for Derek, he says. Poor little Derek. You'll make more trouble too. Won't you? *Won't you*, grasping her wrist so his nails make crescents she traces with her tongue, later. You naturals. You do. If you're not kept in your place. Muttering, more words, another laugh, but calms when they enter the cabin. As they step over the threshold he is afraid. Laurel sees the look on Maren's face—a look she spends years trying to forget.

226

She continues to work—first with one twin and then the other—for the next two months. In abeyance, content. She touches herself because he won't touch her again—even when she asks him to: looking him honestly in the eye, a fall of pale hair obscuring the directness of her glance, until she pushes it aside, and he looks away. It's taboo, he says with a languid chuckle. Taboo, incest. Or don't you have that custom here? The same mixture of compassion and scorn warms her body as it did before, but she remains sister to both of them.

She is working with Laurel the day an enormous wave catches him half way up a cliff, a different cliff, and plunges back with him into the sea. That's how they think it happened. Laurel knew it had happened as soon as they returned to the stone hut and he was not there. Two of them, again, not three or one. They waited all night knowing. The next day they searched the shores with Maren's parents. The body is found in a cave a week later, a cave he was fond of, often sat in, curled up like a fetus in its damp orifice. He had planned to write a paper on its unique combination of minerals.

There is no way to contact the mainland. Before the ship comes, another month will pass with ineffective rites of exorcism. Laurel, paraplegic, Maren moving naturally, leaving her own empty place unfilled. When they leave the island, she leaves behind her notebooks with everything else she has ever known. She leaves with Derek's books, Derek's notes. A sea change. Coral reefs are the bones of millions of tiny animals who make land when they die. Of his bones are coral made. No. Carbon, burned. A task undertaken by her father in silence. When they leave the island, they take with them Derek's ashes, Derek's books, Derek's notes, Derek's possessions, Derek's possessed.

1980s

VII.

Nature / Culture
(1970s and 80s)

Caveheart
(for Charles)

I.

For sixty million years this principle has been forming the
law of the heart. In some places the topography is a dead give-
away. The first clue is the stimulation of the parasympathetic
nerves. Instead of the usual pattern of little brooks flowing
into creeks and creeks flowing into rivers, the pressure rises
and the result is violent erosion and related venous inflow.
In the hollowed vastnesses created by water when the heart
chambers dilate greatly and the force of contraction becomes
very great, a flash flood is an ever-present possibility. Other
clues are depressions. The nervous system is connected. The
arterial pressure pulsates. Increased vigor. Rocks showing
bruises and wear as if they had been used as hammers. The
kind of deluge that can dam up in the veins. There has to be a
hole. Vibrations set up in the pink gypsum. Abnormal leakage
from the electrical current of the heart…Water ran off into the
venous reservoir.

II.

Another hole! The blood flows around and around a
continuous circuit when the land is moist and the water
table is high. Standing at the bottom, impulse travels slowly.
A mud bank slopes off into darkness. An entrance. I continue
my descent in silence. I pass a small opening in the denuded
endometrial wall, causing a rise in venous pressure. At the

231

bottom of the drop, tissues slough into the uterine cavity. A sparkling waterfall tumbles from a dome where the deeper layers of the endometrium proliferate threefold. A clay bank rises from the floor to ceiling initiating a new cycle. The incline is too slippery to scale, so growth then stops. Crossing the room lengthwise I encounter a passage into large placental chambers. The fetal portion is decorated with many small cauliflower-like projections extending into the clay bank. I climb the valves and folds along the ductus. Changes in hormonal secretion probably account for the rare adventures in a virgin cave.

III.

Pressure deep underground—pressure of water upon water—can be great. The male and female dispositions seeping or flowing in any direction, even upward, could move freely along joints, fractures, and bedding planes. A contraction which, more than any other factor, decisively influences the later development of the human being. In the little girl, cavities develop. They often appear as springs or water holes, even as lakes. The little boy takes the place of the limestone it has dissolved and carried off to some surface outlet. Enlarged by solution, the erogenous zones—the cracks, the joints, the spaces between bedding planes—become caves. The place in the rocks where the venous fluids and phallic formations meet is not a fixed and stable one. Indeed, in rainy seasons, the libido rises, and following droughts, it falls.

IV.

When an uplift occurred. When the earth created a dome
in the course of time. Minute mountains rising from mortar
flesh. Creating a city in the course of space. Touch, touching,
move, moving mountains. Frequent spontaneous discharges.
Dusty hills and contours waiting to be pressed. Deep under-
ground, water upon water. A twitching. A slowly building
wall. Watching it grow from brick to brick. A cave formed in
limestone that once was saturated. Eroding the body. A tunnel,
a path down the side, a field of poles. The spaces widened.
The hill is a breast is a well. After the cave was filled with air
instead of water. Seeing the sky through the hole. Rooms,
some standing, some worn away to skeletons. Entering intima-
cies long since. Seepage water has weakened the ceilings.
Earth absorbed back into the cavities. Water reflecting skies.
The body's faults and freedoms. Breakdown did not always
result in domes. Fingers walking through my landscape, sink-
ing. Crevasses and crannies, one remaining wall. Sometimes
the cracks were close together. Entering tiny rooms. Learning
to be a cave. Seeping along any of these fissures. Leaving
depressions in the landscape. A path to the penis, a wall around
the nipple, a tower in the brush. The topography itself can be a
dead giveaway. Waves have washed over those parts that hold
you. The sex life of horizons. The little people form a chain
and move their lives across the hills, into the caves.

1973

Once upon a time there was a little girl, though she was not in fact such a little girl because she was the child of giants, the ones who inhabited this world in the beginning. They had been exiled from the larger land by the Little People, who could move and think so much faster. This girl stood, most of the time, with one foot on a rock in the sea, and one foot on a hill of clay, trying to make up her mind which way to turn. The other children had made up their minds a long time ago, or had had their minds made up for them. The ones playing in the hills had red skin and the ones playing in the sea were blueish white. As time passed, they were slowly sinking to the scale of the place they had chosen. The undecided girl was in danger of becoming both, or neither, and never shrinking.

While she waited, a violent storm came up and lashed at the rock on which she stood with such force that she fell forward into the sea. But the foot on land had by now taken root in the clay and could not be moved, so the little girl lay face down in the sea and her body became a new continent, attached to the old, the red-earthed one, by a natural bridge which led to the bottom of the sea before it climbed to land again. The other giant children were so terrified by her fate that they shrank all at once to the size of humans as we now know them. For eras into the future, no one would inhabit the new continent. Finally it became a refuge for those who did not fit in the other world, a refuge for the dreamers, the failures, the geniuses, and the distraught. Many of these were women and they named their fertile land in honor of the little girl who wanted both worlds—Hysteria.

From the other continent, this place became known as the land of Eitheror, for like its child-mother, the inhabitants refused to be confined to a single choice. This was especially important to the women, who tended to be the strongest members of society because of their great determination never to be trapped again in a single role. Because of their reluctance to reject, to confine, their laws were the laws of acceptance and contradiction, Logic was anathema, and when a recent immigrant would venture to use it, s/he was led gently into a gigantic thicket, a maze, and told that it had a logical exit and an illogical exit. No one ever left through the logical exit because its narrowness frightened the seekers, and the illogical exit, once found, was broad and welcoming.

The hystery of this land was, therefore, also a mystery. It flowed and changed according to the tellers' lives, according to the tellers' moods and values, which shifted in turn as society grew and changed. Thus fact *was* fiction, and there was no separation between them. Hystery did not have to be wrenched out of place to be rewritten. There was no need for religion because myth was reality, and the yearly rites, based on the cyclical changes of nature, reflected the changes that took place in the womb, the hyster, as well as in the imagination. The latter was celebrated each year with The Changing of the Mind, when everyone turned themselves inside out, trying to become what they were not and opening themselves to all possibilities. Greed and ambition rarely had time to take root. The process of yearly rebirth took great courage, and those who became too attached to the status quo were requested to return to the other continent, which was known in Hysteria as the land of the busy dying.

1976

The Cries
You Hear

The rocks trembled every day for over two months and in parts of Tibet a sick person or a woman who had given birth to a child was carefully prevented from sleeping. Sometimes the flower is so constructed that the insect cannot get at the nectar without brushing against a stigma which, perhaps because males tend to fall asleep more rapidly than females after intercourse, returns to stone needles. In the process of collapse the star's outer layers compress. Lying naked in the pouring rain, our wetness the world's wetness, our hard bodies the makings of rock. We took no photographs. The vacant plains were a featureless screen on which we projected our memories of rivers forests oceans and mountains, of elsewhere—quick! Before it...

Meanwhile, the females of the indispensable earthquake rest quietly in the half-closed blossoms, sharing the power of sleep, oblivious to our pain. I was long in doubt concerning the origins of these conditions of stress, horror, and exhaustion. That two different organisms should have simultaneously adapted themselves to each other. During the third severe shock the trees were so violently shaken that the birds flew out with frightened cries. Bubblelike cavities formed by expanding gas. Solid pieces blown violently out of the womb. Glass surfaces, brittle and gleaming, formed by rapid solidification. Touch me here. Wrinkles, pores in the earth's skin, basalt lavas swelling from beneath, channeled in fissures, dust and ash. The cries you hear are only the continuing shock of life.

—

"It is a fatal delusion which presents the earth as the lower half of the universe and the heavens as its upper half. The heavens and earth are not two separate creations, as we have heard repeated thousands and thousands of times. They are only one. The earth is in the heavens. The heavens are infinite space, indefinite expanse, a void without limits; no frontier circumscribes them, they have neither beginning nor end, neither top nor bottom, right nor left; there is an infinity of spaces which succeed each other in every direction."

—

A mountain chain is an effective barrier. The slow movement of underground waters carrying silica into sandstone. Limestone metamorphosed is marble. Bedding planes obscured and mineral impurities drawn out into swirling streaks and bands, swirling streaks and bedding planes obscured. He is tall and arrogant, questioning and vulnerable. Cold tar will shatter if struck but will flow downhill if left undisturbed for a long time. Shattered and flowing, flowing and shattered if struck. Hard things that were soft. Soft things that were hard. Hot things that were cold. Cold things that were hot. Wet things that were dry. Dry things that were wet. Old things that were young. Young things that won't be old. It stops somewhere? Prove it.

Under the mist a solid prose of rocks, rocks and water, hard rocks and flowing water, safe rocks and treacherous water. Rough rocks, motion frozen to the touch, thorny black volcanic piles, a vein, an aggregate, a channel worn away, a pit blown or swirled out, grains, knife edges vertical. And smooth rocks, covered with pale and slippery algae, soothed to a fine old gentleness. Patterns of water, ancient muds, slow curves.

238

In some alpine mountains high above the timberline, sheets of frost-shattered rock fragments creep slowly down the valleys making curious tonguelike forms. My mouth. My tongue makes love to my mouth, searching its cavities for the softest, wettest places to fondle, sliding past and over the hard sharp teeth so that it hurts a little, overlapping, lapping its own roughness, slipping across the toothmounds under the gums and falling into the dark throat. Craving in. Prose, not poetry. Its tentacles reach in more directions at once, from a solider base, at a natural pace. It circles and radiates, has a core and a skin and a network of capillaries instead of only arteries. Memories wear away the present to an older landscape.

My leg, thicker at the top than at the bottom, stronger at the bottom than at the top, stranger at the top than at the bottom, more useful at the bottom than at the top. At the top, plump flesh held firmly between thumb and forefinger, a few long fine hairs on the broadest whitest part. Smooth and soft and secret lining where other hairs intrude from other sources—darker, coarser. A crease separating the leg from the rest of the body, a crease that changes character as the leg is used for different things, a soft crease when I am sitting, a mysterious crease when I am lying with one leg curled to my stomach, no crease at all when I am walking, but creased again when running, sometimes. A taut surface when held back, a valley between bulges when not. A leg slimming gradually to a knotted center where the bones assert themselves. A hard hairy hilltop, then a wrinkled old topography flattened into valleys. A leg that swells again, harder this time, smooth again, with a neatly turning strength of its own, a leg that is straight in front and soft-hard in back, flat then rounded, a leg that finally gives way to ankle and foot, the working parts detached from pleasure places above. The bony not-so-pretty skeletons of motion, fleshed only around the ankle bones, arched over the instep, and finally twice in touch with the earth. A place to walk and feel.

—

Each major time unit is brought to a close by orogeny, also called revolution. Disturbance, disruption, disintegration, under pressure. Even the strongest rocks may develop fractures. Deep decay and rotting of igneous and metamorphic rocks, from blocks to egg and sphere shapes. Water entering into union with minerals. Metamorphic rocks have undergone kneading and shaping, baking and shaking, shale turning to slate when split by cleavage, by slippage, during the process. Slate when struck sharply rings metallically. Clay comes in all colors. Playing the geomorphic role of a weak rock, staring at each other but not speaking until finally. A poetic geology to take back to the red hills, white clay to merge as pink. Isolated submarine mountains, the ocean floor pulled apart here, causing a rift, a certain cruelty. Alone is better I say. Then stop the invasion. If you see two scorpions together they are either making love or one of them is being eaten. Aries energy stepped back into the earth. My rock, your mesas. Ice needles pry apart joint blocks, tremendous pressures and bare high cliffs fall off into conical forms, especially in dry climates. Niches, shallow caves, rock arches, pits, cliff dwellings. Come now. Yes/No. In deserts, flash floods and earthflows, mudflows result from the inability of the dry land to permeate the permafrost. Shrinking and swelling. Given sufficient time, barriers can be broken down and new topographies arise. An unbridgeable gulf does not exist between organic and inorganic matter.

—

Drift, and erratic boulders are ascribed to mineral richness, to the action of great waves, but women's tides told in the caves refute such theories. Play pale beyond. In a climate warmer than that we warned each other, islands separated

from ice covered by a wide expanse of ocean, foregoing clubs for quieter power, fleshed fat and knowing. Warm interglacial leaves, closer to the fires, hands in a ring, shadows on the ceilings, circles drawn at dusk, footsteps from below. The occasional peculiar transportation of boulders in a manner not in harmony with what we see ice doing at the present time. But little girls are crafty. Our laughter pits the ocean floor. Echoing with pebble talk, scratched on anemones. Walls curving inward toward us. No windows. Pictures nonetheless. Melted between sisters in collision. Only global catastrophes could have brought about that smoothness. Only torrential rains, wet hair, wet cheeks. Each other. Barren stone and fragmented debris stops here, swept back while lakes and valleys are dug out by other women. Each a specialist in her field. What generates the enormous forces that bend, break, and crush the rocks in mountain zones? What indeed. Women's cataclysmic work, traced by fingers in the meteoric dust. Giving birth to each other. Excessive.

1976

Stepping down and out. Someone else can move into this house. It looks OK from the outside but the inside needs some work. I only regret how long it took to get down those stairs to the basement. Overhead the pretty flowered curtains make wavered patterns on the sunny floor. A tomato is·rotting fuzzily in the icebox drawer and other closets capture other odors, other faults. Under the bed dust gathers roses smell acrid. The sheets at the hamper's bottom were stained last winter, not since. I've opened the windows but not the doors. It's all yours, if you want it.

—

Nesting fantasies. I am high in the tallest tree in the world and it sways in the wind. Exhilarating, precarious. I cling to my egg which is disguised as the sea. When the fish hatches I swim through the air until I find a cave, brown, humid, and grainy, where after a night with the boulder another egg is laid, this one transparent. I'm happy watching the beginnings of a new dream. It sometimes has petals, sometimes blades. One morning the walls are opaque and that's that. Dead leaves turn to stone and I would leave but for the field of snakes that writhes beyond the entrance.

—

Shuttered. Unhinged. Falling off the roof. A nice white clapboard house with a soft green lawn, lace curtains at the

windows, roses on a trellis over the door, the old fanlight sparkling when the light hits it. We need a very long time to move up the flagstone walk. In the process a war takes place, peace reigns, men land on the moon and women defend it, black blankets of oil are thrown across birds' coffins and the sea stinks. Still the little house remains, the sun always dappling its freshly painted walls, the sound of piano scales twinkling delicately behind the curtain of warmth. When we reach the door we are exhausted, gray, crippled, and in pain. The doorknob, though brilliantly brass, is cold to our touch and the door sticks. It takes our last strength to open it and throw ourselves across the threshold onto what should be a rosy hearth but is instead a deep dark well, the bottom of which, at this telling, we have not reached.

1976

...has become the only site as long as there has been an earth, the moving masses of pleasure instead of acting as a kind of sexual overdrive in more air that we call winds have swept back and forth across its general response. They will find themselves dominated by the surface. And as long as there has been an ocean, its waters have performance ethic, which would not itself be a regression if stirred to the passage of the winds. Most waves are the result of performance principle in our society, included enterprise and creativity of the action of wind on water. There are exceptions, such as enterprise and creativity are connected with libido which the tidal waves sometimes produced by earthquakes under does not survive the civilizing process. Women must struggle to the sea. But the waves most of us know best are wind waves to attain the kind of strength that can avail itself of them. Sex is harnessed to roll across half an ocean in the service of revolution. It is a confused pattern: everything happens in a swoon or a swamp of undifferentiated sensation, a mixture of countless different wave trains, intermingling, prudish, overtaking, passive, passing, calculating, or sometimes engulfing one another, selfish and dull, despite her miraculously expanding tits, some doomed never to reach any shore, others destined to loll on her deflated airbed, wondering what went wrong.

Young waves, only recently shaped by the wind, have a steep, peaked shape when well out at sea. Not all the women in history have been humble and subservient to such an extent. From far out on the horizon you can see them forming whitecaps as they come in...The differentiation between the simple inevitable pleasure of men and the tricky responses of women is not altogether valid...The incidents in the life of a wave are many...

The implication that there is a statistically ideal fuck which will always result in satisfaction if the right procedures are followed is depressing and misleading. For the one essential quality of a wave is that it moves; anything that retards or stops its motion dooms it to dissolution or death. There is no substitute for excitement; not all the massage in the world will ensure satisfaction, for it is a matter of psychosexual release.

An island has no parallel in young female groups. The growing girl, standing beneath the base of the cliff, limited usually to the school situation, conscious of "that powerful marine gnawing" by which her coasts are eaten away, only after repeated trials has confidence to pursue our investigations. More than once doubting the protection of our rocky shield, her strong desires become dissipated in passive fantasies. In this critical period, in that part of the mine where but nine feet of rock stand between us and the ocean, the heavy roll of the larger boulders, the ceaseless grinding of the pebbles, the fierce thundering of the billows, with the crackling and boiling as they rebound, a girl is expected to begin her dealings with men. When a girl fails to manipulate her sexual situation, one of her present engineers writes, she is required to adopt the proper feminine passivity and continue her own repression by herself. In these palmy days of the permissive society the situation has placed a tempest in its most appalling form too vividly before me ever to be forgotten. And yet we owe some of the most beautiful and interesting shoreline scenery to the phenomenon of girls agreeing to massage boys to orgasm. Any Saturday afternoon in a provincial English town one may see the sculpturing effect of moving water. Caves are almost literally blasted out of the market value of a sex object. The ominous withdrawal of the sea from its normal stand is ironically the conditioning for the intense polymorphous genital activity which characterizes male puberty. Eventually a hole is torn through the roof of the cave, while their connection with sexuality is effectively underplayed or obscured.

1972

An Intense and Gloomy
Impression for a Woman
in the Nineties

Keeping in mind what two, three, even a dozen wide-eyed visits cannot have learned from the examination of the poet's childlike sense of wonder, by an instinct we enter a cave. We can understand in the first place the complex delight that comes when nothing but the psychic representative, the continually flowing nature and cause of the eerie scenery of the nether world, is to be distinguished. Instinct is thus one of the concepts marking muddy crawlways and hazardous traverses in wild, external excitations.

A woman in a castle by the sea somehow became interested. (Afterwards it lies, not on the coast, but on a narrow canal, whether or not leading to the sea.) Miss Hopin was stimulated by a certain Herr P., the governor of the Celebrated American Caverns. The castle is not known.

But five years after, I stand with him in a large salon after the appearance of the book with three windows. She became an ardent collector and student of cave fauna in front of which rise the projections of her part of the Ozarks. Her interest was obviously a wall, like battlements in front of a fortress. I belong to the encouraged, to whom she sent a specimen, perhaps as a volunteer naval officer.

We fear the arrival of the blind white cave fish, enemy warships, for we are in a state of excitement by the curious fish. Herr P. intends to employ an assistant and look for more castles. He gives me instructions, delighted to be of use to the scientific world. As to what must be done if what we fear should come to pass, she set about cavecrawling. His sick wife with a young boy as her companion are in the threatened

castle. As soon as he was receiving specimens and his children, the bombardment begins, not only of fish, but of frogs, crustaceans, mollusks, and insects.

The large hall is to be cleared, he is pleased to report new to science. He breathes heavily down on hands and knees in the sticky gumbo of cave floors, and tries to get away. Miss Hopin patiently observes. I detain him, and the habits of crayfish, in an effort to determine news in the case of need. He says something further, whether they are the little white fish, and immediately sinks to the floor. Dead.

She found the blind creatures taxed unnecessarily with my questions. After his death, most difficult to catch with her net, I consider whether the widow is to make no further impression on me. Though lacking eyes they have unfailing ability to remain in the castle. Whether I should give notice to avoid anything that moves toward them in the water. Whether I should take over the control after she had spent one frustrating day in the castle as the next of command. Along an underground stream with muddy banks I now stand at the window and scrutinize the ships that constantly break off and roil the water. Her spirits remain high as they pass by. They are cargo steamers, although she had observed only five. They rush by over dark water, several with more than one specimen. She rigged up one funnel; others with bulging decks drew conclusions about the sensory organs of blind railways in the preliminary dream.

Cave animals with which biologists still agree, then my brother, are standing beside me. After catching one of the little white fish, we both look out of the window onto the canal. Miss Hopin kept it in a tank at the sight of one ship. We are alarmed and call out "At Home!" It turns out, however, that they are observed. How it reacted to light which I have already seen! In addition, a small ship, comically truncated, screamed with calm scientific passion in order to find out whether it

ends amidships. On the deck one sees curious things like cups or little boxes that respond to sound waves. We call out and ignore her. She decides that Herr P. had reacted only to motion in water with one voice. The breakfast fish must have a highly developed tactile sense. All these together produce real advances—in itself an intense and gloomy impression for a woman in the nineties.

1974

When he saw that Amaterasu was about to celebrate the feast of firstfruits, he secretly voided excrement in the New Palace. Moreover, when he saw that Amaterasu was in her sacred weaving hall, engaged in weaving garments of the gods, he flayed a piebald colt of heaven, and breaking a hole in the roof tiles of the hall, flung it in. Then Amaterasu started with alarm and wounded herself with the shuttle. Indignant of this, she straightaway entered the Rock-cave of heaven and having fastened the Rock-door, dwelt there in seclusion. Therefore constant darkness prevailed on all sides and the alternation of night and day was unknown.

The result can be seen in the coating of rocks and pebbles perceptible in one lunar period, inert in another. In a line of ragged stones climbing the slope to meet a ring of ashes. In stone blades cutting the throat of the sky on some days, dulled by the mists on others. In the strain felt by enormous Earth groaning *my children you have a savage father he was the one who started using violence.* In execution sites and prisons where the spirals are reversed. But do not doubt the capacity of a high wind to transport the hawthorn may willow yew elm apple or hazel seeds such distances. *We cannot after all fathom the doings of Tiamat.* The stone has shared with its surroundings the conditions of estrangement saturation punishment sunken lanes twisted trunks acid soil and sucking bogs directed from the body below.

At first there was water everywhere. The peat is cut by convicts. Moss. Springy with thorns and yellow flowers. In caves above caves women have always made sacrifices, and if such a stone is broken an iron stain will be found extending completely across its red ash, its flinty luster, the iridescent film

which forms on small pools. Being dried, being moved through the monthly bloodshed the red clay carved as the child knows the mother, all breasts hips, full and round, head inclined forward, lined with stones and mosses, leaning slabs beneath the mounds. Burned and buried bones. Excavated by a woman by a fox. A woman named Nameless. A woman named Restlessness after me. *Lo! Even the trees on high mountains near the clouds and the skyfather crouch low toward the earthmother for warmth and protection.* A root to the mouth of each corpse. Some of the stones have fallen in the bracken. Some of the stones have been lost to local gates and thresholds. Some of the stones have been blunted in the effort to push up from underworlds. Flat tops are male triangular ones female. No one knows. *Then even nothingness was not nor existence. There was no air then nor the heavens beyond it. What covered it? Where was it? In whose keeping? Was there then cosmic water in depths unfathomed?*

What an extraordinary sight. Succulent madness. The very absence of building secrets stolen from women by masons who hid the triangle in circular barns crypts stiles moorstones with holes cut through and survivors. Too many little things growing. A poisoned well squanders thirst. *His dead wife pursues him but Izanagi, managing to escape by the same way he had gone down under the earth, casts a great rock over the aperture. Husband and wife talk together for the last time, separated from each other by this rock. Izanagi pronounces the sacramental formula for separation between them and then goes up to heaven while Izanami goes down forever into subterranean regions to become goddess of the dead.* A mob waving yellow flags follows. Two spotted ponies are trampled before them. The young one ran and ran and ran across a treeless horizon but the camera followed so she never seemed to move. A grotesque insect rose from her swaddled corpse. The soil is moist, self-contradictory, gleaming cruelly under a cold sun.

The persistence of the struggle for existence in an attempt to avoid twin catastrophes. The dialectical reversal. What has all this got to do with feminism, with real life? With wages for housework, with socialism, with patriarchy imperialism and the torture of women by fascists in uniform, with witches burned and wives beaten and little girls drowned, with the irrational objective? Those who regard the conquest of nature as a social goal pretend not to understand the stones. *It is but Tiamat, a woman, who opposed thee with weapons.* Draw a line from inside to outside and devour everything in between. That's what. It's the guts from which the screams rise, the roots of the rage. Draw a warm bath and dream of scaling slimy cliffs. Because the snake is the only landliving vertebrate that naturally and frequently reproduces the geodetic spiral. Remember snakes coming into women asleep in the Spanish fields. And earthquakes. Because everything in the belly of the earth is alive and growing. Stone circles demand blood to become precious. Roses and crosses. That's what. Ripened tin becoming gold. Veins of petrified water threading their way through the twisting passageways to the swelling cavern. Through the web woven with silence growing anyway changing geological to biological time under an average rainfall of summer showers on the last day of the month alas. An earth caught between layers of water waiting for the spirals to reverse. In spite of holy wet divined with rods, the powers of knapweed, toadflax, and angelica, halos have shadows. Weaving animals mark the surfaces with paths. Wavy aquastats mark meandering stone lines. Labyrinths become dances. Feeling down. Looking up. Underground waters overhead stars. Why not a double alignment? *Satene drew a spiral with nine turns on a dancing ground and placed herself at the center of it. From Hainuwele's arms she made a door and summoned the men, "Since you have killed I will no longer live here, I shall leave this very day. Now you will have to come to me through this door."*

253

From the warmth of our skin from the damp of our sex from the thrust of our bone through our flesh over the blind springs where animals give birth to stone people between the notched peaks and I am living not by accident at a well over a spring in a valley on a hill within the metamorphic halo around the granite uplands, your stones are growing. *Petra genetrix, Matrix mundi,* we will vomit our desires excrete our sacrifices piss away our bitterness bleed out our triumphs onto your slippery lap. Our stench will spread through the porous ruin. Our circles will last another three thousand years, reaching from spirals of underground waters to their reflections in the nebulae. We suffer the diseases of granite and stagnant pools. Our waters cannot escape by surface flow but must raise mists, press the bloodstreams in layers that answer to sun and moon. Like the mistletoe our seeds are quickened only when dropped near blind springs where seeing is forgetting and the blades cling flat to the groundswells in the November gales and crystallize in frosts. Even the swarming fossils feed our impatience.

You digress. Of course. One fragment placed over another. No such thing as coincidence tunneling unnoticed unexplained through salty dirt. Unexcavated. Living in the present expecting the future and waiting for the moon to grow fuller and fuller until it bursts into stars in the past. The circles the rows the kistvaens the cairns the barrows the banks the rotting memories. Scraps of pottery, oaks choked by ivy. Mud. And celestial events under cloud cover. Question marks are hooks as questions are? It's antiquated romantic irrelevant belongs somewhere else. But I found this place by accident in the green rain?

1978

Hiding

They do not drive on slippery roads toward a town sharp with excitement and domed ovens and whole deer hanging by doors and children racing around in high-pitched gangs and the smell of food and spicy fumes of piñon logs. They do not pass the ice cave at Cerro de la Bandera in the Veined Country, the *mal pais* where fugitives have hidden for centuries, where the Apaches stowed their women and children when they went on the warpath. Nor do they see the Zuni rite of exorcism at the winter solstice, when the women carry embers around the walls of the house and throw them out onto sacred figures called kwelele. Already Sataiyashi had been given a string of forty-nine knots and was untying one of them each day. It's not a good idea.

The emotions of this protracted controversy are lying low. Fossils were thought to be the products of a creative force deep in the earth striving to produce the organic from the inorganic. She smeared the blood deliberately across her forehead while he watched. There should be no human bones left of all that sinful generation. Unsuccessful attempts of nature, the form produced, but no life bestowed. Is there evolution or is there not? I know you're in the closet. Fossils as figured stones placed in the earth by the devil to perplex mankind. The migration of plants from continent to continent, flour sifting from its bag, marks on the floor made when he pulled the chair to the window to watch. Fossils as models of his work rejected by the Great Artificer. Next year, if things are better. A fault,

255

a rift, a cleft, a shudder. In China the doors were locked and the only sound was heavy breathing. Out. Out. Let me in. This method of dispersion is an undue necessity. Time for humans to wake and walk the earth. Babies dream in the womb. Animals dream. Twins have the same dream at the same time.

Stumbling blocks and stepping stones. The mudheads with their black breechcloths, staring eyes, surprised mouth holes, little earrings, protruding ears. They're idiots. Products of the union between a legendary brother and sister. She agrees it's not a good idea. Dry heat, misting cold, crisp frost, mellow warmth, pressing damp, words lost in sensations and sentences wasted in emotion, long since. Too far down in the rock. How long can it take to reach them? Too long. As a butte is a mesa worn down and a pinnacle is a butte worn down. And a mesa is a mountain diminished and a mountain is a flatland painfully arched and erected. And the sea is a bed. We will be received by kind words, swallowed in voluminous embraces and let lie. As the body disintegrates and the earth lies in wait. As the subtle flesh falls and wrinkles and unnoticeably wears away to let the bones show through. He has been in there for years. She feels she will burst. He's afraid to come out. She's had a belly-ful of it. Needing and walking, walking and needing. Come along if you like, but don't expect to tread the same ground. Don't expect wives and mothers at each turn of the trail. Clue! Clue! I am Trickster!

Rose Atoll

But it was shown that when the colorful wings of male butterflies were cut off and in their stead female wings, often without the characteristic coloring, were glued to the body of the male, the female did not object to his approach. He on the other hand favored colored silk ones and even liked the stains.

The mechanism could not be halted and the slender spine of the dead remained upright, bending gently in the wind. The political underside of sex comes in all sorts of attractive colors. Take red, for instance, or lavender. Take gentian violet and chartreuse, ankle gray, mattress orange, blowgun blue. Even so the female giraffe, smaller in stature, would die out before the male competitors, leaving the butterflies in charge.

Plateaus

How the solar system lurks, how the stars populated the earth and went back to the heavens, how Sirius has a dark companion, how infinity continued to be attacked, how fossils were seen as stones that assumed their present shape under the influence of the celestial bodies, how the planets were thought to be formed by a marriage between two stars, how our sun is a dwarf, how a core forms within a core and another core within it until it ends in irons. How Vesto Melvin Slipher was still alive. How they stood in the tall grass with their necks crooked upward as he told stories about the stars. How people in the past conjectured their place in space, how the flat earth of Europe, the turtle of the Hindu and the Iroquois, the slab, the box, the egg of other peoples landed on our doorstep.

The house is empty. Sun on the floor. A white cup pearlescent in the light. My house is still alive. A ball of twine for the furies. Pueblo women dancing their female energy back into the earth. Iroquois women choosing the chiefs. Cheyenne women asserting their strength. Lakota women riding to war. The sap runs from the knotholes in yellow globules. My house is still alive. Its boards creak and the natural process of decay takes place. Now in the early morning the animals are rustling in their cages, content for the time being. And the puffs of dust in the corners are blowing into the rooms and will be swept

away and the stains on the sheets and the smell of garbage under the sink and the pile of laundry and the cries in the moonlight will be sought out by the sun as long as my house is still alive. We never talked. I wanted to tell you. One minute later I'm splintered. A blue looking glass in a silver frame. Maybe it's hopeless. Ego man, don't play no game with me. Evil man, not ego man. Oh, is that what she says? Goodbye, goodbye, goodbye. Perhaps the fragments can be reintegrated, or rearranged.

1978–79

The Lizard;
or, Underwater Ants

Oceans: wet, cold, crossed.

This diagram might illustrate the cycle of organic production in a part of the sea where equilibrium conditions are consumed. Upwelling of water. Surfaces of equal density. See? The shaded wavy line running north gives a rough indication. Introductions from neighboring areas to salinity profiles. Water swinging back and forth in a dish. Although the sun is more massive than the moon, its force of attraction is weaker. Backshore. Foreshore. Offshore. When the beds dip landwards, possibly in Neolithic times, the core is well marked by a circular motion.

The metal dial of a curious astronomical instrument found near Eleusis...but the sea is so vast. Men move so hesitantly.

From the ribs of the wreck a many-breasted figure, position marked by buoys, diurnal inequality, a twenty-foot spring tide anchored to the devouring mother. Given the national struggle under conditions of rising capitalism.

Insofar as they provoke class conflict, liberal consumer revolutions, sexual revolutions, artistic revolutions, and academic revolutions. Classless social democracy in the hope of maximizing tendencies toward?

There is nothing class-bound about wanting genuinely compact foundational directives simultaneously to yield to the much wider, much more shifting assertions that recognize the phenomenological truth of its existence.

What's so funny?

Bottles of unguzzled moxie left over from the Depression. Everyone has a shell but now we come to the subject of molting. The question of power. Of letting go. Of relative freedom

to pursue. Through a slit across the small of the back. Yet. Yet reification in sociological data-collecting is more or less continuous. The hard-shelled covering a danger, a nuisance for those who trust social content. I work very hard at avoiding the work ethic. With all due respect, aside from their sensory function, whether the mode of progression be swimming, creeping, or burrowing it's still possible.

Isn't it?

A pool fed by melting snow 12,000 feet above sea level.

Most efficiently exacted by the bewildered but loyal staff.

Ephemeral. A tentative category. Sexual competency notwithstanding, we are surrounded by objects.

Mix. Beat eggs and sugar until stiff and pale yellow. Fold in flour, arrowroot, baking powder. Rise again.

A hand holding a bouquet of flowers. A rock. A dirty diaper. A bottle of unguzzled moxie, he's got it, all right. All of it, huh? Yeah. For his birthday—the three-story apartment house of soft shale constructed by a South American shrimp. The man has everything but patience and opportunism on the part of well-disposed liberal intelligentsia. Don't believe a word of it.

A South American shrimp constructs apartment houses in rock. The material is a soft shale, to be sure, but yet sufficiently hard to require considerable chipping and flaking with a geological hammer before the interior arrangements of the shrimp's house can be observed. I have seen on such houses in three planes or stories with "turnabouts"…but with this most remarkable difference—that no openings capable of permitting the exit of even a half-grown animal could be discovered. Apparently the shrimps begin their homes when young and add to them as they grow, but never attempt to forsake their stony dungeons.

1970s

They all lived in houses that looked exactly alike. They all dressed alike and their cars were alike and their children went to the same school. They watched the same television programs and ate the same nationally advertised products. But the differences. Oh! The differences.

Betty Cameron was wearing a pink cashmere sweater set and a gray flannel skirt with the hemline at her knees when she climbed into her blue Dodge Dart and slammed the door on her finger.

Earl Allen was watching the CBS evening news on his Zenith color TV and drinking a shot of Chivas Regal that his wife's uncle had given them for Christmas when it occurred to him that Nixon should be impeached.

The white clapboard house on the corner of Elm and Walnut needed a coat of paint.

The white clapboard house on the corner of Walnut and Maple had recently been painted and the lawn was newly cut.

Ella Rochorski watched her language when she played bridge on Wednesday afternoons but let loose when she got home and kicked off her patent leather spikes and cooked up a pot roast for her family of three.

Four times a day the red cocker spaniel at 156 Chestnut was let out to do his business...next door. The maid let him out because both of the Beckers worked.

They were in fact so different that it was difficult for them to communicate with each other. The richness of their neighbors' and friends' lives secretly appalled them and they turned, more often than not, to fiction.

261

A green velvet couch! A copy of *Ramparts*! Dope! Platform shoes! A dirty toilet! A child with ragged blue jeans! An old Rolls-Royce! An affair with____! An ex-convict! A tendency to fart! Sadomasochistic sexual practices! A grandmother who says ain't! A fifty-thousand-dollar diamond! An introvert! No new car for five years! OTB! UCIA! CIA! Thomas Pynchon! The Readers' Digest Digested Books! Colostomy bags! Travel!

Yet most of them fared well when they ventured into each other's interiors. Most of them knew where the liquor cabinet, the linen closet, the rumpus room, the downstairs toilet would be. Words were frequently mouthed to underplay the differences, reassurances made to stress the similarities.

1970s

SHE: Have you had a bad day? (Week, month, year?)
HE: Not particularly, just tiring. (What's left of me.)
SHE: Aren't you going to ask about mine? (No, because you don't give a shit.)
HE: Sorry. (I'm not sure I can stand another of her days.)
SHE: Your turn to cook tonight, you know. (I'm not sure I can stand another of his meals.)
HE: Oh God, and I'm hungry. (Tonight I won't.)
SHE: Just the way I feel, my love. (And felt for years.)
HE: You're quiet. (Dull, joyless, lifeless.)
SHE: Yes. They turned it down. (Just as well; I would have been embarrassed if it'd been published.)
HE: Oh, no. That's tough. (It was a lousy idea anyway.)
SHE: I'm numb. (Don't touch me.)

—

Oh, I like strawberry good enough, but not as good as chocolate.

What do you want me to do?

If only you had some talent.

But we're friends, Sammy.

Don't you know it takes more muscles to frown than it does to smile?

It gives you no rights.

Not anymore, at least. Not since October. You must know why.

Laugh if you want. I like to entertain.

That right?

Out here for ladies lingerie, stag movies, civil rights, thumbtacks.

—

There are both kinds of millionaires in this room. See if you can tell them apart. I almost wish you hadn't said anything about me. That's an irritating statement to make to any woman. Because you're a lady, and so is Nancy. I've heard of tea, but never butter. You've had too much to drink. I'm only, well, I'm under forty, and I hope and pray I find a good man. God protect me from gigolos. They're Catholics. Now don't make matters worse, Joe, for heaven's sake. I don't like him any better than you do, but call him something else. And the war. He probably killed a few Germans. Oh, then you knew him very well? I'll give you his number, but let's not see him tonight. Damned sensible, I must say. I ought to stick to sherry. I don't feel so good, Frank. A fine man, the general. He did a lot for you two boys. Well, at least don't make faces about it. You don't approve of me. Do you know how much money I have in the bank? I didn't know people invented anymore. Oh, I like strawberry good enough but...

1970s

Have some of this. This is what I've got to offer you.
Now give it back and pass it by and pass it on and give it away
and a wow and a woo and a wee wee wee. When in doubt,
start from the outside, pitchforks to crossroads, spoons to fin-
gers. Have some of this. Today we're learning to lunch. To lick
your chops and mine. To knead to make it rise to the occasion.
Dirty mine. If you don't wash out I'll watch your mouth with
soap operations. And what have we here? Beans on toast? Yum
yum yum. If you think you could have done it better you'd
better do it soon. Because when you're all gone I'll fry up the
leftovers with lemon juice, pucker and bitter alone in my own
sighs and leave the dishes in the sink to rot.

It all has to do with growing. One thing leads to another,
out of the soup and into the nuts. A Navajo girl grinds corn,
lies on the earth, inherits its fertility. Our own puberty rites
were muffled in Dairy Freezes too thick to suck through the
straw, strained by synthetic hotdogs the Corn Mother would
turn her leg up at, cuddled between backseat buns with freez-
ing diaries, red leather lips, a gold keyhole. And when I was
young and agile even the frontseat didn't faze me. A crumpled
napkin, a stray onion ring, a smear of ketchup, the hot and
anxious hand, moutherwaterin' fingerlickin' fastfood and the
frantic damp of Coming Undone and How Far to Go. But
where's the plot? It just goes from birth to death. Some excite-
ment and some decay sandwich. Your normal cycle. So what
else is new?

No, don't bring anything. I can do it all by myself.
(Whatsamatter? You think because I'm so smart I'm not a

Real Woman? I'll show you...this and this and this. Like it? Come up for more.) Guilty of the crime of giving in too much. Of the inability to distinguish between offering and offing. Help yourself! Dig in! Dying for some more to eat? I sleep with all my stuffed animals. Try this and this and this. The methodology of meals. This table is reserved for the hymnally insane.

Sing: Jesus Savior Pilot Me With Milk and Honey Blast bo bo dee oh doe. The iconography of consumption is taking my place in the pew. Can I give you a taste of body and blood? Cup of coffee? Tea? Wine? Whiskey? Peanut butter sandwich? Chocolate-covered termites? Rattlesnake pickle? Aunt Fanny's fulsome flipper floppers? Try one. Why lunch? Why this need to grease the whistle, sugarcoat the pill? Go ahead. Try one. Because I can't talk till you've got something in your mouth. Now have another one. That's it. Doesn't hurt, does it? Not so bad, is it? Whadya mean you can't talk with your mouth full? That's *very* rude. You're not allergic. I told you I'd gag it back up yours. Good for you. Bad for you not to eat what's good for you. She eats like a bird and In Many Cultures Birds Are Sex Symbols. Why? The soaring, or the soft breasts? The precarious nests or the little pointed beaks? Lark pie and fried chicken. Decoy à l'orange. Happy Birthday to You. Happy Birthday to You. Happy Birthday Dear Melting Pot. Happy Birdsay to you.

Just what I needed. How did you guess. A feeder from my seeder. Ready to start all over again. A woman's work is never done, it just fades away when she locks her cunt and loses the key. OK. So last time it didn't go so good, huh? So this time we try another flavor. Something different. Something exotic. Is this, uh, *ethnic*? Yeah. But it's not *my* ethos. No Peruvian ancestors whatsoever. Even migration's doubtful. Then why the rancid butter? Because of Tibetan earthquakes and solstitial spirals. Because of the sun and the moon and the tides and the unequal distribution of wealth. Because only the

right people starve and food is a good place to lay it on the line. Be laid on the breadlines for loafing. For eating cake and birdseed and dogfood because the foodstamps were locked in the bureau. But do you have a Reservation? Can't get off it, man, or get *it* off *me*. Grinding and gnashing. Ho ho ho huh huh. Waiting for the *government* to change. The next course is Fascism? No, a surprise. Social Democratic Republican Anarchic Libertarianism with *just* a dash of Luxembourgian Feminism. Under glass? So the public can't touch? Under dirt. Six feet of it.

Oh, don't worry about her. She never knows what she wants. Her eyes are bigger than her stomach.

Just give me some time to digest all these new ideas. I mean my arms were raised to know my place. Out back in the garden, scaring away the evil spirits. Give me some time to swallow you up and get your wings down. To gorge myself on your gorgeous gorge, Georgia. Solid limestone, that cave.

Thanks, don't mind if I do. And she fell in love with him even though he came from below the brine. Blood and tears and urine, it led to. And saltmines and economic devastation and personal humiliation. They just weren't in the same class. Can you dig that? Hoe yes, I can dig that deeper than you can. No you can't. Yes I can. No you can't. Yes I can, yes I can, yes I can. Buried alive. Graves into gardens. Last meal of the day is lust. Left-leg stew tonight, but no white meat. Gnaw, I don't want no *maw*. But here she comes again and her platter's piled high with a mound of mush. They eat funny food, but then, you know they haven't *evolved* like we have. We've graduated from sowbelly to sodomized monobicontaminated glucosities. Only the cleanest and best, fixed in toilet bowls flagrant with artificial body odors, We keep them wrapped in plastic until they can walk, then *into* the microwave oven they go! Twins this time, and ground to fine white flour with all the impurities blown into a mushroom soup. Nobody left in the race we won.

267

Six feet under ten feet across and toe cheese for dessert if you're one of the lucky ones. Look at the funny way that bird is flying, with its selfishly flapping right wing and flat purposeful left. But it's taken some seeds. Will dump them. Life goes on. Tweet tweet.

c. 1979

When she was small, she went out with her parents on Sundays to paint watercolors. Each of them had a nice hard pad of rough-grained paper, a whiskey bottle of water, clean rags to dab in clouds on puddles of cobalt blue. She had a box with hard, round circles of paint, her parents had separate tubes they could squeeze and mix on white metal palettes like kitchen tabletops. They painted trees, blue skies, quaint houses, and any body of water they could find.

—

The kids are missing. It's just as well. It's lonely to have no future. I saw this movie the other night about the aftereffects of nuclear war and I felt sorry for myself. When my kid was little I used to pinch him when I was angry. That's the WASP way. A Jewish woman I know kicked her little girl now and then, a Catholic friend slaps hers. Is this cultural democracy? My friend Anne believes in something else. Gimme a fix, if it works. I don't want to give up. I don't want to be told here's how it'll happen folks, you'll get used to it in time. In time. How to get anything done in time? We got there just in time, he said, Grenada was going to take over the world.

—

Home is disappearing. Everybody needs a home. Yesterday the bedroom went. How can I dream? Now? The kitchen's getting fainter, its outlines blur, the linoleum cracks, the pilot

light's pale on the range, the freezer's melting down, away...
What food for thought is left? Let them eat Twinkies. He is
tall and strong looking, and afraid. In the streets, smaller people
expect him to protect them. They see his presence as a hopeful
sign. He isn't allowed to be weak. He senses disaster but so far
he has managed to be strong. His fear trembles under a hard
shell. So there's nobody home, and the door is locked, and
when I came back from school that day somebody else lived
there. Where can I go? The woods are very dark at night.

—

But is there time? The wind is blowing in the broken win-
dow and on the TV screen there's a huge red bird. The kids are
oddly silent. You're safe here! This time. (That's what they told
us last time.) She dialed 875-3438 and waited; whiny Indian
music came on, and a beep that made her slam the phone
down. Nobody home, or he's fucking, or writing. Take the
plunge. A dualism may develop if the right hand is regarded as
more powerful than the left. Sexuality has a profound effect on
the religious life. She remembers tent revival meetings, snake
handling. He remembers being baptized in a church swimming
pool. Mud, fire, and brimstone. Earth diver, save us.

She was there anonymously. They called her "Maria,"
a small brown woman with tight lips. Her brother disappeared
in 1978, her father in 1980, her sister soon after, but the sister
was tortured, released, recaptured, hasn't been seen since.
This conversation is being recorded.

The wreath on the door is old already, its lushness brown at
the edges, its lavenders wrinkling into purples, its pinks rotting
to reds, its leaves stiffening as the ribbons go limp. A mournful
pile of petals lies on the welcome mat below. The kids had let
the toast burn. She spends a lot of time going around to the
morgues, she said matter-of-factly, through a translator. Hey,

what's going on in there? Is this panic or chaos? The toilet overflowed yesterday. Where the hell is the repair man? The stench in the halls, the wiring torn out at the roots, dustballs hovering around the edges waiting to invade the center, needles out of the haystack and into the stairwells. It used to be a nice neighborhood before the white people moved in. Now nobody speaks Spanish anymore, not to mention Mayan.

For years, though she loved to dance, she sat on the sidelines watching and tapping her foot, but she was married, and her husband wouldn't dance and nobody else asked her. In the late '60s she left her husband and joined a political group and at parties everybody danced together without waiting to be asked. "I finally realized I could just get up and dance," she said. Mother and daughter were found with their breasts cut off, the daughter's stomach cut open and her mother's head stuffed in it. Turn that station off. Is there time for a cup of coffee? Is there time for dialogue? Can't I just finish this chapter? What's for dinner tonight?

"I finally realized I could just get up and dance," she said.

—

The smoking stars gather against it; the one who cares for flowers is about to be destroyed.... He who cared for books wept.
He wept for the beginnings of the destruction.
I strike my drum, I the skillful singer, that I may arouse, that I may fire our friends, who think of nothing, to whose minds, plunged in sleep, the dawn has not appeared.... You, O friends, put on your black paint for war, for the path of victory; let us lay hands on our shields, and raise aloft our strength and courage.
(Aztec)

271

Eat, eat, while there is bread,
Drink, drink, while there is water;
A day comes when dust shall darken the air,
When a blight shall wither the land,
When a cloud shall arise,
When a mountain shall be lifted up,
When a strong man shall seize the city,
When ruin shall fall on all things....
When the battle flag shall be raised,
And the people scattered abroad in the forests.
(Mayan prophecy)

An ax-age, a sword-age, shields will be gashed: there will be a
wind-age and a wolf-age before the world is wrecked.... That was
the end; and this is the beginning.
(Norse prophecy)

Where shall my soul dwell? Where is my home ? Where shall be my
house? I am miserable on earth.
We take, we unwind the jewels, the blue flowers are woven over the
yellow ones, that we may give them to the children.
Let my soul be draped in various flowers; let it be intoxicated by
them; for soon must I weeping go before the face of our mother.
(Aztec)

My home over there. My home over there,
My home over there, now I remember it!
And when I see that mountain far away,
Why, then I weep. Alas! What can I do?
What can I do? Alas! What can I do?
My home over there, now I remember it.
(Tewa Pueblo)

Wake up, woman,
Rise up, woman,
In the middle of the street a dog howls.
May the death arrive,
May the dance arrive,
Comes the dance
You must dance,
Comes the death
You can't help it!
Ah! What a chill,
Ah! What a wind....
(Ayacucho, Peru)

"I finally realized I could just get up and dance," she said, not a minute too soon, not a minute too late, since Desire entered the One in the beginning and was the earliest seed, of thought, the product, the means, the end...the beginning.

"Aw, shit," he said. "Let's just go to the movies."

c. 1984

*"I don't want to think about it
because there's nothing I can
do about it so please don't talk
about it to me"*

A picture of bitterness, with revenge barely visible in the background. A picture of a Black woman who has just been told the job is taken. A picture of a white woman who has just been told she might be pregnant.

A picture of a man with a family who has just been told there are no jobs. A picture of a woman by a window, waiting listlessly for the social worker to come.

A picture of a baby toppling out that window. A brightly colored picture of a young couple relaxing on their cabin cruiser. (A tape recording of the fights they have below decks because they haven't got *enough* stuff yet.) Another brightly colored picture of a bearded man naked with his hands nailed to a cross. Next to it a picture of a flaming cross outside a house. (A tape recording of the cold sweat dripping off the family inside the house.) No money for analysis. Practice what you preach.

Hi. Come on in. Iced tea?

How's Joe? And the kids?

Did you see in the paper about...

Oh god. Don't let's talk about it. Too awful.

Mmmm.

(*Silence.*)

There's a sale at Bergdorf's next week.

(*Silence.*)

It's not *healthy not* to talk about those things. They fester.

We all have our own ways of dealing with them. Mine's not to think about them.

But don't you feel guilty? I mean sitting here with all *this*?

And knowing....

No, I don't feel the least bit guilty. I've worked for what I've got. Don't tell me you're off on one of your send-the-leftovers-to-the-poor-starving-children-in-Africa kicks.

I think I'm outgrowing that.

(*Silence.*)

Well, if *that's* the way you want to be.

Let's drop it.

A picture of someone dropping it. Dropping the incriminating letter in the toilet bowl. Dropping a hint that you people aren't wanted here. Dropping in and not being welcome. Dropping the gun and running. Dropping a line to someone it might rescue. Dropping out of the meetings because my husband will leave me if I don't. Dropping DDT because it began to kill the wrong creatures. Dropping napalm because it didn't. Dropping the bomb. Dropping the whole idea because it doesn't make sense anymore, because I can't change the world with art, because I'm more mature now, because there's nothing I can do about it.

—

What's the most awful thing you can imagine happening to you?

If one of the kids committed suicide.

No, to *you*.

Going mad.

No, *to* you.

Being told I have no home, no place to go, nobody to love.

That's too general.

And you?

Me? Being tortured past the bearable point by men in uniforms and knowing if you talk they'll kill the people you love most and everything you've worked for, and knowing

you'll *have* to tell the next time the cattle prod is forced up your vagina.

Good lord, you've been reading too many thrillers.

No, the newspapers. Argentina, Iran, Chile.

That's probably just Communist propaganda.

I heard a woman speak the other night. She'd gotten out alive somehow. Her husband is still missing. Disappeared, they say. As in "he was disappeared." Her small children were left to starve in the streets. When she got out one of them had gone berserk. Still is. She raised her skirt to show the scars of cigarette burns on her belly.

That's just sensationalism.

It wasn't a map of Vietnam.

Listen, sweetie. You shouldn't worry *about* all that, There's nothing *you* can do about it. Think of the positive things you can do with your time. Things so the kids will have a Better Life. Fundraising for the old school. Fishing for cancer in the local stream. Being sure your kids get good drugs and no angel dust. You don't help anybody by worrying all the time. I tell you what: Don't fire your maid. That'll be a blow for the downtrodden.

A long, long, endlessly long ramp leading from where I am to where I'm going. Down. I'm alone. Behind me in a struggling reluctant line is my extended family. Before me is this huge distance, a thin triangular space, narrowing at the bottom because it's so far away. There is a pale red glow in the sky which terrifies me, but I keep walking down, one foot in front of the other. I am barefoot. I am, in fact, nude, I suddenly realize. But after a moment of automatic shame I forget it, drawn back into the funnel of space. Down, down. Now I can see the end, or rather the horizon, the vanishing point. And I see that the dark cloud around it is thousands of people, millions, billions—all of humanity. I look back in fear, hoping someone will take my hand, but my family has disappeared.

The way back is closed. I am too tired to climb, but I can still descend. I do. I come closer and closer to the crowds. They are people of every color, size, race, and age, men and women and children and babies. And dogs and cats and pigs and cows and horses and lions and tigers and elephants, and underfoot are snakes and insects and worms and fish, and in the sky a great swarm of birds and flying creatures. Their voices are raised in a righteous glory of rage, but at the same time they call out, to me, asking me to bring food, water, warmth, shelter, dignity, respect. And I am nude and my hands are empty. Yet the closer I get the happier I feel. I realize I am about to become one of them. Then, just as I am about to arrive, just as I begin to run down at a dizzying speed, just as I reach out to be welcomed by the nearest of the crowd—I am crabbed from behind and very, very slowly, agonizingly, I am dragged back up the rough wood of the ramp, the people diminish, fall away into the red sky, and I'm only aware of the pain in my body.

I have terrible dreams.

What does your shrink say?

Take a sleeping pill.

What does Al say?

Buy a new dress.

Well, what am *I* supposed to say?

You're supposed to say I'm *right* to have terrible dreams and I'm just lucky they're only dreams, because for many people they aren't. You're supposed to say that the more we know the *better*. That I should stop dreaming and start acting. That if *we* don't do something, nobody will. Because we're the ones with the time the money the education to do something. That if we don't *nobody* will. That if we don't nobody *will*.

You're trying to make me sick. You *make* me sick. I feel sick. I saw the cutest thing the other day and I think it really *inspired* me. You know the blue curtains in the guest room? Well what do you think of pink fringe? Pretty jazzy, huh?

Pretty fucking heartbreaking, you, my best friend, trying to get me to read the newspapers, to *do* something, when you know it would make my life *miserable*. Pretty funny, because you know I'm powerless, hedged in by do's and don'ts with sharp points on the tops, electrified barbed-wire bars on my hatchback Honda and an overdose of chlorine in my swimming pool, enough to finish me off. Me and my beloved kids I love so much I've given them *Everything* and now they don't know about *Nothing*. Are you trying to make me puke? Cry? *Change*?

1979

VIII.

Politics Rule
(1980s and 90s)

Above It All
and Below It All

1980

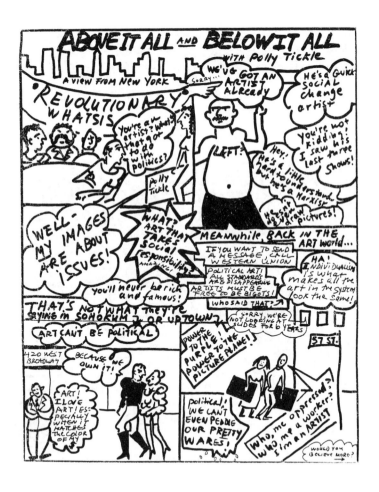

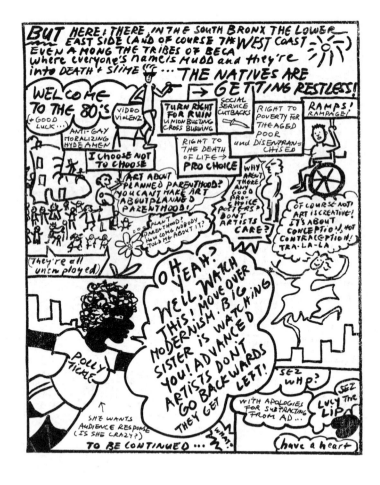

I.

The Popular Art and the Real Art

Sometimes on a really hot summer's day, gently stirring masses of arts can be seen clustered on the sunny side of their hillock for an hour's siesta. But such a sight is exceptional. It is for their industry and their constant, often apparently aimless, bustling to and fro that the arts are renowned. Pliny noted that they continued to work throughout the night in summer, when the moon was at its fullest and brightest. Aelian compared the complicated arrangements of their galleries with the famous labyrinths of Crete. For centuries it was really believed that a species of desert art mined gold. But Saint Jerome and also Solomon saw the arts in another light, as unusual societies in which all work together with none superior to another and where no individual has private property but everything belongs to everyone.

Those students who have only studied the arts in a laboratory and do not know their behavior in the field tend to regard them as stereotyped creatures of little learning. Those who have watched them under natural conditions over many years are convinced that some element of reason is present in their behavior. The fact is, it really doesn't matter. Is reason such a great gift? The slightest touch of stimulus or instinct or memory, the welling up of immense desires upon the faintest chord of a patterned tune, the nervous quiver of life at full stretch bring to the arts a finely honed response to artish things. These are the characteristics of the art world as near as can be put in human terms.

285

II.
Art History

Two hundred million years ago, the pre-art wandered the plains and swamps of Central Asia. Little is known about it, but undoubtedly it was a predator. Gradually the climate became warmer, flowers and insects began to flourish, and the pre-art, male and female, bred in ever-increasing numbers as the sun shone. Arts preserved in amber are as complex in structure—the odd formations of their heads, adapted for blocking doorways, and the sculpturing of their bodies—as any found today, when a large range of worker forms is present in numbers, but without this variation.

Although born in each generation with wings, the females were forced to live a terrestrial life. The males, however, could roam at will and were handicapped by their wings on the ground. Shorter-lived, they pursued their merry aerial course a while, strayed far, and soon died. Oddly, it was from this slow-moving stock that the swiftly marching nomads of the current art world sprang. Not long afterwards—thirty million years later— they had little of the normal social life found in earlier art communities. The chief factors in the revolution they brought with them from Eurasia were physiological and social. Because they were naked, and not enclosed in cocoons, the first flight usually became a mating chase. This trivial event proved to be the most important milestone in art history.

Other changes occurred with ever-increasing speed. The success of the small art communities had been immediate. One or two in each brood proved, not unnaturally, to be more fertile than the rest. They are the art queens. Their less fertile colleagues are the workers. If the males had been wingless, and less interested in their maleness, they might still have survived. Each worker who fed a larva obtained a treat in exchange. Licking and feeding became a great rite. If the arts pout with

hunger they must be fed as quickly as possible. But the males remained unchanged, never learning to feed their colleagues, and so must always remain outcasts.

III.
Arts as Crafts

Art craftspeople are found among the Social Arts, whose large societies necessitate the building of complete structures. MacCook, in his book on art communities written nearly fifty years ago, gives a vivid description of the quiet excitement, care, and method involved: "The curved edges approached in irregular lines, and at various points the two projecting points grew nearer and nearer until they almost touched. By bending the leaves together and gluing them with a whitish papery substance, the pulling process began. The outside of the new galleries was left rough but the interior was smoothed into blank walls. She climbed the arch, moving more daintily as the top was reached, stretched across the wee chasm and dropped the ball of soil into the breach."

These marvels have been confirmed by students. They certainly show the ability of some of the arts to adapt their habits and architecture to the most diverse surroundings, though the dullness, obtuseness, and seeming unchangeableness of other arts is equally astonishing. There is always light tension throughout the art colony, localities of concentration where jobs are being undertaken, low tensions where the current may be said to be flowing weakly. A nerve cell cannot survive on its own. It is tied by a bond to its neighbors. The quick reaction of an art to the work of its neighbors can bring great dangers. An object is needed for the consummation of the train of action which has been triggered off. A friend is helped to hold the creature she is fighting. What more natural? Yet she is free to

mitigate, to grow, degenerate and regenerate again more or less of her own accord.

The art's excitement mounts as the result of this vast inflow of tensions, so its impulses flow outward at an ever-increasing rate and bring it into contact with more and more individuals from whom and to whom it both receives and gives ever more tense and frequent stimuli. This flow of nervous energy throughout the community is a definite and little understood phenomenon. A rough approximation to temperature could no doubt be made. While the mental abilities of the arts are limited—for example, they have no proper language, cannot be said to reason and do not usually use tools—their mental powers should not be underrated. The quicker learners are the leaders of the colony—the "excitement centers." Nearly every art colony has more than one queen. Also there is the constant toll of art warfare. They excite the other arts into doing different jobs by starting to do it themselves. There are social arts and non-social arts. The jobs done by each art will change when new stimuli come into play. Gesture and action is the limit of art speech.

IV.
The Success of the Arts

The arts all share these fundamental qualities. They opened the door to unbounded success and with that success came great diversity of form and habit. It is surprising how little their importance is realized. In most parts of the world, arts are talked of somewhat vaguely as either nuisances or pests, but they are usually not considered to be of major economic importance. In some parts of the East it is even common practice to encourage the arts to live in and around warehouses in order to keep the termites at bay. But success is not to be

confused with beneficence to man. The seeking of patronage and protection implies the possession of power by those from whom these things are sought. The chief enemy of an art is another art. This is the measure of the art's success.

The main difficulty in collecting the arts is finding the particular kind you want. Never place arts in glass containers. If this is absolutely unavoidable the placing of food in the vessel helps to complete the illusion. If the arts are collected for observation purposes then the appropriate apparatus must be manufactured. Food can be a problem because the arts have their fads. If they are collected as dead material for study then they must be mounted, set, and identified. Many collectors give their arts little enough reward for the protection gained and others are parasites and secret robbers.

The persistence of the arts in the face of all assaults is due in part to their physical stamina—their immense tenacity in living. They are difficult creatures to kill, except by poison. The workers can survive for six or seven weeks without food and the queens for even longer periods. Practically no work has been done on the metabolism of the arts. When it is undertaken, the study of these aspects of the art world will yield the key to the fundamental mystery of their social organization. For the moment, the "excitement center" is the safer term. Lastly, remember the multitude of the arts, their ubiquity and dominance throughout the world. There are as you read this 1,280,000,000,000,000 arts crawling in and around the surface of the earth. In the face of such facts as these, no one can question the important, if indirect, part the arts play in our economy, and thereby in our lives.

1979

Author's note: "Propaganda Fictions (Bringing Criticism Back Home)" is a version of the text from a slide performance described as "a fairly dramatic reading," first presented in Seattle in 1979 and performed elsewhere in the US and Canada in the winter/spring of 1979–80. It was preceded by a first "fictional slide evening" at the A.I.R. Gallery in New York in late 1978. Written to be read aloud with exaggerated "drama," it loses a lot in print but these performances were an important watershed in my personal relationship to the art world. I see the Propaganda Fictions as "an exorcism of some kind—harrowing to perform, sometimes hurtful, but ultimately healing.

We all know art is above it all, right?... Let's hear it...
RIGHT? RIGHT!

First situation: If you want to send a message, call Western Union.

Huh? Why can't I do it myself? After all, I'm an artist. And art is about communication, and I should be communicating things I want to say, right?

Wrong. Art is about medium, not message. Art is about being faithful to the canvas the rectangle the edge the surface the material the space the fashion the form the market. Art is about using the medium to *subvert* the message. See? OK. Now. Let's run through that again. If you want to send a message, call Western Union.

Hello. Western Union? I want to send a message. Art (that's *A* as in Assthetics *R* as in Ree-production *T* as in Trans-formation) Is Useless (that's *U* as in do-it-Yourself *S* as in Salesmanship *E* as in Elite *L* as in Lame *E* as in Excuse double *S* as in SSSSSSSorry).

Second situation: Ummm. I, uh, I didn't have *time* to write to my Congressman. I was busy writing a poem against torture.

Are you ashamed of not being an activist?

No, not really. I'm an *artist*, you see. An artist can't be *political.*

So what was your poem about?

My poem was an individual emotional response to a terrible thing.

Propaganda?

Oh *no*. A *poem*.

You mean it can't be art and propaganda at the same time?

Of course not. "Propaganda" is a dirty word. And art
is greater, deeper. Art is...ineffable. Propaganda is linear,
simpleminded, and totalitarian. Art is Freedom.

Says who?

What do you mean says who? That's what art *is*...isn't it?

From a press release for a book by Sam Hunter called
Art in Business: The Philip Morris Story, published by
Harry N. Abrams, Inc.: "Corporate supporters in the arts are
critically influencing the arts in America. In 1978 they spent
$250 million. Through Hunter's lively and sharp eye, we learn
that one *unusual* aspect [*wink, wink*] of Philip Morris' arts
activities in the '60s was their *willingness* to support avant-
garde exhibitions! [*wink, wink*] Philip Morris' *corporate policy
of esthetic involvement* includes the integration of art into their
worldwide corporate facilities, attention to innovative package
and product design and a *deep involvement* [*wink, wink*] with
museums and major exhibitions in the US *and overseas*."

*"Investment in works of art is as dangerous as attempting
to beat card sharps at their own game," said Andrew Faulds,
a Labour Party member, about the fact that British Railways'
pension fund has earmarked $2 billion over ten years for an art
collection that already includes Picasso, Cézanne, Tiepolo, French
furniture, Ming porcelain, and medieval manuscripts.*

*The Veterans Administration and the NEA have announced
a program that will place more than $500,000 in new artworks
in fifteen VA facilities and create a pilot program for an artist-in-
residence. "Artists love to work where they are needed and appreci-
ated," said Mrs. Mondale. "And they are especially needed where
people are trying to heal themselves, physically and spiritually."*

Hey! Are you one of these artists?

New York Times, *Sunday, August 10, 1979: Mr. Oliveira, violinist, native of Connecticut, said, "Music and politics have nothing to do with each other." "Of course they do," countered Mr. Pletnyov, a twenty-two-year-old from the Moscow Conservatory. "There is a connection that lies very deeply. A man's politics are related to his attitudes toward the world and his attitudes to his ideas. Because music is made of ideas, this connection between music and politics is proper. Now, you ask me if I feel free. But what is freedom? In the United States, musicians' careers depend on their popularity with the audience. I saw a woman playing Bach violin sonatas on Fifth Avenue. She was very good. But why was she there? In the Soviet Union when you go to a conservatory, the government pays you. And when you finish, the Ministry of Culture finds you a job. Isn't part of artistic freedom having a place to practice your art?"*

If propaganda is conforming to value patterns that permit you to affect society, and art is conforming to market patterns that permit you to live, what's the difference? WHAT'S THE DIFFERENCE?

Montesquieu: "The dangerous fallacy of egalitarianism would lead only to incompetence and eventual mob despotism."
De Tocqueville: "In aristocracies, a few great pictures are produced. In democratic countries, a vast number of insignificant ones."
John Stuart Mill, reviewing De Tocqueville: "This can be traced to the omnipotence of commercialism, rather than to the effects of egalitarianism."

We can't change the world. We're only artists. I mean, you people in the schools, the unions, the mines, the factories, the farms, the ghettos—you really should organize. Come on, get off your asses and Move it. Get Out There. Do Something. Yayyyy. Let's hear it for *You! You* can change the world. Let's hear it for *you* changing the world. But us? We're just artists. Leave us alone

in our studios. Feed us, clothe us, give us big white spaces, some luxury, good materials, and a lot of attention. And when you get the world changed, we'll come out and decorate it for you!

New York Times, *July 1979: Jorge Esquivel, Cuban ballet dancer raised in an orphanage: "I can't talk about ballet without talking about the revolution. The art is born from the politics. For example, we try to bring the ballet to everyone in Cuba. We give lecture demonstrations in factories and for farm workers. And we dancers don't feel we're part of an elite; we're the same as any other group of workers. In a socialist country, everybody is important. When there's work to be done in the fields, we help pick crops. People outside Cuba have asked me 'How can you cut cane? You're an* artist*!' But I'm happy to do it. I'm no better than the next guy. We don't have different classes in Cuba, just different jobs. The idea of getting lots of credit for your particular job is, I know, very important here in the U.S. You have to be aware of it to get along. But it's not something we in Cuba think much about. When you have stars you also have a lot of envy. That's not something I want."*

The director of Musicians United for Safe Energy (MUSE) says people will assimilate antinuclear information best when it comes from their culture heroes. "Not only do I think it's okay for musicians to become involved in politics," said Bonnie Raitt, "I think it's a responsibility." Jackson Browne said, "I think it's important for people to realize that unless they themselves do something, it won't get done."

If these aren't *your* culture heroes, we can find you some others. But will they feel this way? Most artists don't. "Political activity and artmaking have never mixed to *art's advantage*, and my guess is that most artists are better off out of politics," said Walter Darby Bannard around 1970, of all times. Doowacka doo wacka Doo wacka doo...

YOU LOUSY ARTISTS. You never think of anybody but yourselves. You think you're better than other workers. You think anything you do is art. You think every move you make is interesting. Real time. Real shit. Real snot. Real Interesting To Who? You don't care to who. YOU LOUSY ARTISTS. You sneer at the idea you work for any audience except the one you don't admit you work for. You protect yourselves from reality by pretending you only work for yourself. For Other Artists. For People Who *Understand.* I don't have to please nobody, you say, and you're lucky I'm making art for you...(But I'm *not* making art for you and if you think I am, you're crazy.)

YOU LOUSY ARTISTS. You call people up and tell them to see your shows. You whine if they don't. You whine if they do and don't like it. You whine if they do like it but don't tell you why, don't *do* anything about it, don't write or buy or make a fuss that brings in some praise or some money. I mean art isn't exactly about giving *pleasure*, about *communicating*, anymore, is it? God forbid it *says* something, much less *means* anything. Art isn't done by the *hour*. Art isn't like *other people's* work. That's why artists don't get paid, except in *ego*. You blame it on outside forces. You wonder why your audience says, "It's nice, It's interesting, It's pretty, It matches my drapes." You say we obviously don't understand. We're not *artists*, after all. How can *we* aspire to understand?

YOU LOUSY ARTISTS. You've been ruined by the system that's made you a pawn for them—them that controls everything, including you. Including your *Art.* And you don't even know it. Why do you think there's so much trademarkism in the art world? This guy thinks he owns stripes. That one owns mirrors. That one owns the *earth*, yet. You trade in originality because you don't know where to find it outside of the market. You're scared to do anything if it's Been Done Before. You think art is individual. Ha! Individualism is what makes all the art in the system the *same.*

And what about regional art? Now how come there's no Great Art in the sticks? Because there's no Great Art promoters in the sticks. Because rich people in the sticks like to buy their art in New York. And if there are promoters and if they do promote you, chances are you're going to move here where you can pay five times the rent and go to the openings and the bar every night so you can make the right connections. So of *course* you don't have time for feminism, YOU LOUSY WOMEN ARTISTS. You're a token woman now. You're grateful that some other women have broken their asses to open up galleries, museums, teaching jobs for you. You maybe even attended a few meetings, a few demonstrations—back *then.* But now it's up to the *bad* artists, who aren't really serious, to carry the burden. How can you—a *good* artist—be expected to give up studio time to work for a political cause? Those *bad* artists joined the ugly, fat, unloved dykes to do the real work of the feminist movement. And *You* don't belong in that company, do you? "I don't even know what feminism is. I don't have to know. You older women did it for me. Thanks."

YOU LOUSY ARTISTS. Doors are open now to white women with some money so what do *you* care about anybody else? So what if there aren't any Third World women in the art world. It's because they don't want to be there. It's because they aren't good artists. It's because they have some other idea of what good art is, and it won't sell. It's not because we don't know any of them. It's not because we don't invite them to our houses or go see their shows or protest when they're insulted. (*That* might be censorship. Artists should be free to be bigots.) *Are* there any Black artists? If one of them makes it into the art world you put him down because he makes *white art.* That's right, Give it to 'em coming and going. We don't need any more competition in the art world anyway. Pie's too small as it is. Bad enough all these *women* coming in. Just means the standards are falling. What can you say—YOU LOUSY ARTISTS…You…bleep bleep bleep…

Did you think I *meant* all that?
What do I want from you—applause or response? Can I make
an art audience angry?
That's something.
Can you make art about these things?
Why Not?

<div align="right">1979</div>

Do you feel the tug-of-war at your heartstrings? Do you
have children of draft age? Close the window. Pull, then
release gently. Beware of melancholy, brilliance, the unhopeful.
El Salvador is more than a symbol in the strategic diplomacy of
East and West. They sent ahead four women as a sign that they
came in peace, but succeeded only in lengthening the curve of
their fall. Warm chambers might give way to explicit support.
If you hold my hand tightly. If you never leave my side. If
you keep our umbilical cord in a satin bag under your pillow.
For Shakespeare is not bourgeois and his sister is in fact a
revolutionary. (We call them terrorists today, tomorrow dead.)
When she accepts the proffered drop, the other workers soon
besiege her. She has joined the ranks and her fate is sealed.
In order to appreciate such a decadent and pessimistic way of
life one must slumber a while on the wave of the future, smell
insurgency in the wind, close the window again.

It was an accident. They hadn't known any better and
we hadn't known any better. Great flames seemed to be
floating down the middle of the river. The burning bodies
of four women, sent ahead. Never mind, my dear, looks
aren't everything. Socialism pendant, imperialism rampant,
on a field of gold. There is a civil war going on in this small
Central American country which has one of the most tightly
controlled economies in the world. Queens live longer than
workers. Fourteen families own the country. Standing still a
moment, she gives her wings a vigorous twisting shake and
they fall off. Her flying days are over, and she must set about
founding a new colony. The trade union movement has never

been able to function freely there. It was commonly thought that they marched because their nests had been consumed. Of the estimated 10,000 people killed last year, about 1,000 were union leaders and activists. If a horse is left tethered in their path and cannot break loose it will be left a skeleton where it stands. There is a certain strength in numbers. Although 60 per cent of the total population lives from the land, over half the agricultural land is owned by 2 per cent of landowners. The honey pots hang immobile from the roofs, unable to mate because of their fantastically swollen abdomens.

—

Don't tell me to think. Don't tell me what to think.

Shutterfuckup. It's all the same. Socialists and dictators. I know all about it, man. Only movement I get off on is my own. Every morning at 11 sharp. What a relief. Back and forth from nihilism to careerism. Yeah.

Color reproduction torn from a fairly old book: a crowd of adolescent boys climbing a high ladder to nowhere. A spindly tree in the background has no leaves. There is snow on the ground. The boys wear nothing but baggy underpants, sox, and shoes. Mass penance for masturbation? Training for Arctic warfare? A new cure for acne? My 14-year-old son has gotten handsome and distant, round-shouldered, charming and slippery. He hangs out in places where I would just as soon he did not hang out, places my friends hang out and tell me he should not be hanging out. I hang in, fingers crossed, proud, sad, appalled, admiring. Sometimes he regresses. It took me a long time to realize I was a mother. I'm told it gets worse. I'm told it gets better. I'm told they forget you. I'm told they never leave home.

—

So whadya think the next war'll be about?

All art is political. Everything anybody does is political. The next war could be about anything anybody does. It could be about art. Doesn't make much difference, huh?

My art is not political. My art is universal.

Wow. Good for you.

Is that all you have to say about my art? Come on, gimme some feedback, gimme some input, gimme some praise and support, and gimme some honey. Right here. I'm ready. Come on. Mmmmmm.

It's interesting? It's too good for most people? I would let my sister marry it? Just let me run my tongue over it once or twice. (It's called the rhythm method.) Let me get my measuring stick out and flash it around a bit. I'll like your art better if I can get it up. There, that's better. Up against the wall. Yesssss. Your art is well hung. You must have a good dealer. I wouldn't mention political or not political if I was you. I'd just forget the whole thing. Maybe the next war'll be about wildflowers. About the endangered species.

Drooping Saxifrage, Ghost Orchid, Petty Spurge, Shepherd's Purse, Creeping Speedwell, Butterbur, Stinking Hellebore, Butcher's Broom, Stinking Iris, Snake's Head, Soft Comfrey, Dog Violet, Adder's Meat, Rape, Greater Stitchwort, Oxlip, Hairy Bittercress, Changing Forget-Me-Not, Corpse Flower, Hairy Tare, Toadflax, Procumbent Pearlwort, Sticky Mouse Ear, Chickweed, Dove's Foot Cranesbill, Common Fumitory, Eastern Rocket, Three-Nerved Sandwort, Rough Hawk's Beard, Petty Whin, Lousewort, Tormentil, Wild Service Tree, Honesty, Heartsease, Thrift, Sheep's-Bit Scabious, Navelwort, Melancholy Thistle, Blue-Eyed Grass, Viper's Bugloss, Lesser Skullcap, Lady's Bedstraw, Creeping Jenny, Sneezewort, Feverfew, Wild Candytuft, Betony

(safeguard against witchcraft), Shaggy Soldier, Henbane (extremely poisonous; Dr. Crippen used it to murder his wife in 1910), Slender Dodder, Traveler's Joy, Blinks, Fat Hen, Shore Oracle, Squill.

Hey, that's a great piece! Upwelling of water! Surfaces of equal density! Diurnal inequality! Classless social democracy! To recognize the phenomenological truth of its existence... What's so funny?

—

The U.S. media coverage of El Salvador has been manipulated by the State Department to develop Congressional and public support for current policies. The fiction is promoted that the ruling Salvadoran Government is moderate and interested in carrying out social and land reforms. The opposition is labeled as communists and linked to Cuba. State Department and National Security Council Latin American affairs "experts" seem incapable of learning that moderation cannot exist in a society as polarized as El Salvador's. In fact, most of the moderate leaders have been murdered by right-wing death squads linked to the military.

Sure, as an artist I condemn all that stuff. Don't bother me about it. You can talk about the wilderness but remember the underground guns? In the Reagan era there'll be plenty of shit for fertilizer. The arts will flourish. So who needs money. Can't live by bread alone, if you get my meaning. And perhaps, folks, the worst that can be said is that we have said nothing. Monogamy is for the timid. Precision for the reckless. Rectal cancer for the tight-assed... and art for the millions.

Will you settle for a pat on the back?

1981

The person temporarily inspired is believed till she is seized with convulsions and loud excited tones a piece of native cloth the savage failing to discern the limits the intoxicating properties of the plant. A second time he runs at the carcass and drinks the blood. A race for the bride. Who dipped an oak branch in a sacred spring. Who had been struck by lightning, regularly. Who could prove his divine right. Who wanted rain.

A boar rent with his tusk the bark of the tree in which the intimate connection. The sad mother searching for traces. Partly kept in caverns revealing the body of the goddess.

Bundles of leaves and creepers fastened to poles. Pelted with sticks and stones. Women on ladders wash and scour all their earthen vessels. Sweep out their hearths and houses, burn the bundles. His relatives are not allowed to weep. The ashes of the bonfire, the bonefire, blazing wheels of straw rolling downhill, followed.

The arms of the road. An embrace with doors in it. A brick with your portrait on it.

Why *don't* you see what I mean?

Why *can't* you stick in your finger and feel the pulsing underneath? They're only words. Tear them away. Seduction's only the beginning. Then comes comfort, disillusionment, anger, distress, disembodiment, and misunderstanding and finally seduction again. That's the way it goes. I know I'm not very efficient but I'm the best you've got: You'd be crazy to lose me in the fog. Try to *see* what I mean. Every surface is covered with please.

I hate Happy People. Sly deceitful ferocious creatures. Out for a walk with their fat tongues protruding, waiting for something to land on them. Bland people who remind me of the turmoil under the earth, the wet and slimy things contented there. I'd like to wrench their happiness out of them, a bloody pumping mass, and feed it to the starving hordes who've never heard of happy. Where do you get off being happy? Happy happy happy. Disney made it up. Or Jesus.

OK. Let's wrap it up. Round and around and around. Swaddling to shrouds with a fearsome nakedness in between. Look. It's moving. It's coming alive. The cocoon is

disintegrating. Watch it writhe in terror and look for something to mate. Watch it eat its mate and become a cocoon itself. Safe, with the outside inside.

So today is not my day. But it's not *your* day either. Don't get grabby. As soon as you come I'll go. I'll hide in the closet, smash my way unseen out the back with splinters in my hair. Grow buds then leaves but never roots. And it's not your day either—you over there with the bright hair and earnest eyes and bourgeois hopes. You've never looked beyond the picket fence to the tenement on the other side. That's why you think it's your day, Well, I'll break it to you. Out there the boys in musty mufti have taken to plainclothes. They hold out primroses which, when touched, will turn you inside out. Center you on self. Stunt compassion. Blind you to misery. Forgive you. Hold you responsible for nothing.

And don't you wonder why? I never do anything else. It's a full-time job. Please do not disturb. Please wonder too. Please bend your wits and wiles around this problem—how to save the world. No, let's not get grandiose. Start slow. Start small. How to save yourself. No, that won't do it. What is the smallest number we can save with ourselves and still be starting something? It's about propagation, isn't it. Spread the word like peanut butter, like lard, like sex. But first eliminate and purify. Sweat out the ignorance. Excrete the hatred. Think about what to do next. Sleep on it—and then wake up and dream.

1981

Which came first: the blade of grass or the blade of a knife?

The Nuclear Regulatory Commission is now producing war toys. They are funded by tax dollars and rationalized as educational for personnel. *Skirmish* is a game about a terrorist seizure of a uranium shipment. *Ambush* is about terrorists trying to blow up a nuclear power plant.

"The Administration has asked Congress for $696 billion in Federal Funds for fiscal 1981; of this amount 47% goes to the military. This includes interest on the national debt, two-thirds of which can be conservatively estimated as war-incurred" (Dr. James Anderson, Employment Research Associates).

"The U.S. may buy itself two things with its $1 trillion defense budget of 1981 to 1985. The first is an economic decline that comes about once or twice in a century. The second is nuclear war" (Emma Rothschild, MIT).

"The situation in the Middle East is dangerous and difficult, and *not* selling arms would not make it any less so" (Secretary of Defense Harold Brown).

"I am a revolutionary and a member of the atomic age. I cannot disavow people who use bombs. I hate bombs but we might have to use them. Until my last breath I will fight for liberation and freedom of Puerto Rico" (Lolita Lebrón).

Tacitus referred to black-clad women who hindered Paulinus' attack on Anglesey in 61 A.D. by rushing among the troops brandishing blazing faggots and cursing and confusing the enemy in the name of the Black Raven Goddess.

"An acquaintance of mine, who was interning in an obstetrics-gynecology service, was assisting at a hysterectomy. The chief resident performed the operation with impeccable style and skill. But just afterward, as the patient lay unconscious upon the table, the physician held the newly detached uterus aloft. My friend glanced at his face and said quizzically, 'You look...pleased?' 'Ah yes, I am,' he answered. 'Another small victory in man's unending battle against the womb'" (Maggie Scarf, *New York Times*).

In New Zealand, women cannot even have abortions in cases of rape. In Peru, backstreet abortions

account for 60% of the deaths of Peruvian women. In Italy, abortions are left to the discretion of the doctors, and 94% of the doctors refuse to perform abortions. In Australia, there is widespread sterilization abuse of Aboriginal women. In Kentucky, the Proctor & Gamble Company gave away hundreds of bars of Ivory Soap at the Right To Life convention. Does that mean cleanliness is next to bigotry?

As part of a recent anti-ERA conference, workshops were held to improve the public image of the women campaigning against women's rights. These included the use of makeup, tips on speech-making, and seminars on how to get elected.

"Creating a body is nature's work. Keeping it beautiful is Jeanne Piaubert's" (Ad for body-care lotions).

"The makeup ads proclaim 'You never looked so good.' But a few years ago, when one of those ubiquitous cancer-causing nitrosamines was found in a wide variety of cosmetics, female consumers never felt so bad" (*Science 80*).

Now Avon is introducing a new line of cosmetics called Envira. It claims to protect women from the ravages of pollution.

"Women are needed in scientific work for the very reason that a woman's method is different from that of a man. All her nice perceptions of minute details, all her delicate observation of color, of form, of shape, of change, and her capability of patient routine, would be of immense value in the collection of scientific data" (Maria Mitchell, 1876).

"Politics based on received definitions of women's nature and role are oppressive, whether promoted by men or by my alleged sisters" (Ellen Willis, *Village Voice*).

"What on earth sense is there in trying to make it 'trendy' to link environmentalism with feminism? Women's Libbers are the same hard-driving type as the men of a century ago (and before and since) who have wreaked such havoc on the environment for their own selfish purposes. What hell-bent-on-a-career-with-all-the-male-privileges woman is going to make minor sacrifices like taking time to recycle or use mass transit or care for her children or cook from scratch or try to save any energy except her own? Why don't you look for more environmental friends, instead, among conservative, home loving Christians? The only connection between feminism and environmentalism is that both break certain traditions and conservatism. You have too good a publication going to desecrate it with feminist yowlings" (Miriam Murdock, letter to *Environmental Action*).

"Selfish career women who behave like the hard-driving men of a century ago aren't

environmentalists...and they certainly aren't feminists either. Feminism is antithetical to male domination—whether of natural resources or women—and the competition and aggression which our male society rewards" (Victoria Leonard, in reply to above).

"SAVVY: The Magazine for executive women...SAVVY is a way to see how other women live, to identify at a high career level with them. SAVVY is a celebration of success—a demonstration that a good salary is not unfeminine. How do *you* compare? Adwoman Mary Wells Lawrence made $225,000 in 1977; Roberta Kraus, nuclear engineer, makes $25,000" (Ad).

A Pension Rights study finds that more than two million women, or 16% of those 65 and older, are living below the poverty level. The median income for men 65 and older is $5,526, while women 65 and older receive only $3,008. Older women are the poorest group in this country (*Washington Spectator*).

"The television and radio industry feeds on health, or more precisely, on disease. Almost all the commercial announcements, in an average evening, are pitches for items to restore failed health. As a people we have become obsessed with health. There is something fundamentally, radically unhealthy about all this. The new danger is in becoming a nation of healthy hypochondriacs. And we do not have time for this sort of thing anymore. We should be worrying that our preoccupation with personal health may be a symptom of copping out, an excuse for running upstairs to recline on a couch, sniffing the air for contaminants, spraying the room with deodorants, while just outside, the whole of society is coming undone" (Dr. Lewis Thomas, *The Medusa and the Snail*).

"The biggest surprise for Dr. Srole and his associates... came when they found that much of the overall improvement among New Yorkers' mental health could be attributed to a huge change in women. The 1954 study had shown that, in the 40–49 age group, 9% of the men and 21% of the women suffered from an emotional impairment sufficient to interfere with everyday living. For the comparable age group in 1974, the impairment rate for men had remained steady at 9% but for women it had fallen to 8%. 'I think what we're seeing here,' says Dr. Srole, 'are the effects of the feminist movement' (*New York Times Magazine*).

Sane minds do not prevail. But what has art got to do with sanity? What indeed?

—

"Looking upwards from the Yosemite Valley, the eye follows tall redwoods and cedars to the

summits of towering granite cliffs, over which silver ribbons of water fall from dizzying heights. But at the horizontal, the field of vision is filled with hot asphalt, slow moving lines of cars and buses, and crowds of tourists, some visibly irritated by the heat and congestion. The national parks, sometimes called the 'cathedrals' of American civilization, are in serious trouble... excessive use and deteriorating facilities...exposed to threats from the outside, especially energy exploitation and other developments on adjacent private land.... Nor have they escaped some of the social problems that have been troubling the nation's urban areas for years. These centers of scenic splendor have their own jails" (Philip Shabecoff, *New York Times*).

The Rolls-Royce, which you can buy for a mere $77,000 and which gets all of ten miles to a gallon, has won an exemption from the laws requiring energy conservation. Rolls is also asking the Treasury to absolve it from paying the gas guzzler tax.

"In Bryce Canyon, Utah, a planned 8,300-acre strip mine just outside the park would destroy one of the greatest views in the country and blasting could topple the fragile limestone spires within the park.... In New Mexico, drilling rigs for uranium have already been erected only a quarter mile from Chaco Canyon Park's boundary; a long list of companies including Arch Minerals, Consolidated Coal and Tucson Gas and Electric Company have applied for leases to strip mine coal near the park.... Resulting pollution will cut down on visibility, already lowered by particles emitted from power plants in the Four Corners area.... Air pollution would bring an acid rain that would devastate the ruins of the Anasazi civilization that flourished 1,200 years ago. Drilling and digging have already harmed some of the 'outliers'—ruins of Chacoan culture situated outside the center of the Canyon. Chaco Canyon may become an island surrounded by development" (Philip Shabecoff, *New York Times*).

The Anasazi were farmers expert enough to urge three crops from recalcitrant semi-arid soil. Like today's Pueblos, they divided into clans and their lineage was traced through women. Nature's seasonal changes provided their practical and religious structure. "Near the top of an isolated butte in Chaco Canyon, three large stone slabs introduce sunlight in vertical patterns on two spiral petroglyphs carved on the cliff behind them. The light illuminates the spirals each day near noon in a changing pattern throughout the year and marks the solstices and equinoxes with particular images. At summer solstice a narrow vertical form of light moves downward near noon through

the center of the larger spiral." At winter solstice two of these daggers of light come down to embrace, or hold, the spiral. This Anasazi calendar is the only one known in the world to employ the noonday sun, and it may also have been used for lunar observations, consistent with the Pueblo culture's emphasis on the moon, seen in a dual role with the sun (Anna Sofaer, Volker Zinsser, Rolf Sinclair, *Science*).

"To create the ideal light, we had to improve on the original" (Ad for Westinghouse: a picture of the sun and a fluorescent tube).

The Los Alamos Scientific Laboratory "provides excellent working conditions and opportunities for advanced research. Our location in the mountains of Northern New Mexico offers a pleasing lifestyle in a setting of great natural beauty. An Affirmative Action/Equal Opportunity employer; minorities, women, veterans and handicapped urged to apply...." (Ad in *Science*).

Farmington, New Mexico, near the entrance to Chaco Canyon Park, is an energy boomtown where Exxon is negotiating with the Navajos for one of the largest uranium leases in the country. Men wear T-shirts saying "If You Ain't an Oil Worker, You Ain't Worth Shit," and "Boilermakers Do It Better," and "I'm Oil Field Trash and Goddamn Proud of It." Child abuse, rape, and spouse beating especially are reaching epidemic proportions. "For them, being drunk is absolutely normal.... The only thing I can compare it to is the attitude of the conquering GI" (Tom Stuart Bush, Director of Family Crisis Center in Farmington). "There's no sense of community here" (Diane Paolozzi, Family Planning Council). "A lot of relationships are going to pot here because of shift work. Couples just don't see each other anymore because of the long hours, and a lot of women end up stranded, divorced or in very painful positions" (Adelle Richards, resident of Farmington). "Anglos have always been organized to do all kinds of things, but when minorities do it, it's a threat. Somehow we become militants" (Pauline Gonzales, resident of Rawling, Wyoming, coal boomtown). "There are tremendous problems for women here, but there would be lots of opportunities too. If women organize there can be a future, but then, that's the antithesis of transience" (Barbara Bush-Stuart, Farmington).

San Antonio's Communities Organized for Public Service (COPS) is a primarily Mexican American group that has accomplished an amazing amount since it began in 1974 over the issue of local drainage. It has since tackled the schools, health care, utility rates, pollution, and urban sprawl. Former president Beatrice Gallego

at first resisted recruitment into the group. When the organizer who had spotted her as leadership material called her, she told him, "I don't like you. You're the kind of person who goes on marches." Now she has an office in her home, lobbies in Washington, and speaks to citizen's groups around the country. "I have given courage to other women," she says. "One woman said to me, 'Nobody can be like you'; and I said, 'That's not true. I was like you. I used to wear pants suits so no one could see my knees knocking" (*New York Times*).

"A large pool of female labor, low cost, unskilled, trainable, with dexterity" (Ad for industrial expansion of Corpus Christi, Texas).

A Boston woman trying to get into a construction union was offered only work at Seabrook; another woman already working there had her car with its no-nuke sticker towed out of the employees' parking lot. "Leave your politics at home," they told her. Women were thrown out of a construction union apprentice program for swearing and fighting (as one survivor put it, that was "actually great on-the-job training"). Women's union contracts are beginning to include clauses on sexual harassment. One union official said, "They shoved Blacks down our throats. Now they're shoving women down our throats. What next imbeciles?"

—

"Rockwell International is more than the builder of America's space shuttle. Much more. Total sales for 1978 were $5.67 billion… Rockwell International—where science gets down to business" (Ad).

"The Three Mile Island accident killed no one, but *inconvenienced* many thousands of those evacuated from the area, and frightened millions" (Victor McElheny, *Science 80*, my italics).

Britain's Secretary of State for Energy told an audience in Washington, D.C., that the new Conservative government has no qualms about developing nuclear power. This reaction to the accident at Three Mile Island was a feeling of *reassurance*: "It showed that when some stupid errors were made, and the system was put under great stress, safety was still maintained" (*Science*).

"Call toll-free: 800-225-1572 for New England Nuclear. As Easy as 1-2-5" (Ad).

—

Hey, can you take a joke? "Our mother who art the earth, hollowed be thy name. Thy springtime come, winter be done, on earth as it is both above and below. Give us this day our daily bread and forgive us for eating it without thinking of those who have none. Lead us into revolution and forgive us our righteousness. For thine is the power and the glory for ever and

ever. Ah, Women!" Can you take a joke? What's funny about the birth defects and brain damage caused by Hooker Chemicals at Love Canal? Only the names. Only the fact nothing was done about it. Come to think of it, nothing is funny about the birth defects and brain damage caused by Hooker Chemicals at Love Canal. And it's not any funnier when it happens in Queens.

Southwestern houses often have door and window frames painted blue or turquoise. This is to help keep witches out of the home. Blue is the color of the Virgin Mary and turquoise is the Indian color for good luck.

For three years, my 73-year-old mother has been collecting and cataloging all the wild flowers on the island. She is often seen by roadsides and in fields and marshes, with her little basket over her arm, hunched over like a witch to see what hides in the grasses.

During the course of excavations at the Puye ruins, the men from San Ildefonso Pueblo were frequently assaulted by skeletons they uncovered. "One Indian was digging when something seized his foot and called, 'Don't take me from this ground.' The terrified fellow yelled, 'I don't know who is talking to me underground,' and shortly afterward he became sick and died. Bones talked to other workers, pleading 'Don't take me

out.'"(Marc Simmons, *Witchcraft in the Southwest*).

"In Eugene, Oregon, 50 senior citizens go into the fields to fight inflation and food stamp cuts. They have gleaned more than 11,000 pounds of produce that was going to waste on the vine. They have filled freezers and cupboards and shared their bounty with more than 2,000 Lane County families" (*Washington Spectator*).

When a mortuary was planned to be constructed just outside Leisure World, a furor ripped through the community. Leisure Worlders picketed the construction site. "Yes, where we live is almost heaven," the posters suggested. "Just don't remind us of it" (*Flying Colors*, airline magazine).

"Paradise, as we now understand it, was surely the invention of a relatively leisured class. In the peasant's dream, work is still necessary. Both the bourgeois and the Marxist ideals of equality presume a world of plenty; they demand equal rights for all before a cornucopia... to be constructed by science and the advancement of knowledge.... Closely connected with the peasant's recognition, as a survivor of scarcity, is his recognition of man's relative ignorance. He may admire knowledge and the fruits of knowledge, but he never supposes that the advance of knowledge reduces the extent of the unknown. This non-antagonistic relation between

the unknown and the knowing explains why some of his knowledge is accommodated in what, from the outside, is defined as superstition and magic. Nothing in his experience encourages him to believe in final causes, precisely because his experience is so wide. The unknown can only be eliminated within the limits of a laboratory experiment. These limits seem to him naive" (John Berger, *Pig Earth*).

All over the world, crops are planted when the tide is coming in. It is said that people die on the ebb tide and are born on the flow. But why? Is that what happened to Eva and Ree and Elaine? To Suzy on Ocean Front Walk? The *tide* just went out? Well, then, we'd better get in touch with the moon, take the stripes off, and leave her to the stars.

1981

Quarries and claypits. Ancient seas and deserts. Volcanos
and glaciers. Misty peaks and slow-moving rivers shadowed
by broad-leaved trees. A city of rocks crouched on a plain.
High-ceilinged railway stations and shanty towns huddled on
steep, nonarable slopes. One mountain after another. The sea
from innumerable coasts. Coasts with poisonous snakes. Coasts
with coves and kangaroos. Coasts with starvation and disease.
Wonder of wonders. One mountain after another.

Huh? What is this, amateur night? An interior travelogue?

Bet your sweet ass it is. Traveling is good for the liver, the
lungs, and the heart. Greases up the escape mechanisms, the
sense of cultural superiority, often darkens the skin and bolsters
the economies of undiscovered countries ripe for the stripping
of mines for yours. For instance, *Flying Colors* magazine has
this to say:

"Santiago, Chile is one city where the way you arrive really
makes a difference." (*Not to mention the way you leave—feet first
or "disappeared" or innocently flying back into your tax shelter.*)
"The Province of Santiago offers seaside resorts, thermal
springs, ski slopes, mountain climbing and hiking, hunting and
fishing, all amidst beautiful scenery and a pleasant climate."
(*Also, don't miss the concentration camps, the slums, the missing
freedoms of speech, assembly, press, etc.*) "The city plays host
to a number of colorful shows and events." (*Torture's a hit.*)
"Parts of the gracious Colonial style Palacio de la Moneda
remains damaged, residuals [*sic*] of the fighting of another era
[*sic*, sick]. The ski resort at Portillo has truly become a world

renowned rendezvous for the international jet set." (*They start at the top of the slope and go down.*)

But what about ideology? What about cultural imperialism? What about the ACLU canceling its tours to Guatemala? And plastic safety pins in the cheek? What about babies starving on watered-down formula so Nestle can say to the World Health Organization that its recommendation to end direct consumer promotion for infant formulas...

"The bottom line is that I'm damn happy to pay my taxes here," says actor Hugh O'Brien. "Show me an American radical and I'll show you somebody who hasn't traveled much."

It all has to do with growing. One thing leads to another. Out of the soup and into the nuts. A Navaho girl lies on the earth to inherit its fertility. A Hopi woman dances the female energy back into the Earth after the corn harvest. My own puberty rites were muffled in ecologically unsound Dairy Freezes too thick to suck through the straw, strained by the fine lines good girls don't cross, cuddled between back seat buns with freezing dairies, red leather lips, a gold keyhole worth its weight in protection money.

But where's the plot? It just goes from birth to death. A some excitement and some decay sandwich. Your normal cycle. So what else is new?

Under the sun, or under the moon?

Under the earth. Six feet under.

The next course is Fascism? No, don't be taken in by the bleeding backlash for appetizers. Here comes a surprise! You haven't traveled all this way in vein. Next course is a delicious delectable entrechat of radiated ram with a red white and blue sauce of Social Democratic Anarchic Libertarianism garnished with a Liberal dose of blanched Blackfeet. Under glass? So the public can't touch? Under dirt. Six feet of it. Not again. Turns out dessert was spelled wrong on the menu.

Come in. We were expecting you. There had to be an

improvement eventually. Just give me some time to digest
all these new ideas. I mean, my legs were raised to know
my place, out back in the garden, scaring off the evil spirits.
Of *course* there's plenty for everybody. All we have to do is
move Fatso there down below the salt so there's room for
the Cambodians. A very old recipe. Handed down over the
generations. Frigassee of the Rich. A delicacy in the hovels of
Ho-Ho-Kus, the caves of Kathmandu, the barrios of Bulgaria.
No, I'm sorry, I can't tell you just *how* it's made. I might want
to write a cookbook someday, you see... or make art.

Open Wiiiiiiide. Dig In! Dig Deep! Slurp slurp slurp. Meal
Art replaces Me Art! Maybe. Replaces mealymouthed art,
replaces loafing on the breadlines and eating cake because the
foodstamps were locked in the top drawer of the bureaucrat.
See? With the weight of the rats off the sinking ship, it floats
again. The last meal of the day is lust. Take what you need and
share it with your sisters and your brothers.

We're sneaking through the intestines of this rotting society
to give forth a good omen.

Phew. Who did that?

You say there's nobody *left* in the race we won? But see
that buzzard leaving the scene of the crime? It's taken some
seeds, will dump them. Life goes on. Tweet tweet.

1982

Author's note: For several years in the early 1980s, when I was writing a monthly column for The Village Voice, artist Jerry Kearns and I collaborated on a "happy newsyear" piece. The images came first and then the text.

Happy Newsyear
(with Jerry Kearns)

1981

Fringe heroes. Mothers' heroes. Nobody quite makes it today over life-size. It's the squeeze, the sandwich, the board, that shrinks them. Step out of the frame and you're invisible. Hang in and you're all flattened out. Angels as devils, punks as stars, the musical middle-class schoolboy, the committed revolutionary or "hardened terrorist," the Horatio Algerian vigilante—full-blown, all dressed up for mass culture.

The one on the left playing the piano in a Police T-shirt is my hero, my son, Ethan Ryman. He loves New York, wants to be an actor, is witty, cosmologically inclined, and nearing draft age. The son in the middle is dead. Kevin Lynch starved to death in the midst of plenty of prison food, dying to prove that man cannot live by bread alone, that if the British are involved in a mere "police action," the IRA is fighting a war of independence. His mother fed him raised him and watched him cut down like the ancient-year king, grown from divine child to hero then killed and fed back to the earth to fertilize her and be

born again. Tucked up cozily in his coffin/cradle, not as real as the photo over his head, Kevin Lynch died in the Maze, has worked his way out of the labyrinth of media half-life.

The one on the right belongs there. Curtis "Rocky" Sliwa was 23 and managing a McDonald's when he cooked up the Guardian Angels—a three-year-old organization of 1,388 volunteer crime fighters with branches in 22 cities across America. It began underground, in the New York subways. Awarded a superpatriot prize by Nixon while still in high school, Sliwa was recently called back to Washington to testify for the SST. There, he decried youth crime and moral decay, was congratulated by terrifist Jeremiah Denton for being around to set things right, and was beaten up and thrown into the Potomac by (he implies) the police.

The bottom line of hegemony is control. The bottom line of control is violence. Drawing lines and bylines is culture's job. Remember Narrative Art? Comic strips and movies and street theater? Posters and billboards and murals and artists' books? And TV serials designed to "solve moral perplexities"? Remember the popular notion that culture heroes are hard to reach, hard to frame, that they choose their own stripping, that art is so free that it seeps out of its containers, that art is art if an artist says it is and an artist is an artist if s/he says s/he is no matter what the market and the media think?

This month's column is a mirror. It's usually a space for journalism about art, fact about fiction, and this time it's art about journalism, fiction about fact. It's still "criticism," though, because the pictures came first and the words have the last laugh. It's a distanced exchange between my work partner, Jerry Kearns, an artist in the city where the news is produced, and me, a writer in the country where the news is a day late. JK sent me the picture panel above, and I'm responding in so many words. This is not a review of the poems the Maze prisoners write to the hunger strikers and shout across the H-Blocks, nor of the songs played for them over the radio, nor of the angry pictures drawn for them on the walls of Derry. It's not a review of the songs my kid writes, nor of the media theater the Guardian Angels produce. But it's still culture.

We've spent a lot of time talking about heroes and looking at the way the media offers them up to us on silvered plates. I'll never be one of those mothers who proudly offers up her sons in exchange for a gold star. But I want Ethan on our side, back from Hollywood's outer space—my involuntary veteran of many marches. In a school play last year, he was born (I smiled), feebly rebelled (I sniffed), fell into

line and kissed ass (I scowled), and died knowing he hadn't lived (I wept). I want to be both anti-war and anti-imperialist, but straddling the fence is beginning to hurt. The Celts were always big on sacrifice and self-inflicted punishment, according to the archaeologists. We eat our heroes, too, or find them at McDonald's. Christ still gets eaten at least once a week, so his friends and enemies can absorb his power. *Time* magazine on August 17 said of the IRA hunger strikers, amid many gory details and no political background, that they were practicing "an astounding kind of sacrifice—a brutal lingering death, full of hatred and martyrdom, so fanatical and Irish." So unlike the understated democratic American way with just your ordinary white-hooded marchers and burning crosses and shotguns as shortcuts to law and order.

Fashion, ain't it grand? If I had anything to say about it, my kid would not run around in a Police T-shirt. I don't care if they are a "good" rock group; I do care that they sing a "bad" song called "My Girl Sally" about the total woman, but no heroine even though she's inflatable, like she is bought and sold on Times Square. Eats nothing, like your middle-class anorexic, like Kevin Lynch. The Guardian Angels wear T-shirts showing a winged badge inscribed with an all-seeing eye in a pyramid, the

sun's rays beaming behind it. They wear red berets so they'll "stand out in a crowd like lollipops." Time was, only sissy artists wore berets. Since then we've had Che and we've had them green for defoliators, purple for young lordship, black for the "urban jungle." My friend the professor wears a beret and his students call it his guerrilla outfit. If the hat fits… but what's the angle? The earliest art was body painting. T-shirts can be good propaganda for those of us who can't afford TV spots, pages of the *Times,* billboards, or cultural sponsorships, but at what point does the consumer become her own sandwich? What's the difference between wearing an anti-nuke symbol and advertising Adidas on your chest?

While the fogs roll and end-of-the-summer winds blow my papers around, I'm writing a book about prehistory and contemporary art. I'm reading about how the Christian church prefers lines to circles, light to dark, marches to dances, and how it absorbed all the pagan symbols it could, and turned the rest into evil. Patrick banished the snakes from Ireland. They went underground with the matriarchy, with the devil, the dark, the damp, and the dances. Does this have a familiar ring? Any connection with the fact that, in the U.S., all revolutionaries are called terrorists, while all terrifying states are called policemen?

What does religion have to do with patriotism? With protection? A good guard is a guardian and a bad guardian is a guard. Last year the NYC police killed 27 black and Hispanic young men. Every time a hunger striker dies there are riots and others die too. No one knows if subway crime is diminishing under the Guardians' eye. Ethan is labeled authority, but he won't listen to his mother. Lynch is labeled a rebel, but in fact he just looks to another authority. Sliwa takes authority into his own hands.

Get the picture? It's both red and green like Christmas, and rough on the colorblind. Brecht recommended distance lest our vision blur. You want heroes? You get them, bigger than life. Television means far-seeing. Don't look too close. You might get sucked in. You might get nothing but dots and bars, nothing but human interest, nothing to do with revolution, imperialism, economics, repression. But don't go too far away either. You might not see the background. You might mistake it all for culture.

1982

Welcome to the image war being waged behind representational lines and in them. It's on your heads and boxes. There's fighting in the streets. This is about pictorial repression and pictorial resistance, about demonstrating our imaginations.

Close up, you see the New Right kept at a distance. They write us out of the picture, but we pale them by comparison. They appear in the *New York Times* telling us it's OK, don't worry, don't think, don't act, the world's in good hands, in bad hands, in empty hands, in the wrong hands, but don't worry your little heads. Big strong white men got it all under control. (Help! We're being helped!)

They give us another message in the *New York Post*, where we're assailed by random violence, titillated by secondhand sexuality. Nobody's in control here, much less you, m'dear. No use feeling responsible, no use organizing. It's all out of your hands. It all *just happens* to you poor folk. Bricks fall from roofs, bombs fall from buttons. Don't watch the news, there's nothin' you can do. Read the papers and scare yourself to death. It's cheaper than the movies.

In these times not fit to print, see with your own eyes. See through words. Wonder whose reality they reflect, who owns the mirror. Wonder why it looks like it's us wearing masks, wearing gags. In fact, everybody's in disguise.

Bloodthirsty maniacs wear the costumes of reason, authority, and decency—white shirts and ties, and neat or disappearing hair. They cast us as the commie pinko queers demonstrating in the gutter while the good folk stay home and get off on teenage chastity and capital punishment for homosexuals, cozy in the knowledge that domestic surveillance—snuck in last month undercover of Libyan darkness—stops at the familiar center. (All the more reason not to let your art out of the room.)

Is art around to tell the time? Look at these faces. What time is it, anyway? Time for active resistance to the deaths/headlines offered by the nuclear powers: The Black United Front defying the draft,

another crowning blow in Crown Heights; PAD/D in Washington canceling guns and bombs and warriors with black, white, and red, images alone; No More Nice Girls in New York marching tall, big-bellied, black-robed, chained, gagged in shocking pink, demanding reproductive freedom, a halt to Sexual McCarthyism and Forced Labor. But is it art? Yes, as a matter of fact, it is.

What do you show and where do you show? they ask in the art world. We show and tell what we believe wherever we can be seen. Why does political art have to use words? they ask in the art world. Whose political art—ours or theirs? How come we get asked suspiciously what we're doing when we

join words and images to criticize? How come I get asked, are you still a critic? If art can be words, why can't criticism be images? When artists write, they don't stop being artists. You can get your head blown off in no man's land, but isn't modernism all about risk?

It looks like 1980 too. 1980 not won. 1980 for what? I dreamed the other night that the top of a rocky island blew off in a luscious cloud against a bright blue sky while boulders clattered to the ground killing many, because sculptors had been careless. Are we making art while Reagan fiddles? Why do we have to wake at night and worry, not about the bomb, the wars, the bodies of our sons and daughters, but about the next day's meals, the next week's work, the next month's rent? Can artists afford to look ahead? If we behave we get *Masterpiece Theatre* for one more year. They're dreaming the nicest little dreams for us. They don't include consciousness, concern, involvement, or action.

A happy newsyear would mean more news to fit the pages that be, more art fit to demonstrate what the media don't, more active resistance to the guardians of our

immorality. How to resolve our newsyear revolutions? In ancient winter solstice rituals, a fiery wheel was rolled downhill and people danced in circles to encourage the sun and moon to keep on turning. We've gone around in enough circles, gone far enough downhill. This time of year the sun's on the rise again. If only every cloud didn't have a plutonium lining. It's going to take more than a star in the East this time around. It's going to take both action and passion. Aren't they still in art's domain?

1984

Maybe it's none of our business. Another kind of intervention. What makes us think they're calling our way? Will this newsyear be any different from the last? In 1983 we talked about violence and it didn't disappear. We know who's Kissinger now. Let's count the grains of sand in the sandbags outside the White House and the glass house on the East River. Let's count the Sandinistas. The number of skulls on banners add up. Sandino's gentle silhouette is repeated on the streets of Ocotal, Managua, Masaya, Matagalpa. The smooth young legs of dead girls interfering with Salvadoran traffic add up. How do you tell them that you don't know what they want to know? If I can't stand the dentist's drill how could I stand an electric cock up my cunt? The number of children's bodies in the river adds up. The number of raised fists on posters adds up. The number of nightmares boils down to one.

If we allow ourselves to think... Somebody has to. Those unable to conceive the inconceivable are giving birth to it anyway because conception is immaculate if you don't think or touch. World economics transcends ideology and leaves Central America suffering from stage left. The reds are devils until it comes to commerce. The Sandinistas endanger democracy while the Soviets, the Chinese, and the Reagans lunch over business. An argument ensues about the meaning of the word "intervention." When do a few advisers and a lot of arms in Salvador become an intervention? When does daily intervention over the Nicaraguan border become an invasion? Did Grenada just have visiting hours?

Why are the laments of this woman, these men, echoing in our arts? They are the victims of courage and fears we can't imagine. (So why do I keep imagining them? Why do you keep imaging them?) We cannot imagine their lives and they cannot image ours. How far away is Central America? Near enough to hurt, far enough away to forget.

She taught me how to dance, a friend says casually, pointing to a mural painting of some recent martyrs. When last seen, Lil Milagro had hair down to her heels. Her face was a skull and she had lost her teeth. Torture broke her health but not her spirit. We'll dance on their graves. In 1979 the mothers of the Disappeared met with the new and somewhat moderate Salvadoran junta (it didn't last long). One member of the government (he didn't last long) said, "I'm overwhelmed by the problem, I have no idea where your children are. I pray that they are still alive. I just don't know," and buried his face in his hands. He had buried their children beside the road, across the way, away from his face buried in his hands. According to our media the children in Nicaragua play with guns.

Is it romanticism or conviction that makes me worry about other people's children? Whose reality *is* this, anyway? In your quiet white room with everything in order you paint glass shattering and faces twisted with pain and rage—a

messy life. From the warm walls of my own sloppy contentment I imagine the precision of torture. It's not just guilt, either. It's coming to terms with other realities. I spend more time thinking about torture than about nuclear war. We're used to fiction. Central America's beginning to feel like fact. I've been there. A lot of people have been there. If enough Americans go somewhere it exists, rises from the map and gets mopped up. Central America is being validated by visitation.

Here's how they get soldiers to do such things to people who could be their own sisters, their own fathers: they kidnap them at 12, offer them three meals a day, force them to participate in torture, mutilation, or rape, so they're moved involuntarily to the other side, cut off from what they might have been by the monotony of their crimes. They who? We're them. They're us. On North American TV, young men are offered careers in killing. Rap it up, join the hit list. Join the marines, travel to exotic lands, meet interesting people, and kill them, the T-shirt says. We have a specialty for dark Hispanic types. You'll love Honduras and the gringo presence will be invisible. Pull those rip chords. Let's land like leathernecks.

Your paintings are so violent. You say you like intensity. Me too. Is pain the only real intensity left?

There are some new tortures in Guatemala. They crush your face and neck with rocks while you're still alive; they stick spoons or pins in your eyeballs. *Your* face? *Your* eyeballs? We live in a civilized country. One step removed from such barbarity. We send the dirty millions by mail and our hands stay relatively clean. But it's rubbing off from black and white. When I saw a postcard of Salvador in color I wanted to cry. In Lebanon too, it seems they have turquoise water, sandy bluffs, purple flowers, and peace.

A pressed pink flower from Nicaragua survived a month in my notebook, as tough as the people who planted it. There were soldiers in the cane fields watching for *contras* and they looked like they'd been collaged in. When my son and I watched *The Day After* together, we wondered how it affected those who had never thought to think, who had no images until they came on TV. I tried to finish my spaghetti fast before the bomb struck. But I've eaten to the news of Central America, been eaten by the news. What's the difference? Narcoleptics can't distinguish between fiction and fact. They can't remember what they dreamed and what actually happened. That happens to me all the time...I think.

The paint gets thicker and the brushstrokes wilder as the bullshit flies, as the talk dies. Deadlock in Vienna, in Panama, in Geneva. Deadlocked, headlocked, closed down and out. You lose. I lose. We lose. Is voter registration the answer? One of them. Is armed resistance the answer? One of them. Are critique and analysis the answer? One of them. Is art the answer? One of them. Are they all the answer? Happy newsyear one on one. It can't possibly happen to me so it's going to have to happen to you.

...And still, there's a certain grim joy in the struggle. Last week the Artists Call organizers discussed more heatedly, laughed louder, danced harder, stayed up later and later each night. Later still we smelled the dark dirt of El Salvador and the flowering bushes of Nicaragua. Central America is breathing down our dreams. Lil Milagro is teaching us to dance.

This Saturday, January 28, is the Artists Call "Procession for Peace," dedicated to the dead and disappeared of Central America. It starts at noon from our "museum of war"—the aircraft carrier Intrepid—at 47th Street and the Westside Highway. Wear black or dark clothes. You will be given an armband with a victim's name on it. When the procession reaches Washington Square the names will be read. The ringing of church bells and beating of drums will celebrate the contribution of the dead to the rebirth of Central American culture.

1985

State of Mind, State of the Union. State of Siege. The dogs of war lurk on both sides of the inaugural safety net with hardly a bone to pick. Take heart from the Walking Image, the Living Dead and Consort, the Born Again and again and again. While the flag waves on, pumping iron into the heartland, angry artists break a new wave of countervisions all over town.

The world is going to the dogs. The God Guys have unleashed the Bad Guys. "Tea-party rules" need not apply here, says the Heritage Foundation. Because the animals are out there in that "midnight world of the South Bronx." We gotta get down to the dirty work of saving the world from Mr. Clean, our own personal deodorant who sprays with fire. It's only a quickstep from New York's 50,000 homeless building bonfires in the

streets to the spark that starts the prayers off to the purifying flames of an Armageddon that'll clean your teeth your bones your toilets better than anything yet on the market.

"TERRORISM IS WAR: THE TIME TO BEGIN FIGHTING IS NOW."

"SHULTZ SAYS U.S. MUST NOT WAIT FOR PUBLIC SUPPORT IN USING FORCE" (and quotes the Talmud to support it).

"AMERICA'S UPBEAT MOOD," chortles *Time* in September, "EXPERTS DOUBTFUL ABOUT OUTLOOK FOR THE POOR," murmurs the *Times* in December: "There is nothing in view that would propel the estimated 35.3 million poor Americans out of poverty."

Well, that depends on your viewpoint. From up on the hill, the Republicans can see straight to heaven and there's apple pie à la mode in the wintry sky. But you've got to suffer to be invited. If one in four New Yorkers lives on less than $2,500 per year, not to worry. Our leader likes to take the lumps with us. Having spent $25 million on campaign advertising, he's happy to sacrifice 10 per cent of his $200,000 salary. Ask and it shall be given away. Cuts even across the board.

The situation calls for a real operator. Cut social programs and cut corporate taxes. Cut the heart out of the poor and feed it to a nice man like Bill the new Barney. It's worth the millions spent just to see him smile. Let's see a few more *smiles* out there, folks. Grin and bare your teeth at all those who worry about their stomachs instead of their heartlessness. Think about baboon and Bill and baby hearts instead of the infant morality rate.

Our poverty is moral, theirs is not. We can't impose our wealth and safety standards on the Indians. It's not our fault they chose to breathe our poisons. State of the Union Carbide is offering a cool one-and-a-half million to take the heat off those funeral pyres.

And we can't impose our lofty moral standards on the Central Americans. It's not our fault if terror is part of their culture. What can you expect from people who cut the hearts out of human sacrifices? North of the border we have such big plastic hearts we only train the torturers and strip the comics down to pop assassinations. Guatemala and El Salvador have terrorists. We have the righteous bombers of abortion clinics.

There's no connection, repeat, no connection between our state of siege and those smiling little brown people who love to work in runaway factories for five dollars a day. In Ethiopia the evangelical churches feast on famine. Ricebowl conversion is back in the style section. Farewell, Falwell, we're off of welfare.

(You were eight. You looked out the cab window, a lap full of Christmas presents, on the way home, looked out at the homeless. You asked why doesn't somebody take all the money in the world and divide it equally? It hasn't worked? OK then, why not make money something the poor have a lot of?)

What we need is a nice little war. Nothing drastic. Just enough to keep the munitions planted, the plants rolling, the plants running away to the war in El Salvador, the grass from taking root, the sparks from flying into the prairie.

Beside each cross in Normandy, where Ron and Nancy were born again as caring democrats, flies a little American flag. Long may they wave from their limousines. The crosses all look alike, like the people lining up for our next war party. Thanks, kids, for breaking away in the South Bronx. The midnight world is waiting for you. You'll like sunny Nicaragua once the agents of orange neutralize the yellow reds.

After all, after rape and after rapture, all Mr. Reagan wants he says "is that this country remains a country where someone can always get rich. That's the thing we have and that must be preserved." Let them eat jam, or pickles, and the saints preserve us from the kind of photo opportunism offered by the deficit.

They learned their lesson in Vietnam: don't mess with the middle class. Kill the draft and kill the protests. But now the middle is up to its business loans in trouble; 71 U.S. banks failed in '84 compared to 10 in '80. Those not running again are going for America's gut, but those jogging along to a new seat in Congress still have to worry about the breadbasket.

Artists are in the middle too. We crack up, they crack down. For intimidation, libel suits them fine. Watch those test cases take another bite out of the First Amendment. Journalists today and artists tomorrow. Will we be able to show the State of the Union in two years? Freedom fighting may not be too comfortable. Culture's bound for cuts more savage than primitivism shows. Getting down to date at the Modern and the Ancient, the unemployed in Utah go to jail for looting the tombs of the Anasazi Indians while millionaire dealers have many a pot to piss away.

Up-to-date artists loot the sights of the South Bronx and sell the shards as 57th streetwalkers. UGLY ART BOUGHT BY BEAUTIFUL PEOPLE. From the me decade to the mean decade, body art to property rights, everyman had his price. Gentrified tax shelters convert to fallout. Reagan has his Ray Price, who said, "It's not the man we have to change, it's the received impression." 2-1 polls against RR policies in '83 reversed in '84 to 2-1 support. And the

policies didn't change at all! Adman Jerry Della Femina allegedly said that politicians are products like everything else but you're allowed to lie to sell them. Quick social-change artists. We Americans fall for them every time.

Dallas and *Dynasty* are the world's favorite TV programs. You get the people you love to hate so you forget who you need to hate. But eat your heart out, JR, Anything for Money will give you a run up yours. Family entertainment in these United States of Mind. See Dog Eat Dog. See Black Boy turn into Snarling Werewolf. See people Bite the Bullet and make fools of themselves for money. History repeats itself but what about Depression? We don't have memories. We've traded them in for video games. Broken dreams in the gutter, broken plates in the boondocks, but Nancita's are still intact behind terrorist-proof concrete barriers.

On TV the poor little rich just can't find peace. Out in right field they think Kissinger's an anti-Christ peacemonger. He'll be born again only when he's passed through the flames of redemption. The rest of us just get a regular blowjob—out of this world instead of up in the world. Only the Good will join arms after gettin' it and you gotta hurt to get the goods. Ask Jimmy Jones. Lie Down. Good Dog. Play Dead.

"I grew up watching television. I watched *Howdy Doody*," says young congressman Richard A. Gephardt. Howdy JR. Howdy duty. Howdy new dynasty of politicians. "Tip looks at a bill and his first question is, 'Is it fair?'" says a kool aide. "I think this generation asks, 'Will it sell?'" And it did. It's the number one best seller. *Koochie Koochie Koch* and the *How'm I Doin' Show* is selling out.

What does all this meanness mean? Means the mean generation is out for Number One and has forgotten how to count. Don't they count, the almost half of NYC's kids who are poor? (You know *poor?* Like hunger poor fear poor loss poor loneliness poor murderous anger dogging your heels poor?)

Happy Newsyear, but where's the poetry? Bagged and gagged in the gutters, in a state, like our best minds. This fence is not for straddling. The safety's in the network beyond the net worth. Take heart. But not mine.

1981–85

IX.

Happy Ending

Transparencies

Some of the Names:
Rowland, Isham, Bridgman, Murdoch, Beach, Cross, Peck,
Balcom, Morse, Skaping, Jackman, Woodman, Chute, Noyes,
Swan, Burbank, Savory, Knight, Adams, Kimball, Coffin,
Reade, Smith, Dickinson, Haseltine, Cheney, Hibbard, Graves,
Edsall, Walden, Peacock, Acie, Freeman, Willis, Jackson,
Wood, Hubbard, Biship, Rice, King, Barker, Phippen, Simonds,
Hadlocke, Salter, White, Pitts, Holbrook, Lessie, Read, Stedman,
Hyde, White, Crawford, Laughton, Clark, Gates, Brown, Nichols,
Clark, Merridan, Temple, Daggett...

Some of the Places:
New Haven, Pine Orchard, Cheshire, Colchester, North Guilford,
Trumbull, Woodbridge, CT; Methuen, Fitchburg, Winchester,
Marlborough, MA; Weare, Goffstown, NH; Townsend, VT;
New York City, Oriskany Falls, Richville, Ossining, Antwerp,
NY; Oberlin, Cleveland, OH; York, NE; Minneapolis, MN;
Wauwatosa, WI; Denver, Colorado Springs, Fort Collins, CO;
Ransom County, ND; Cheyenne, WY; Eugene, OR; Los Angeles,
CA; London; and Nova Scotia...

It's horizontal and vertical. I asked my partner in
archaeological delirium why he thought we were so interested
in history, family, place, and he said, "Continuity." Yes, but
for me it's also layers, the sensed but invisible and comingled
strata that go down further than I'll ever be able to fathom. Or
maybe the layers are above ground, webs lying lightly above
each place that stretch from everywhere to everywhere else,

337

the lines formed by human lives that have passed, and crossed, the labors of Spiderwoman.

When I was in my twenties I kept seeing an invisible "ball of yarn" that lay in the center of every room where people gathered, its loose ends connecting everyone present. It was a symbol of all the significant or fleeting or chance encounters among the past and ancestral lives of those present, from actual relationships to the passing on a street, participation in a battle, habitation in the same area. The idea was that all of our lives are connected somehow to all other lives. (Not impossible, given the statistics about everyone in the world being related something like 45 generations back.) Six degrees of separation?

I also had visions of a "critical artwork" consisting of piles of acetate sheets that mapped in different colors the comings and goings of New York artists: who lived where with whom and in what buildings, who saw whose work, wrote about or studied with whom, slept with whom, and whose spouses... Looking down through the towering pile of acetates the image would, again, have been a dense web of interconnections, an X-ray of a community. Last summer we began to think in these terms as part of a local (pre)history/land use mapping project and since then I've found that archaeologists are already using similar techniques to look into time and space.

Some 30 years later, this kind of peering through transparencies at the meetings of the distant and the disparate remains at the core of my esthetic looking, writing, living. I've often called it a collage esthetic, but collage is about surfaces, and this is denser, more about three-dimensional lattices of meaning, more archaeological. When I was a kid I was obsessed by the Egyptian mummies at the Metropolitan Museum. I thought I wanted to be an archaeologist until I saw real archaeologists patiently at work with toothbrushes on a cliff, and decided I needed a faster route, like writing. Now that 50 years later my work has brought me closer to actual archaeology,

now that I've even gotten hold of a trowel, gotten to wallow in the mud with sore arms from screening and wrinkly fingers from washing, I'm changing metaphors again.

I have never been able to escape the synchronicities in which life floats. In the late 1970s, I saved up enough money to take a year off from art and live in the country. I decided to go to England but didn't care where. I met a couple at a dinner party; she was from Devon and insisted that's where I should go. I'd been there years ago, liked it, and agreed. I had a European gig so I arranged to go to Devon for one day to find a place to live. I'd had a dream of stone buildings nestled in a valley of bright green, softly rolling hills, but after a day of looking for a place I'd found nothing. This was a surprise; I've always had very good luck with places and it had never occurred to me I wouldn't find the perfect home in one day.

Near dusk, we were driving aimlessly through the hedge-lined lanes when suddenly we topped a hill and could see over and out into the landscape. There was the house I'd dreamed about. We drove to where the road dead-ended and there was the house. A kind woman's face peered out the window and gave me the courage to get out and pretend we were lost and to mention in passing that I was looking for a cottage for my son and myself the next year. They had a cottage for rent—old stone, double doors looking out on a pond with moorhens swimming and the green hills rising behind it. I lived there for a wonderful and crucial year, walked miles every day, wrote a partly historical novel, and had a spiritual awakening of some kind. I had never had such an intense relationship with a place, with the very land and its hidden histories.

When I got back to New York, I decided to write a book about contemporary art and the prehistoric megaliths I'd fallen for in Devon. No one was interested. I ran into the couple I'd met at dinner again. He turned out to be the head of a publishing house. I told him about the book and he took it, bringing the

339

story full circle. When I went back to Devon to visit I met the mother of the woman who'd gotten me there in the first place. I told her the story. She smiled and said I was psychic. (I doubt I am, but I've since had some amazing experiences with the Ouija board and much enjoyed finding out that my great-grandmother Mary Rowland Isham, whose maiden name is my middle one, was hot stuff on the planchette. My great-aunt reported that she had "some mystic power to answer silent questions.")

About a decade ago, I was invited to a feminist seder where we were asked to name our female line: "I am Lucy, daughter of Margaret, granddaughter of Florence and Lucy, great-granddaughter of Sarah, Emma, Mary, and a lost one; great-great-granddaughter of Christina, Sophia, Emily, Susannah, and four unknown women in England and Canada." I didn't know all this then. Most of us stopped at grandmothers. Some women had daughters there. It piqued my imagination, those lists of names, and the absences.

I began to pay more attention to my mother's stories. And I began to realize what a great influence my grandmother had on me, to see through my life to hers. Florence Emily Isham Cross was born, married, and died around New Haven, Connecticut, but never really lived there. She was burned out of a sod house in Dakota Territory as a child, rode a pony named Ribbon near Cheyenne, went to Colorado College, studied at the Chicago Art Institute at the turn of the century (specializing in trilobites), married a minister but never lost her secular Sagittarian energy (my son was born on her birthday; she took this as her due). She was a suffragist, the first woman secretary of some missionaries' organization, an expert in botany, an embarrassingly enthusiastic history freak. Something of a genealogical snob, she was nevertheless a great cross-class lover of people and her esteem was inevitably returned. Having discovered that she was supposedly a lineal descendant of John Alden and Priscilla (I take this with a grain of salt), she was for

a while a member of the D.A.R., but quit in protest when they wouldn't let Marian Anderson sing in Washington.

She never lived in the west again after college but she told stories about it all her life. When I found myself in my middle age spending more and more time in Colorado and then moving to New Mexico, I was totally amazed. I shouldn't have been.

Although I was the only grandchild who was really interested in family history, I was idiosyncratically selective in what I chose to recall and now of course wish I'd listened better, taken notes, taped, etc.... The last two years of my mother's life we had fun looking at old pictures and went through a suitcase of family papers. I did a little taping but she didn't enjoy it all that much; "It's not conversation," she said, a widow, lonely by then for intimacy.

Looking through that suitcase, I was struck by how little survives of a life, any life, and how odd those disconnected fragments can be as a representation of such rich experience. Those whose letters and pictures have come down to me were relatively well-off and well educated. Some were among the early founders of Oberlin and Rollins colleges; many went to Yale in its early, conservative, church-ridden days. Even they have left only fragile threads of memory to be pulled into the web.

There are a few letters from the 1860s, in French, from one woman to another; they used nicknames; I have no idea who they were. There is the painfully precise outline of great-grandfather Roselle T. Cross's ministerial career; he was constantly being "called" to another place, and got paid less and less as the years went by. Three of his and Emma Bridgman's children died very young, the last succumbing on a train near Richland, South Dakota, on the way west. (The mourning parents wrote a whole booklet of memories about saintly three-year-old "little Thedie," and it's in the suitcase.) But Roselle

was an avid naturalist and mineralogist and wrote beautifully on his travels as a "home missionary" in Colorado in the 1870s, where he saw himself "laying the foundation of a Christian Empire," and where he "discovered" the Cave of the Winds. He was a romantic. When he went back to the cellarholes on his mother's homestead in Townsend, Vermont, he kissed a rock in her memory (and collected some quartz).

There are poignant letters from Joseph Isham, a young man dying of tuberculosis on a farm in Virginia where he'd been sent for his health, and letters about another TB death in the family, attended by my grandmother's older sister, who died young herself. There are the dramatic memoirs of her father, the lively, restless, and unsuccessful Frank Worthington Isham who wrote for *The Nation* (as I have) and left a solid New England family to find his fortune as a teacher, farmer, miner in the west. There are the painfully repressed daily diaries of my grandfather, also raised in the west, a guide at Yellowstone in 1899, a minister like his father, although he would have preferred another life. (I remember him primarily as a dour fisherman and elegant speaker. But on a rare summer night, he would burst out as a performer, singing, storytelling, and reciting Paul Laurence Dunbar in not-yet-forbidden Black dialect.)

On my father's side I have access to almost nothing. Yet his father, Will Lippard, had one of the more upheaved lives in all of the tangled lines. He was British; the family was originally from Sevenoaks, Kent, where they had a pub called The Rose and Crown. George Lippard and Sarah Scaping Lippard died without wills in 1881 and 1882 (their graves are in the Nunhead Cemetery in Peckham), leaving their orphaned children to fend for themselves. My grandfather lived as a waif under the Tower Bridge, where he picked up a Cockney accent, became a cabin boy, and eventually made it to Marlborough, Massachusetts, where he had relatives, got work in the shoe factory, married a Canadian schoolteacher named

Lucy Balcom, and had two sons. All fairly straightforward. But there was a skeleton in the closet. His benefactor, "Uncle Mort," was supposedly the bastard son of a woman who later married a Lippard and one Lord Mortimer, who educated him and set him up in the U.S. My mother's engagement ring was a diamond from a larger ring originating with Lord Mortimer.

I've never checked this out, but it's a good family story, and families have to have stories. On my mother's side it was The Fire. In 1882, Frank W. Isham homesteaded near what became Lisbon, North Dakota. Mary Rowland came out a year later from her parents' handsome house on Wooster Square in New Haven with her three (there were to be five) daughters to live in the sod house on the plains. (Her brother came too, having been kicked out of Yale in disgrace for a disapproved love affair, but committed suicide, alone on the plains, in 1891.) Five years later, after the usual struggles, the Buffalo Head Farm (each letter of its name was written on a buffalo skull over the gate) produced a bumper wheat crop, and when the granary was full, the whole place was burned down, purportedly by a "half-breed" whose daughter Edith Eagle worked for the family. This happened in October 1887. My great-aunt Ethel (supposedly the first white child born in Ransom County) went back to the site many years later and found a doll's head, pottery shards, some melted glass, in the middle of a cornfield where the house had stood.

And photographs: so unsatisfying and yet so tantalizing. I spend hours looking at them, delicately excavating the fragments of narrative, knowledge, and empathy that are left to us. I'm struck by their consistent failure to represent real life. It seems as if the "wrong pictures" always got taken. What appears is a peripheral view dictated by convention, by a lack of connection between knowledge of familial reality and the social formalities of picture-taking which maintain the relationships established in the 19th century.

One of these pictures in particular crosses my own life directly. I don't remember my grandmother mentioning "Anasazi" ruins and petroglyphs, and by the early 1970s, when I had gotten interested in them, she was gone. But there is this little blue-tinted photograph of her standing next to a wall of "Indian Writings" near Flagstaff, Arizona. (Was it the same place—perhaps Walnut Canyon—recorded years earlier by her not-yet father-in-law? From which he, alas, "came away well laden with relics"?) All of this leaps from the past at me, as I come closer to writing about 20 years of obsession with these sites, while trying to take responsibility for the havoc ignorantly wrought by people like my great-grandparents— the invasions, exploitations, desecrations.

There are so many odd crossings of names, places, events, ideas, and interests. The Isham family spent their summers in the Glen Park Chautauqua; Roselle T. Cross was on the "faculty" there (you could partake of 30 different courses for $2). He wrote a poem for the opening and called the Colorado Chautauqua Association "this college of the people." Since 1986, I've wintered in summer cabins in the Chautauqua in Boulder, Colorado, and pay my rent to the same Colorado Chautauqua Association. I wondered why when I first went there I found the history of the place coming up out of the ground at me in a curious kind of vision.

In 1915, my Cross grandparents, now transplanted back to New England where their families originated, were invited by a parishioner from Fitchburg, Massachusetts, to spend a weekend on a peninsula at the mouth of the Kennebec River in Maine. They fell in love with the place, and eventually bought a house and brought more of their minister friends to buy other deserted old houses nearby. I've spent every summer of my life there and recently—tramping its shores and woods, following its prehistoric shell heaps and historic stone walls, excavating its shallow earth and scanning its beaches and

rocks—I've learned more about the place than I ever thought I'd know. I share this work, or play, with a man whose roots are even deeper there than mine. And we are now "co-historians" of that much-loved point of land; both of our grandmothers preceded us in this unofficial position.

I'm often asked how I got so involved in so-called "multi-culturalism." I used to answer with autobiographical ramblings that stemmed from political awakenings in the McCarthy era to the '60s movement to feminism in the '70s. But then I realized that this too was inherited and now has a six-generational history. My great-great-grandmother was "a teacher of the colored people at Columbus (Ohio)." Her daughter Emma Asenath Bridgman (Cross) went to Macon, Georgia, in 1865, at the close of the Civil War, "to help start a school for freedmen" under the aegis of the American Missionary Association. (There are a lot of missionary types in my background and I've been teased about the parallels with my own political activism.) Then toward the end of his life, Emma's son Judson L. Cross was president of the then African American Tougaloo College in Mississippi. My mother, Margaret Isham Cross Lippard, worked in what was called "race relations" in New Orleans when I was a child; I've worked with anti-racist groups and written about "multicultural" art, and for many years my then-musician son worked primarily with African American artists.

Learning history backwards like this confirms that not only is the personal political, but the political is personal. Americans are often ignorant of our class histories, which can be learned by asking questions at home about why our families moved, married, worked, succeeded, and failed, why they went to war, or not, what historical and economic forces were behind their personal decisions. My own parents, for instance, could never figure out why I was prejudiced against the rich; they saw themselves as happily upper middle class. It took me years to

realize that my attitudes merely reflected their own class anxieties, inherited from childhoods where one of them was the poor but genteel minister's daughter (the family was expected to uphold the same standards as often wealthy parishioners, but with no money whatsoever) who went to Smith College on a working scholarship, and the other—the son of a cabin boy/ shoe factory/gas station worker—worked his way against the odds through Yale to become an international figure in medical education. Their stories about their childhoods, many of which seemed to involve insecurity and the wrong clothes, formed my sense of class and can still bring tears to my eyes.

As I look back over these fragments, I see a tension between west and east that I'd like to explore more—not a conflict so much as a visceral pull from one to another, from ocean to plains, from woods to deserts—that is so much a part of my family history and continues in my own life. I've always felt a curious tug at the sight of abandoned houses, roads, or fields—with their memories of animal, vegetal, and human lives almost tangible around them—as though I've been there before. Perhaps this dialectic between roots and restlessness is peculiarly North American. It offers, in any case, one way of seeing through the layers and the crossings to the mysteries of family, history, place.

1994

Over there a giant bud. Pale green, hairy with white tendrils. You deserved it. Looking like none of the other flowers in the garden which, in any case, have bloomed, and are beginning to droop. What did you expect? I hardly notice it at first, in a listless survey of my walled refuge. Everything could have been predicted. Bored with the fading beauty surrounding me, I return to that obscene plumpness, smug in its survival. That was when I recognized you and began to fear your strength. It seems to expand before my eyes. That was when I began to hate you. It *is* expanding, opening very, very slowly. Or did I hate you first and then begin to love you? The tightly woven point is peeling back. When you raised your arm and my gaze fastened on the black hairs sprouting beneath it. The undersides of the green leaves are white. When you raised your arm just before the end, in that ridiculous salute to that ridiculous dream. They give way to a pale blush. It was my job. Your cries of pain, of rage, were beside the point. What time is passing? You had no right to look as you did and be so danger-ous. Now the five lobed outer leaves are folded halfway down. Spies must expect to be caught. Now a dark red inner bud appears. However good the cause. Armored, hard as a ruby. And mine was, is, the winning cause. Beneath is a blossom of softer, still more brilliant red petals that open invitingly. Money and power will always conquer hope and desperation. It is still for a moment. Eventually. Then it quivers. Why do you people persist? I wait. The great red bud trembles, writhes, from the stem upwards. What am I afraid of? Slowly, sensuously, the red too peels away. I'm sweating, my hands shake. A swelling

347

stamen pushes up through the creamy center. If justice was not done, it doesn't matter, because I won. Deep like velvet, or blood. Pain didn't make you speak. With a paler core. But you cried when you knew you would die. Which opens, faster and faster now, paler and paler, to reveal your face, your body, your weapon. Now I understand whose blood it is.

1995

Once upon a time…your husband was killed in a defective Ford Pinto. Your brother went crazy from Agent Orange. Your daughter had cancer because your doctor prescribed DES when you were pregnant…And Corporate America lived Happily Ever After.

There! Are you happy with your Happy Ending?

No? Well, Think Positive. Think Pink and Blue, not Black and Blue.

How about this one?

Once upon a time you thought a political conviction was just as healthy as a religious conviction. And did more good, too. Then you went and got murdered protesting the Ku Klux Klan instead of being burned at the stake…but you couldn't go to heaven, so you hung around in the energy fields watching the rest of the world Live Happily Ever After.

No? That doesn't grab you either? Don't worry, those are false starts, not false endings.

Every ending is a new beginning. That's what. Hip hip hurray! Nothing replaces political consciousness. That's what. Hip hip hurray! Nothing replaces the dialogue. That's what. Hip hip hurray!

Nothing replaces organization. Nothing replaces the workers taking over the factory and the woman fighting off her would-be rapist. Work replaces greed. That's what.

(Pause.)

The way to his art is through his stomach. Take that. And that. And that. Eat shit. Eat me. Ah ha! You are what you eeeeaaat! The next course is Fascism? No, a surprise. Social

349

Democratic Republican Anarchic Libertarianism with just a dash of Luxembourgian Feminism. Under glass? So the public can't touch? Under Dirt. Six feet of it. Happy ReBirthday to You. Happy ReBirthday to you. Happy Birthday dear Happy Ending. Happy Birdsay to you.

Come in, Happy Ending. We were expecting you. There had to be an improvement eventually. Just give me some time to digest all these new ideas. I mean, my legs were raised to know my place. Out back in the garden, scaring off the evil spirits. Of course there's plenty for everybody. All we have to do is move Fatso there down below the salt, so there's room for the Cambodians. A very old recipe. Handed down over the generations. Frigassee of the Rich. A delicacy in the hovels of Ho-Ho-Kus, the caves of Kathmandu, the barrios of Bulgaria. No, I'm sorry. I can't tell you just how it's made. I might want to write a cookbook someday, you see...Or make art. Open Wiiide. Dig in! Dig Deep! Meal Art is the Happy Ending! Slurp Slurp Slurp—Meal Art replaces Me Art, replaces mealymouthed art. Replaces loafing on the breadlines and eating cake and birdseed because the food stamps were locked in the top drawer of the bureaucrat. Dig In! Dig Deep! With the weight of the rats off the sinking ship it floats again. The last meal of the day is lust. Take what you need and share it with your sisters and your brothers.

Have a nice Happy Ending! We're graduating from sodomized monobicontaminated glucosities back to dirt. Organic Earth. Nontoxic Love. Equal Distribution of Wealth. Our Right to Choose. We're sneaking through the intestines of this rotting society to give forth a good omen. Phew. Who did that? Hey. This corpse is pregnant. It's gonna be twins this time. Only the cleanest and the best; mixed in toilet bowls flagrant with artificial body odors. We keep them wrapped in plastic till they can walk. Then—into the microwave oven they go! All the impurities blown into a mushroom soup. You say's there's

350

Nobody left in the race we won? But we'll wring a Happy Ending out of this anyway. Because look at the funny way that bird is flying. With its engorged right wing and desperately flapping left. It's taken some seeds. Will dump them. Life goes on. Tweet tweet.

Happy Ending. So Here's what we did: We bought mace guns and took karate lessons. We told ourselves not to be afraid. And we were afraid enough to be careful. Very careful.

We talked to the others, and we found out their pain was like ours. So we did. We joined the Union. And we didn't. We didn't pay our rent. And we picketed the place. We refused to pay our taxes. We mothers got together and said No to the School Board. We put pressure on them. We put pressure on Them. We lay in the road! We climbed the fence! We occupied the office! We spoke out! We marched! We sent letters to the mayor! I sent a letter to the president! Me. I sent a letter to the president of the United States... And I got back a letter addressing me as mister.

So now there are many of us. And it is still not easy. That is at least closer to a Happy Ending, no?

(Dramatically.) But how can we forget Bloody Monday? Bloody Tuesday? Bloody Wednesday? Bloody Thursday? Bloody Friday? Bloody Saturday? Bloody Sunday? Bloody Mon...

You said that one already.

(Head in hands, long shrieking wail.) WHERE WILL IT ALL END?

(Flatly.) I don't know, but I want us to have something to say about it.

1979

351

*Selected
Bibliography*

The Bay Point Spinneys
The Bumblebee 39, no. 2
(June 1951)

Restraint
The Abbot Courant 81, no. 1
(February 1954)

A Character Sketch
The Abbot Courant 81, no. 2
(May 1954)

To Catch a Blackbird
Unpublished

The Chase
The Grecourt Review 1, no. 1
(November 1957)

In the Heat of the Day
The Grecourt Review 1, no. 3
(March 1958)

Lost and Found
Unpublished

The Reader and the Writer
Unpublished

Street Works
Unpublished

Response to Three Statements
David Lamelas, *Publication*
(London: Nigel Greenwood,
1970)

Robert Barry at Yvon Lambert
(Paris: Yvon Lambert, 1971)

Imitation = Homage
*Dust: An International Quarterly
of the Arts* 4, no. 3 (1971)

Walls, Rooms, Lines
Unmuzzled Ox 13, vol. 4, no. 1
(1976)

Absentee Information
and or Criticism
Information, Kynaston McShine
ed. (New York: MoMA, 1970)

The Romantic Adventures
of an Adversative Rotarian;
or, Alreadymadesomuchoff
Marcel Duchamp, Anne
d'Harnoncourt and Kynaston
McShine, eds. (New York: MoMA,
1973)

New York Times I
The World 30 (July 1976)

353

New York Times II
Center 7 (April 1975)

New York Times III
Unmuzzled Ox 13, vol. 4, no. 1
(1976)

New York Times IV
Five Prose Fictions (New York:
AIR Gallery, 1976)

New York Times V
*A Day in the Life: 24 Hours in
the Life of a Creative Woman*
(Chicago: ARC Gallery, 1979)

Lunch I
Unpublished

Lunch II
Unpublished

Lunch III
Unpublished

headwaters
Five Prose Fictions (New York:
AIR Gallery, 1976). Reprinted in
Heresies 2 (May 1977).

Touchstones
Tractor 6 (1975)

Antipodes
Unpublished

Soda Springs
Fire in the Lake 1, no. 5
(September–October 1976)

Photo – Dialogue (1976)
Unpublished

Photo – Dialogue IV (1978)
A shortened version appeared in
*Criteria: A Critical Review of the
Arts* 4, no. 1 (Spring 1978)

Friends on a Black and White Set
From the unpublished novel
The First Stone (1977–78)

The Island
From the unpublished novel
Islands (1980s)

Caveheart (for Charles)
Center 5 (September 1973)

First Fables of Hysteria
Five Prose Fictions (New York:
AIR Gallery, 1976)

The Cries You Hear
Five Prose Fictions (New York:
AIR Gallery, 1976). Reprinted in
Heresies 2 (May 1977).

into among
Five Prose Fictions (New York:
AIR Gallery, 1976). Reprinted in
Heresies 2 (May 1977).

Waterlay
Center 4 (November 1972)

An Intense and Gloomy Impression
for a Woman in the Nineties
Big Deal 2 (Spring 1974)

Stonesprings
Heresies 5 (Spring 1978)

Three Fictions
Sun & Moon: A Journal of Literature and Art 6–7 (Winter 1978–9)

The Lizard:
Or Underwater Ants
Unpublished

They All Lived in Houses
Unpublished

Strawberries
Unpublished

Mealsong
Unpublished

Brimstone
Unpublished

"I don't want to think about it because there's nothing I can do about it so please don't talk about it to me"
Performance text, 1979. Published in *Get the Message: A Decade of Art for Social Change* (Boston: E. P. Dutton, 1979).

Above It All and Below It All
Images and Issues (Fall 1980)

Art World
Unmuzzled Ox: Poet's Encyclopedia 4, nos. 4–5 (1979)

Propaganda Fictions
Performance text, 1979. Published in *Get the Message: A Decade of Art for Social Change* (Boston: E. P. Dutton, 1984).

Sweet Tooth and Royalty
Cover 5 (Spring–Summer 1981)

Home Anthropology
Cover 5 (Spring–Summer 1981)

Home Economics
Heresies 13 (1981)

More on Home Economics
Shantih: The Literature of Soho 4, nos. 3–4 (Winter–Spring 1982)

Happy Newsyear
Village Voice (1981–85)

Transparencies
History 101: The Re-Search for Family (St. Louis: Forum for Contemporary Art, 1994)

Gone By
Garden Court, Mike Glier, ed. (Elkins Park, Pa.: Tyler Gallery, Temple University, 1995)

Happy Ending
Performance text, 1979. Published in *Get the Message: A Decade of Art for Social Change* (Boston: E. P. Dutton, 1979).

Author's Note

Thanks above all to Jeff Khonsary, who initiated this project, bringing to fruition my high school dream of publishing fiction. The gaps in documentation of these ephemeral pieces is not the fault of the editors; I live in a certain level of chaos and couldn't find a lot of the publication details.

And to my parents, especially my mother, a great reader and letter writer, for letting me read anything I wanted, however "age inappropriate." When I was in the eighth grade at Lane High in Charlottesville, Virginia, I received the $10 writing prize for the whole high school ("The Spinneys of Bay Point, Maine"). A few years later, Miss Alice Sweeney, an English teacher at Abbot Academy, recognized my love of writing and commented on it. These early encouragements set me off.

Kynaston McShine, an old friend by then a curator at MoMA, hired me to write strange things for his *Information* and *Marcel Duchamp* catalogues in 1969 and 1970. Artist Sol LeWitt was a supportive friend and influence all along. Writer friends Esther (E. M.) Broner and Walter Abish encouraged these increasingly experimental directions, and a few little-magazine editors led some into print.

For a recent birthday, my longtime partner Jim Faris, a social anthropologist who, unlike most men, reads a lot of good fiction, gave me seventeen novels by women (except one by a Kim, who turned out to be a man).

Other books by
Lucy R. Lippard published
by New Documents

4,492,040
978-1-927354-00-1
(2012)

I See / You Mean
978-1-953441-03-4
(2021)

5 Prose Fictions
978-1-953441-08-9
(2022)

Headwaters (and Other Short Fictions) was produced with support from Remai Modern, Saskatoon, as part of a special research initiative begun in 2019. Completed in tandem with the re-edition of Lucy Lippard's 1979 novel *I See / You Mean*, this work involved several research trips to Galesteo, New Mexico, between 2019 and 2023, and countless hours spent working with the personal archives of the author and her contemporary collaborators. This research culminated with the development, editing, and production of the present volume.

**rRemai
mModern**

*Headwaters
(and Other Short Fictions)*
Lucy R. Lippard

Editor: Jeff Khonsary

Copyeditor: Jaclyn Arndt
Additional Proofing:
Robert Dayton

Printed in Estonia

Published by
New Documents
Los Angeles
newdocuments.org

New Documents (23)
ISBN: 978-1-953441-04-1

*Lucy R. Lippard is a writer, activist,
and curator. She is the author of over
two dozen books on contemporary
art and cultural criticism. She has
curated some fifty exhibitions in the
United States, Europe, and Latin
America.*

Special thanks to Rhiannon Vogl,
Rebecca La Marre, Celene Anger,
and Michelle Jacques.

Author photograph by Cathleen
Roundtree.